Dutch A.
Aruba, Boi ＿ ＆
Curaçao

Don Philpott

Dedicated to Pam, My Beautiful American Rose

ACKNOWLEDGEMENT

My grateful thanks to all who helped me over the last few years during my trips to the islands to research and write this book. In particular I would like to thank Myrna Jansen-Feliciano and Castro Perez of the Aruba Tourism Authority, La Cabana All Suites Resort, Aruba and Aileen Zerrudo of Lou Hammond and Associates; Roland Martinez of Tourism Corporation Bonaire, Sand Dollar Beach Club, and Pamela Maitland, Adams Unlimited; and Charla Nieveld, Curaçao Tourism Development Bureau, Lea Preece, Sonesta Beach Hotel and Casino, Curaçao and Marcella Martinez Associates.

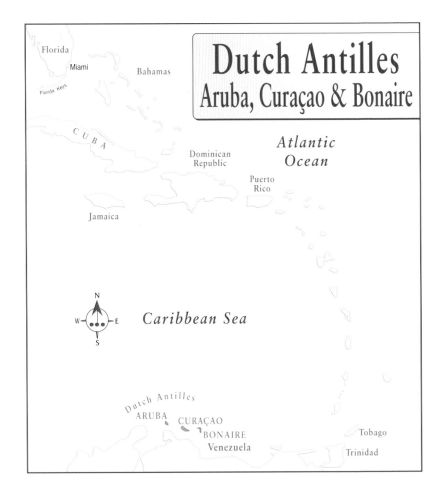

Dutch Antilles
Aruba, Curaçao & Bonaire

Florida

Miami

Florida Keys

Bahamas

CUBA

Dominican
Republic

Puerto
Rico

*Atlantic
Ocean*

Jamaica

N
W — E
S

Caribbean Sea

Dutch Antilles
ARUBA
CURAÇAO
BONAIRE
Venezuela

Tobago

Trinidad

*Opposite page: 'Fofoti' tree
on Eagle Beach, Aruba*

Dutch Antilles
Aruba, Bonaire & Curaçao

Don Philpott

• CONTENTS •

• FEATURE BOXS •

• MAPS •

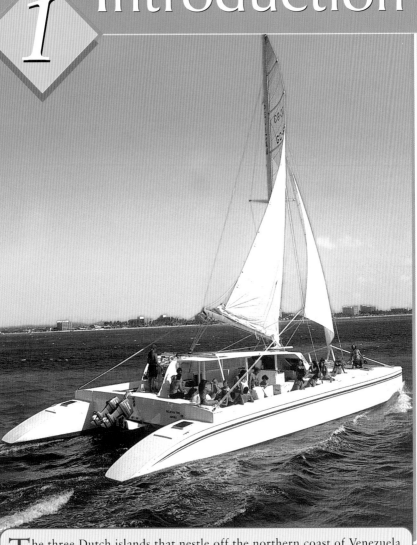

The three Dutch islands that nestle off the northern coast of Venezuela offer the best of Caribbean beaches, weather and hospitality – with a difference. The islands, known as the ABC's – **Aruba, Bonaire and Curaçao** – are traditionally Dutch and this is reflected in the wonderful Dutch-colonial architecture, red Dutch post boxes, currency, road signs and many customs. English is widely spoken, and the official language is Dutch although the everyday language is Papiamentu, a Spanish-based Creole that has incorporated words from many other languages. The warmth of the islands' greeting is best expressed in a line from Aruba's national anthem that translated means: the greatness of our people is their great cordiality.

GEOGRAPHY

The three islands of Aruba, Bonaire and Curaçao are a Caribbean anomaly in more ways than one. Until recently they were all part of the Dutch Antilles (Nederlandse Antillen), two groups of Caribbean islands 500 miles (800km) apart. Aruba was a member of the Dutch Antilles until 1986 when it achieved its own political status as a separate entity within the Kingdom of the Netherlands. The Kingdom of the Netherlands today comprises three elements – The Netherlands on mainland Europe, the Netherlands Antilles and Aruba.

The northern group of the Netherlands Antilles include Sint Eustatius, Saba and Sint Maarten, the southern half of the island of St. Martin, the other part of which is French and administered by Guadeloupe. These islands are within the Leeward Islands of the Lesser Antilles. The southern islands in the Dutch Antilles are Curaçao and Bonaire, with Aruba geologically part of this island chain which lies about 60 miles (97km) off the north Venezuelan coast. Curaçao is the largest island in the Dutch Antilles, and Willemstad, its capital, is the largest city in the islands.

And while other Caribbean islands are noted for their lush, tropical vegetation, the immediate impression of these is of a dry, almost desert-like appearance with eroded poor and infertile soil because of the very low annual rainfall, and centuries of over-grazing. Because of

Islands with a difference

All three islands are very different from others in the Windward Islands to the east and those to the north. They are largely flat although there are hills on all three islands, in Aruba the highest point is Mount Jamanota is 620 feet (189m), on Bonaire it is Mount Brandaris 787 feet (240m), and on Curaçao it is the 1,230 foot (375m) Mount Saint Christoffel.

the low rainfall – ten times less than in the rain forests of Grenada to the east – most drinking water comes from desalination plants. The islands are all the result of submarine volcanic action and uplifting and consist mostly of lava rock and then rock coral that was deposited after uplift.

Aruba is the smallest of the three islands with an area of 70 sq. miles (182 sq. km), It is just under 20 miles (32km) long and 6 miles (10km) wide, and is about 50 miles (80km) north west of Curaçao, and 18 miles (29km) north of the Venezuelan peninsula of Paraguana. The island is low lying, consists mostly of igneous rocks and is fringed by coral reefs. The island's highest points are Mount Jamanota 620 feet (189m) and the 560 foot (171m) Mount Hooiberg, which means 'haystack' and looks just like a giant one. There are also huge boulders

of diorite, often piled on top of each other, around the island.

Bonaire has an area of 111 sq. miles (289 sq. km) and lies 20 miles (32km) east of Curaçao. It is 24 miles (39km) long and on average five miles (8km) wide.

Curaçao is the largest of the Dutch islands with an area of 174 sq. miles (453 sq. km). It has a deeply indented southern coastline, including the massive Schottegat Bay, one of the finest and largest natural harbors in the Caribbean and the site of the capital, Willemstad.

A LITTLE HISTORY

The original people of the islands were the gentle Arawaks, an Amerindian race, although little is known about them or when they first arrived. They are believed to have come from Asia to the Orinoco region of South America about 40,000 years ago. They fished, hunted and cultivated plants such as maize, tobacco and cassava, but food was plentiful and they had lots of time to lie in the sun and party! They lived in small coastal communities, wore few clothes but decorated themselves with tattoos, feathers and beads, and were skilled potters.

Other Amerindians including the warlike Caribs, followed them into the Caribbean some time between AD800 and 1000, but it is thought they did not permanently settle but moved on in their huge war canoes to colonize other islands in the Caribbean where in most cases, they virtually eradicated the Arawaks.

For at least 300 years before the Spanish 'discovered' the islands, the Arawaks of the Caiquetio tribe lived there. It is known that the Amerindians had a well-developed social system and common language throughout the Caribbean islands. They were ruled by hereditary kings called *caciques*, although *shamans* (religious leaders) also wielded enormous power. The Caribs were renowned warriors and their war canoes could hold more than a hundred men able to paddle fast enough to catch a sailing ship. Europeans feared them because of horrific stories about cannibalism with victims being roasted on spits. The Caribs were even said to have a taste preference, thinking Frenchmen were the tastiest, and then the English and Dutch, with the Spanish considered stringy and almost inedible.

Villages were built in inland forest clearings, and each settlement had its own chieftain. Huts were round with timber walls and palm thatched roofs. Early paintings show that they enjoyed dancing, either for pleasure or as part of rituals, and that they played ball games. They were primarily fishermen and hunters, although they did cultivate kitchen gardens, and developed a system of shift cultivation, known as *conuco*.

The early Spanish recorded their surprise at the Amerindian agricultural techniques, use of fibers and pottery and boat building skills. They were such skilled weavers that they could produce containers able to hold water.

The ABC islands were 'discovered' in 1498-9 by the Spanish explorers Alonso de Ojeda and Amerigo Vespucci (the man who gave his name to America), but little interest was expressed in them. The low-lying islands were officially declared *islas inutil* (useless islands). The Spanish realized there were better pickings to be had elsewhere although there were occasional forays

to collect salt. Many of the Amerindians living on the islands were captured by slavers and sent to work in Spanish possessions in other parts of the Caribbean, particularly Hispaniola. Only on Aruba did significant populations of Arawaks survive.

Naming of the islands

The first Spaniards gave Curaçao the name Gigan (giant) because the Indians were so tall – more than 7ft (2m) according to accounts by Amerigo Vespucci. Curaçao is the Spanish word for heart, but how the island got this name on early Portuguese maps is unclear.

The Spanish established settlements on Bonaire in 1501, and on Curaçao in 1527 and imported farm animals to produce meat for the crews of the passing ships. For the next century or so, little happened although pirates and privateers frequently raided the island, and Spain for much of the time was locked in war with Holland.

In 1634 Johannes van Walbeeck of the Dutch West India Company ousted the 20 or so Spanish settlers and occupied Curaçao and immediately set about fortifying the island to prevent attacks from particularly the Spanish and the English. At the same time he claimed jurisdiction over Aruba and Bonaire, and both became part of the Dutch West India Company in 1636. The Spanish did raid Bonaire in 1642 but the Dutch had left for the safety of Curaçao and so the Spanish burned the settlement and left empty handed.

The three islands became important not only as trading ports for the Dutch but because of their extensive saltpans. The Dutch needed huge quantities of salt for their fishing industry as the catches, especially herring were packed in salt. Curaçao's commercial prosperity was largely the result of Governor Peter Stuyvesant, who later became Governor General for all Dutch territories in the New World based in New Amsterdam, later to become New York.

For almost the next 200 years, apart from British occupation between 1807 and 1814, Bonaire was a Government plantation, while Aruba was used first as a huge cattle ranch and then to breed racehorses with local Indians working the ranches.

Under the patronage of the Dutch West India Company, Curaçao became a powerful trading force with slaves being one of the most important 'commodities' traded. Bonaire had slave farms to supply the Curaçao market.

Twice during the Napoleonic Wars Curaçao was occupied by the British but the island was returned to The Netherlands by the Treaty of Paris in 1815, and all three islands were officially handed back in 1816. The islands' proximity to Venezuela also made them convenient havens for political refugees from South America, and Simon Bolivar sought refuge on Aruba in 1812 after his First Republic collapsed.

The Dutch were slow in freeing their slaves and did not emancipate them until 1863, almost 30 years after Britain abolished slavery in the West Indies. With emancipation the economy of the islands declined, and in the nineteenth century large areas were offered for sale and much

of it was planted with aloes, which were in demand by the pharmaceutical industry in Europe and North America. Oranges were also planted. On Aruba gold was discovered in 1824 and although it was mined until the early twentieth century, production was never large.

The economy continued to decline until 1918 when Venezuela discovered oil, and Royal Dutch Shell and Exxon opened refineries on the islands. Shottegat oil refinery was opened on Curaçao, and another at the port of San Nicolas on Aruba, importing crude oil from the South American wells. Its closure in 1985 caused near economic disaster that was averted by the vigorous promotion of tourism.

After the World War II talks began to grant the islands greater self-rule and on 15 December 1954, a charter was signed making Bonaire and Curaçao autonomous parts of The Netherlands. Curaçao was rocked by strikes and riots in 1969 over the Dutch Government's call for the islands to become independent. In 1977 Aruba, concerned at its dependence on and domination by Curaçao voted to leave the Dutch Antilles federation, yet remain a separate entity within the Kingdom of The Netherlands (the Dutch Government granted this in 1986 on the condition that Aruba would accept full independence in 1996). In 1978 Bonaire and Curaçao both accepted island self-determination but remain within the Netherlands Antilles with Curaçao as the administrative capital for the federation.

Dutch architecture

Most of the population lives in urban areas and there are few villages. A feature of Curaçao is the large number of *landhuizen*, which are large eighteenth- and nineteenth-century country mansions built among the hills, and all three islands boast some magnificent Dutch colonial architecture with appropriate adaptation for the tropics. The buildings' appearances are further enhanced by their traditional orange or red roof tiles and being painted in a range of striking hues from orange and ochre to dark green, and often trimmed with white which adds to their attraction. According to legend, in 1817 the Governor Admiral Kikkert, who had only just taken up his appointment after the islands had been returned to the Netherlands from Britain, ordered that no buildings could be painted white because he found the color too bright on his eyes.

Dutch facades at Eagle

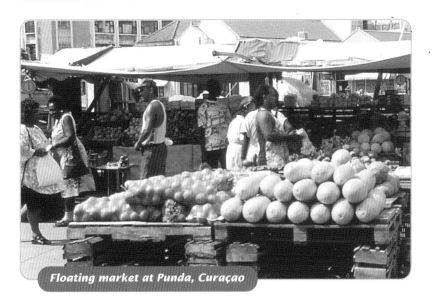

Floating market at Punda, Curaçao

THE PEOPLE

The population of Bonaire and Curaçao is mostly of African descent although there are small white minorities, while on Aruba, the population is racially mixed with many people claiming Caiquetio Amerindian blood, although there are few of African descent as slaves were not widely brought to the island. Curaçao has a very diverse population as there was significant immigration from other Caribbean Islands, Venezuela and Europe after the oil refinery was opened in 1918.

ECONOMY

The economy of the islands has never been based on agriculture as with other Caribbean islands, and Curaçao's dominance was built on the Netherlands' skill as a trading nation. Curaçao became a major regional trading center, an infamous one as its main trade was in slaves.

With the slave trade came wealth, and Curaçao also developed into an important financial center and free port area. There was a further boost with the discovery of mineral wealth, especially oil, and more recently, tourism has become an important element in all the islands' economies. Curaçao has calcium phosphate deposits that are mined, Bonaire produces salt and Aruba concentrates on tourism with a busy hotel and casino expansion plan. The island is also diversifying its economy with a large free-trade zone and attempts to establish itself as a major international offshore center.

Livestock was introduced by the early European settlers but the land was unsuitable and much of the vegetation was destroyed. Aloes were grown for the pharmaceutical industry and the special bitter oranges that are the main ingredient for Curaçao's most famous export, Curaçao liqueur.

Oil refining is the main industry on Curaçao. Oil was discovered in north Venezuela in 1914, and a massive oil refinery was opened on the island four years later. Bonaire has a textile factory and tourism, with all its associated industries and services, continues to grow in importance. The main exports are oil and oil products from Curaçao, and Curaçao's free ports are also major handlers of freight in transit.

POLITICAL LIFE

Bonaire and Curaçao as islands within the Dutch Antilles, are self governing parts of the Kingdom of The Netherlands. They have a Governor, nominated by the locally elected Government, and appointed by the Crown, who is the formal head of the Government and the monarch's representative. The executive authority is in the hands of a Council of Ministers led by a Prime Minister. There is a one-chamber assembly (the Staten). In 1986 Aruba was allowed to leave The Netherlands Antilles federation and become a separate entity within the Kingdom of The Netherlands, It has a Governor appointed by the Crown, who is the formal head of government. The Council of Ministers headed by the Prime Minister is the island's executive authority, and there is an elected one state chamber. The Kingdom of the Netherlands is responsible for defense and foreign affairs, but the three islands are each responsible for all other matters.

Jurisdiction lies with a Common Court of Justice of Aruba and the Netherlands Antilles and a Supreme Court of Justice in the Netherlands.

PLANT AND ANIMAL LIFE

Aruba, Bonaire and Curaçao have their own very distinct Caribbean vegetation. The islands have for centuries been overgrazed and the soil is poor and in many places severely eroded, and this, coupled with the low annual rainfall, accounts for the predominantly cactus, scrub and other drought-resistant vegetation. The divi divi (Watapana) trees have been sculpted by the prevailing trade winds into fascinating shapes with their boughs generally pointing to the southwest, and some of the cacti stand 30ft (9m) high. There are, however, very diverse habitats and vegetations to be seen from stunning sandy beaches to dramatic coastal cliffs, mangrove swamps, lowland woodlands, freshwater lakes and lagoons and rolling hills.

The islands take conservation seriously. There is a 3,500-acre (1400-hectares) reserve on Curaçao, Bonaire has the 13,500-acre (5400-hectare) Washington-Slagbaai National Park and all the offshore waters are protected, and Aruba has the Arikok National Park and many other protected areas.

Beach morning glory with its array of pink flowers is found on many beaches, and is important because its roots help prevent sand drift. The plant also produces nectar from glands in the base of its leaf stalks that attract ants, and it is thought this evolution has occurred so that the ants will discourage any leaf-nibbling predators. Other beach plants include seagrape and the manchineel, which should be treated with caution.

Dangerous tree

Beware: The manzanilla or manchineel, which can be found on many beaches, has a number of effective defensive mechanisms which can prove very painful. Trees vary from a few feet to more than 30ft (9m) in height, and have widely spreading, deep forked boughs with small, dark green leaves and yellow stems, and fruit like small, green apples. If you examine the leaves carefully without touching them, you will notice a small pinhead sized raised dot at the junction of leaf and leaf stalk. The apple-like fruit is poisonous, and sap from the tree causes painful blisters. It is so toxic, that early Caribs are said to have dipped their arrowheads in it before hunting trips. Sap is released if a leaf or branch is broken, and more so after rain. Avoid contact with the tree, do not sit under it, or on a fallen branch, and do not eat the fruit. If you do get sap on your skin, run into the sea and wash it off as quickly as possible.

Of course, the sea teems with brilliant fish and often, even more spectacularly colored coral and marine plants. Even if you just float upside down in the water with a facemask on, you will be able to enjoy many of the beautiful underwater scenes, but the best way to see things is by scuba diving, snorkeling or taking a trip in a glass-bottomed boat.

There are hard and soft corals but only one, the fire coral, poses a threat to swimmers and divers, because if touched, it causes a stinging skin rash. Among the more spectacular corals are deadman's fingers, staghorn, brain coral and seafans, and there are huge sea anemones and sponges, while tropical fish species include the parrotfish, blue tang surgeonfish, tiny but aggressive damselfish, angelfish and brightly colored wrasse.

Gardens and hotel grounds provide most of the color on land. Flowering plants include the flamboyant tree with its brilliant red flowers which burst into bloom in early summer, and long dark brown seed pods, up to two feet which can be used as rattles when the seeds have dried out inside. On Curaçao it is believed that every flamboyant tree is the home of a spirit and it is said to be bad luck to walk under the tree at midday or midnight because the spirit might appear.

Bougainvillea blooms in a host of different shades. In fact, the color does not come from petals but the plant's bract-like leaves that surround the small petal-less flowers. There are yellow and purple allamandas, amaryllis, chaconia, poinsettia, hibiscus, heliconia, giant anthurium, frangipani and multi-colored flowers of the ixora.

The leaves of the travelers palm spread out like a giant open fan, and the tree got its name because the fan was believed to point from south to north, but it rarely does.

The flowers attract hummingbirds like the doctor bird, as well as the carib grackle, a strutting, starling-like bird with a paddle-shaped tail, and friendly bananaquit.

And, areas of scrubland have their own flora or fauna, with plants bursting into color following the

"Gouden Regen" flower

first heavy rains after the dry season. There are century plants, with their prickly, sword like leaves, which grow for up to twenty years before flowering. The yellow flower stalk grows at a tremendous rate for several days and can reach 20ft (6m) high, but having bloomed once the whole plant then dies. Other typical scrubland vegetation includes aloe, acacia, prickly pear and several species of cactus. Fiddlewood provides hard timber for furniture; highly colored variegated crotons, the white flowered, aromatic frangipani and sea-island cotton, which used to provide the very finest cotton, and the calabash tree whose seedpods are used as maracas. The fruit of the calabash is very versatile and has long been used as a water carrier. The wood of the kibrahacha tree, which grows to about 70ft (21m), is so hard that its local name is 'break axes'.

There are few land animals although you can see wild donkeys and goats and there are some deer on Curaçao, but the islands are rich in bird life and are a bird watcher's paradise. More than 300 species have been recorded on the ABCs, many of them found only on the islands and many others are visitors from South America or on migration from the North. Among the most interesting, are parrots and parakeets, hummingbirds, a wealth of wading birds and the brightly colored trupial, which is the national bird of Curaçao. The Barika hel (on Bonaire it is called the Chibichibi) is a noted sugar thief and is quite likely to land on the breakfast table if you are eating outside, to steal a sachet of sugar which it rips open and scatters about. You can also see the Chuchubi, or tropical mocking bird which some islanders believe which predicts the future with its calls. The calls that sound like words in Papiamento, are said to presage either good luck or bad. Bonaire has two reserves where you can see West Indian flamingos.

Offshore you may sight the magnificent frigatebird, easily recognizable by its size, long black 7ft (2m) wingspan, forked tail and apparent effortless ability to glide on the

winds. There are brown booby birds, named by sailors from the Spanish word for 'fool' because they were so easy to catch. Pelicans that are so ungainly on land and so acrobatic in the sky, are common, as are laughing gulls and royal terns. Several species of sandpiper can usually be seen scurrying around at the water's edge. There are lots of insects including irritating mosquitoes, ants and sand flies, and there are frogs and toads that croak loudly all night.

Above: Donkeys roaming the cunucu, Aruba

Left: Cacti, Aruba

Below: Watapana trees in the "cunucu" (countryside), Aruba

Turtles

Lumbering sea turtles also come ashore at night between March and September to dig their shell nests in the sand and lay between 80 and 125 eggs. A turtle may nest six times at nine-day intervals in one season, laying more than 700 eggs. The incubation period ranges between 55 and 70 days and results in another incredible sight as the tiny, young hatchlings dash to the sea. The best time to see nesting green, hawksbill, leatherback and loggerhead leatherbacks is between June and July, with the hatchlings emerging between July and early October. A fifth species, the Olive Ridley turtle is very rare, and is known locally as the Turtuga Bastardo. There are lots of opportunities to watch these endangered creatures but they should never be disturbed.

If you are really interested in bird or nature watching pack a small pair of binoculars. The new mini-binoculars are ideal for island bird watching, because the light is normally so good that you will get a clear image despite the small object lens.

As most of the plants, fruits, vegetables and spices will be new to the first time visitor, the following brief descriptions are offered. Not all grow on the islands but all come from the Caribbean and may be served to you in one form or another:

FRUITS

Bananas have been such an important crop in the Caribbean they have earned the nickname 'green gold' – and they grow everywhere. There are three types of banana plant. The bananas that we normally buy in supermarkets originated in Malaya and were introduced into the Caribbean in the early sixteenth century by the Spanish. The large bananas, or plantains, originally came from southern India, and are largely used in cooking. They are often fried and served as an accompaniment to fish and meat. The third variety is the red banana, which is not grown commercially and is quite rare. Most banana plantations cover only a few acres and are worked by the owner or tenant, although there are still some very large holdings. A banana produces a crop about every nine months, and each cluster of flowers grows into a hand of bananas. A bunch can contain up to twenty hands of bananas, with each hand having up to 20 individual fruit.

Although they grow tall, bananas are not trees but herbaceous plants which die back each year. Once the plant has produced fruit, a shoot from the ground is cultivated to take its place, and the old plant dies. Bananas need a lot of attention, and island farmers will tell you that there are not enough hours in a day to do everything that needs to be done. The crop needs fertilizing regularly, leaves need cutting back, and you will often see the fruit inside blue tinted plastic containers, which protect it from insect and bird attack, and speed up maturation.

Breadfruit was introduced to the Caribbean by Captain Bligh in 1793. He brought 1200 breadfruit saplings from Tahiti aboard the Providence,

and these were first planted in Jamaica and St. Vincent, and then quickly spread throughout the islands.

Mutiny on the Bounty

It was Bligh's attempts to bring in young breadfruit trees that led to the mutiny on the *Bounty* four years earlier. Bligh was given the command of the 215-ton *Bounty* in 1787 and was ordered to take the breadfruit trees from Tahiti to the West Indies where they were to be used to provide cheap food for the slaves. The ship had collected its cargo and had reached Tonga when the crew under Fletcher Christian mutinied. The crew claimed that Bligh's regime was too tyrannical, and he and 18 members of the crew who stayed loyal to him, were cast adrift in an open boat. The cargo of breadfruit was dumped overboard. Bligh, in a remarkable feat of seamanship, navigated the boat for 3600 miles until making landfall on Timor in the East Indies. Some authorities have claimed that it was the breadfruit tree cargo that sparked the mutiny, as each morning the hundreds of trees in their heavy containers had to be carried on deck, and then carried down into the hold at nightfall. It might have proved just too much for the already overworked crew.

Whatever the reason for the mutiny, the breadfruit is a cheap carbohydrate-rich food, although pretty tasteless when boiled. It is best eaten fried, baked or roasted over charcoal. The slaves did not like it at first, but the tree spread and is now found almost everywhere. It has large dark green leaves, and the large green fruits can weigh 10-12lb (5kg). The falling fruits explode with a loud bang and splatter their pulpy contents over a large distance. It is said that no one goes hungry when the breadfruit is in season.

Calabash trees are native to the Caribbean and have huge gourd-like fruits that are very versatile when dried and cleaned. They can be used as water containers and bowls, bailers for boats, and as lanterns. Juice from the pulp is boiled into syrup and used to treat coughs and colds, and the fruit is said to have many other medicinal uses.

Cocoa's Latin name *theobroma* means 'food of the gods'. A cocoa tree can produce several thousand flowers a year, but only a fraction of these will develop into seed bearing pods. It is the heavy orange pods that hang from the cocoa tree which contain the beans that contain the seeds that produce cocoa and chocolate. The beans, containing a sweet, white sap that protects the seeds, are split open and kept in trays to ferment. This process takes up to eight days and the seeds must be kept at a regular temperature to ensure the right taste and aroma develop. The seeds are then dried. In the old days people used to walk barefoot over the beans to polish them to enhance their appearance. Today, the beans are crushed to extract cocoa butter, and the remaining powder is cocoa.

Chocolate is made by mixing cocoa powder, cocoa butter and sugar.

Coconut palms are everywhere and should be treated with caution. Anyone who has heard the whoosh of a descending coconut and leapt to safety knows how scary the sound is. Those who did not hear the 'whoosh' presumably did not live to tell the tale! Actually, injuries from falling coconuts are rare but it is not a good idea to picnic in a coconut grove!

Coconut trees are incredibly hardy, able to grow in sand and even when regularly washed by salty seawater. They can also survive long periods without rain. Their huge leaves, up to 20ft (6m) long in mature trees, drop down during dry spells so a smaller surface area is exposed to the sun reducing evaporation. Coconut palms can grow up to 80ft (24m) tall, and produce up to 100 seeds a year. The seeds are the second largest in the plant kingdom, and these fall when ripe.

The coconut you buy in a supermarket is the fleshy seed surrounded by a hard shell. In its natural state this shell is enclosed by a layer of fibrous copra and covered by a large

• VISITING AND THE CLIMATE •

Any time is a good time to visit the islands. The high season is generally regarded as between mid-November and mid-April, with March, the driest month, but the islands now attract visitors by air and from cruise ships year round. Most of the rain falls between May and October but even this does not amount to much.

Climate

The islands enjoy a marvellous climate with near year-round sunshine and much lower rainfall than Caribbean islands to the east and north. Even when it does rain, it is warm rain and generally does not last long. The islands lie within the tropical zone in the path of the northeast trade winds (that the Dutch call the passatwinden), and have a typical sub-tropical maritime climate of year round sunny, warm weather. Temperatures along the coast are moderated by the onshore sea breezes.

Temperatures remain fairly constant throughout the year, with only a few degrees fluctuation between summer and winter. The average daytime temperatures year round are about 81°F (27°C) and average night temperatures around 65°F (18°C). During the hottest part of the year, however, temperatures some days can often be in the high nineties, and humidity can be high.

Rainfall on all three islands is low and is often less than 20 inches (51cm) a year.

Hurricanes

The islands are outside the general hurricane belt that runs to the north. Hurricane season in the Caribbean lasts from June to November with September and October usually the busiest months for tropical storms. If a hurricane should threaten, follow the advice given locally.

• ABC HOTSPOTS •

Aruba

Palm Beach and Eagle Beach

Oranjestad

Scuba diving

Arawak caves at Fontein and Guadirikir

Arikok National Park

Bonaire

Bonaire Marine Park

Pink Beach

Kralendijk

Goto Meer for the flamingoes

Washington-Slagbaai National Park

Curaçao

Willemsted for its historic districts, forts and shopping

Seaquarium

Christoffel Park

Westpunt Beach on a weekend

Hato Caves

The Landhuizen

Above: Christoffel Park, Curaçao Below: Family on Eagle beach, Aruba

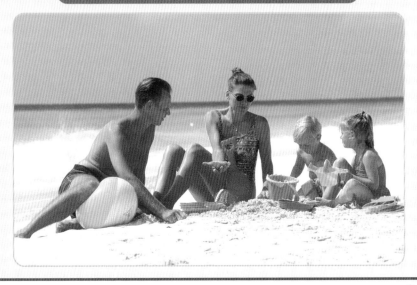

green husk. The seed and protective coverings can weigh 30lb (14kg) and more. The seed and casing is waterproof, drought proof and able to float, and this explains why coconut palms which originated in the Pacific and Indian Oceans, are now found throughout the Caribbean – the seeds literally floated across the seas.

The coconut palm is extremely versatile. The leaves can be used as thatch for roofing, or cut into strips and woven into mats and baskets, while the husks yield coir, a fiber resistant to salt water and ideal for ropes and brushes and brooms. Green coconuts contain delicious thirst-quenching 'milk' while the coconut 'meat' can be eaten raw, or baked in ovens for two days before being sent to processing plants where the oil is extracted. Coconut oil is used in cooking, soaps and synthetic rubber and even in hydraulic brake fluid.

As you travel around the islands, you will see groups of men and women splitting the coconuts in half with machetes. You might also see halved coconut shells spaced out on the corrugated tin roofs of some homes. These are being dried before being sold to the copra processing plants.

Dasheen is one of the crops known as 'ground provisions' in the islands, the others being **potatoes, yams, eddo** and **tannia**. The last two are close relatives of dasheen, and all are members of the aroid family, some of the world's oldest cultivated crops. Dasheen with its 'elephant ear' leaves, and eddo grow from a corm which when boiled thoroughly can be used like potato, and the young leaves of either are used to make callaloo, a spinach-like soup.

Both dasheen and eddo are thought to have come from China or Japan but tannia is native to the Caribbean, and its roots can be boiled, baked or fried.

Guava has an aromatic, pulpy fruit that is also popular with birds who then distribute its seeds. The fruit is used to make a wide range of products from jelly to 'cheese', a paste made by mixing the fruit with sugar. The fruit ranges from a golf ball to a tennis ball in size and is a rich source of vitamin A. It also contains lots more vitamin C than citrus fruit.

Mango can be delicious if somewhat messy to eat. It originally came from India but is now grown throughout the Caribbean and found wherever there are people. Young mangoes can be stringy and unappetizing, but ripe fruit from mature trees that grow up to 50ft (15m) and more, are usually delicious, and can be eaten raw or cooked. The juice is a great reviver in the morning, and the fruit is often used to make jams and other preserves. The wood of the mango is often used by boatbuilders.

Nutmeg trees are sometimes found. The tree thrives in hilly, wet areas and the fruit is the size of a small tomato. The outer husk, which splits open while still on the tree, is used to make nutmeg jelly. Inside, the seed is protected by a bright red casing that when dried and crushed, produces the spice mace. Finally, the dark outer shell of the seed is broken open to reveal the nutmeg which is dried and then ground into a powder, or sold whole so that it can be grated to add flavor to dishes.

Passion fruit is not widely grown but it can be bought at the market. The pulpy fruit contains hundreds

of tiny seeds, and many people prefer to press the fruit and drink the juice. It is also commonly used in fruit salads, sherbets and ice creams.

Pawpaw trees are also found throughout the islands and are commonly grown in gardens. The trees are prolific fruit producers but grow so quickly that the fruit soon becomes difficult to gather. The large, juicy melon-like fruits are eaten fresh, pulped for juice or used locally to make jams, preserves and ice cream. They are rich sources of vitamin A and C. The leaves and fruit contain an enzyme which tenderizes meat, and tough joints cooked wrapped in pawpaw leaves or covered in slices of fruit, usually taste like much more expensive cuts. The same enzyme, papain, is also used in chewing gum, cosmetics, the tanning industry and, somehow, in making wool shrink resistant. A tea made from unripe fruit is said to be good for lowering high blood pressure.

Pigeon Peas are cultivated and can often be found in back gardens. The plants are very hardy and drought resistant, and give prolific yields of peas that can be eaten fresh or dried and used in soups and stews.

Pineapples were certainly grown in the Caribbean by the time Columbus arrived, and were probably brought from South America by the Amerindians. The fruit is slightly smaller than the Pacific pineapple, but the taste more intense.

Sugar apple is a member of the annona fruit family, and grows wild and in gardens throughout the islands. The small, soft sugar apple fruit can be peeled off in strips when ripe, and is like eating thick applesauce. It is eaten fresh or used to make sherbet or drinks. **Soursop,**

is a member of the same family and its spiny fruits can be seen in hedgerows and gardens. They are eaten fresh or used for preserves, drinks and ice cream.

FOOD AND DRINK

Dining out in the Caribbean offers the chance to experiment with all sorts of unusual spices, exotic vegetables and fruits, with the freshest of seafood, Creole and island dishes, and, of course, Curaçao rum punches and other exotic cocktails.

And, because of their diverse population, the cuisine of the ABC islands is even more exciting with East Indian, Chinese, Creole, French, Indonesian, Italian, Japanese, Lebanese and Latin American influences. There are also fast food outlets serving both American burgers and fried chicken, and traditional island fast food snacks.

Many hotels have a tendency to offer buffet dinners or barbecues, but even these can be interesting and tasty affairs, especially when the superb local fish and seafood is offered. Eating out is generally very relaxed, and few restaurants have a strict dress code, although most people like to wear something a little smarter at dinner after a day on the beach or out sightseeing.

BREAKFAST

Breakfasts can be very healthy with wonderful exotic fruit juices and fresh fruit. There is watermelon, mango, pineapple, bananas and papaya. There is also traditional porridge on Curaçao called fungee and made from sorghum flour, as well as funchi, which is made from cornmeal, and is a staple part of the Aruba, Bonaire and Curaçao diets.

Above left: A glance into the past, Aruba

Above right: Brightly painted Dutch facade, Bonaire

Left: Couple swimming in "Cura di Turtuga" (Conchi/ Natural Pool), Aruba

Below: One of the many beautiful beachs on Bonaire

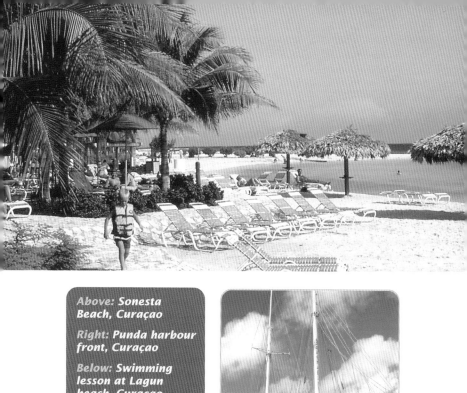

Above: Sonesta
Beach, Curaçao

Right: Punda harbour
front, Curaçao

Below: Swimming
lesson at Lagun
beach, Curaçao

THE STAR NC 2425

Sunday brunch has become something of a tradition on the islands, and many hotels compete with each other to provide the most sumptuous spreads, often accompanied by champagne.

LUNCH

Lunches are best eaten at beach cafés that usually offer excellent barbecued fresh fish and conch. Lobster and crab are also widely available. Dishes are mostly served with Caribbean vegetables such as fried plantain, rice with moro (beans), polenta or funchi, and sometimes with banana, hasa, cassava and yam, while fresh fruit such as pineapple, mango, golden apple or papaya, makes an ideal and light dessert.

DINNER

There is an enormous choice when it comes to dinner.

Starters include sanger yena, an Aruba sausage similar to English black pudding. There is also scavechi, an appetizer of marinaded fried fish. Try traditional Caribbean dishes such as christophene and coconut soup, and Callaloo soup made from the leaves of dasheen, a spinach like vegetable also called elephant's ears, with okra, pumpkin and coconut milk added. On special occasions crab or other meats are added.

There are lots of special soups (sopi) such as sopi di pisca made from fresh fish, sopi di marscos, seafood soup, sopi di bestia chiquito made from mutton, sopi di giambo (or yambo) made from okra and fish and is the Aruba version of bouillabaisse. There is also a tasty sopi di mondongo made from tripe.

Fish and clam chowders are also popular starters. Try heart of palm, excellent fresh shrimps or scallops, smoked kingfish wrapped in crêpes or crab backs, succulent land crab meat sautéed with breadcrumbs and seasoning, and served stuffed in the shell. It is much sweeter than the meat of sea crabs.

The fish is generally excellent, and do not be alarmed if you see dolphin on the menu. It is not the protected species made famous by 'Flipper', but a solid, close-textured flat-faced fish called dorado, which is delicious. There are also tuna, grouper, barracuda, snapper, mula, dradu, lobster, swordfish, baby squid and mussels. Conch is known locally as karkó and while readily available because of imports, it is protected on Bonaire and Aruba.

Try seafood jambalaya, chunks of lobster, shrimps and ham served on a bed of braised seasoned rice, shrimp creole, with fresh shrimp sautéed in garlic butter and parsley and served with tomatoes, or fish creole, with fresh fish steaks cooked in a spicy onion, garlic and tomato sauce and served with rice and fried or boiled plantain.

More exotic dishes include sautéed scallops with ginger, curried fish steaks lightly fried with a curry sauce and served with sliced bananas, cucumber, fresh coconut and rice.

ISLANDS' SPECIALITIES

Other islands' specialties include bakiou stoba (dried salt codfish stew), balchi pisca (fish balls), keri keri (stewed fish served grated), keshi yena (filled cheese shells), komkomber stoba (stewed Aruba cucumber), mochi di pisca Estilo Arubano (fish Aruba-style), and stoba di bestia chiquito, which is a meat stew usually of lamb or stoba

di cabrito, made from goat. Galina stoba is chicken stew.

Side dishes include pan bati, which are Aruba pancakes, and funchi, made from polenta. You might be offered iguana stew, especially if at a celebration, and iguana soup is said to have aphrodisiac properties.

It seems such a waste to travel to the Caribbean and eat burgers and steaks, especially when there are so many much more exciting snacks to be enjoyed. Try bolita di keeshi (cheese balls), cala (black eyed pea puffs), calco (pickled or stewed conch), croquettes of meat or fish, pastechi (savory or sweet pastries) and suls, which is pickled pig meat.

The East Indian influence is represented by curry and roti, Caribbean fast food with a difference. It is an envelope of paper-thin soft split pea dough containing rich curry and vegetables. You can get different fillings – beef, pork, chicken and fish as well as combinations – and if you get the chance, try the chicken, pumpkin and channa combo. The chicken roti can contain bones that some people like to chew on, so be warned.

You could try curried chicken, goat and fish sometimes served in a coconut shell, gingered chicken with mango and spices; Caribbean souse, with cuts of lean pork marinated with shredded cucumber, onions, garlic, lime juice and pepper sauce. There is also delicious Indonesian food, including the sumptuous rijsttafel (rive table) that is a feast of up to 20 dishes featuring different meats, fish, vegetables and sauces.

For vegetarians there are excellent salads, stuffed breadfruit, callaloo bake, stuffed squash and pawpaw,

baked sweet potato and yam casserole.

For dessert, try fresh fruit salad, or one of the exotically flavored ice creams, like mango or coconut. There are also banana fritters and banana flambé, coconut cheesecake and tropical fruit sorbets. Try cocado, which is coconut candy, dushi di tamarijn, a sweet and sour tamarind dish, kesio, an Aruba flan, pan pollo which is bread pudding, and soenchi, deliciously light meringues.

On the buffet table, you will often see a dish called pepper pot. This is usually a hot and spicy meat and vegetable stew to which may be added small flour dumplings and shrimps.

There are wonderful breads in the Caribbean, and you should try them if you get the chance. There are banana and pumpkin breads, and delicious cakes.

Pepper sauce

Another note of warning: on most tables you will find a bottle or bowl of krioya, a creole pepper sauce. It usually contains a blend of several types of hot pepper, spices and vinegar, and should be treated cautiously. Try a little first before splashing it all over your food, as these sauces range from hot to unbearable.

If you want to make your own hot pepper sauce, take four ripe hot peppers, one teaspoon each of oil, ketchup and vinegar and a pinch of salt, blend together into a liquid, and bottle.

Don't be afraid to eat out. Food is often prepared in front of you, and there are some great snacks, both savory and sweet, available from island eateries. On Curaçao for instance, you can try stoba (hearty meat stews) and rice and peas (which is really rice and beans) or something more exotic like iguana (juwana) or gambo with funchi, which is maize meal mixed with the sweet fruits of cacti.

DRINKS

Rum and liqueurs are the main drinks with Curaçao, world famous for its delicious bitter orange liqueur, and Aruba noted for its own specialty called Coecoei. You can visit the Senior Curaçao liqueur distillery and Curaçao's Amstel Brewery where they brew beer using desalinated seawater.

Rum is the Caribbean drink. There are almost as many different rums in the West Indies as there are malt whiskies in Scotland, and there is an amazing variety of strength, color and quality. The first West Indian rum was produced in the Danish Virgin Islands in the 1660s and by the end of the century there were thousands of distilleries throughout the Caribbean. Rum rapidly became an important commodity and figured prominently in the infamous Triangle Trade in which slaves from Africa were sold for rum in the West Indies that was sold to raise money to buy more slaves.

Rum has such fortifying powers that General George Washington insisted every soldier be given a daily tot, and a daily ration also became a tradition in the British Royal Navy, one that lasted from the eighteenth century until 1970.

Origin of rum

Columbus is credited with planting the first sugar cane in the Caribbean, on Hispaniola, during his third voyage, and the Spanish called the drink produced from it aguardiente de cane, although it was officially named as saccharum, from the Latin name for sugar cane. It was English sailors who abbreviated this name to rum. It is sometimes suggested that the word rum comes from an abbreviation of the word 'rumbullion'. While the origin of this word is unknown there is a record of it in 1672, and it was later used to describe a drunken brawl.

Rum can be produced in two ways. It can be distilled directly from the fermented juice of crushed sugar cane, or made from molasses left after sugar, extracted from the cane by crushing, is boiled until it crystallizes. Dark rums need extensive ageing in oak barrels, sometimes for up to 15 years, while light rums are more light-bodied and require less ageing.

Most of the production is of white rum, and there are some excellent barrel-aged drinks that are best sipped and enjoyed as liqueurs.

Most tourist hotels and bars also offer a wide range of cocktails both alcoholic, usually very strong, and non-alcoholic. Apart from Curaçao liqueur, Aruba is noted for its own liqueur called Coeciei and Ponche Crema, a local eggnog. When these two are combined, they produce a drink called a Pink Panther.

• ARTS, CULTURE AND ENTERTAINMENT •

The islanders have a natural artistry that is evidenced by the wonderfully woven baskets, rugs and hats, decorated pots and ornate jewelry, often using natural material such as seeds. This artistic ability has been handed down over scores of generations, with even the earliest Arawak ceramics showing ornate patterns and designs. Pottery and basket weaving were skills passed down ever since the Arawaks.

Music is an essential part of life and the islands throb with the pulse of Latin and Caribbean rhythms such as tumba, salsa and reggae, and this is best experienced during Carnival that traditionally precedes Lent. Each of the islands has its own carnival with Curaçao's being the largest and longest. Jazz is popular and Curaçao hosts an annual jazz festival that attracts top artists from around the world.

Christmas and New Year are also times for lots of celebrations, and harvest festival celebrations are still important on Bonaire and Curaçao.

Curaçao's most celebrated artists include Hippolito Ocalia born in 1919 in a thatched cunucu house. He started drawing with charcoal at the age of 3 and although he never had any formal training, his vibrant pictures vividly capture all aspects of island life. Others include sculptor Maximilian 'Nepo' Nepomuceno, Lucila Engels, Luigi Pinedo, Ellis Juliana, Jean Girigori, Yubi Kirindongo, Nelson Carilho, Jose Capricorne, Anton Vrede, Rasta Elijah, Rudsel Martinez, Minerva Lauffer, Phillipe Zanolino, Ria Houwen, Ati Schotburg and Johannes Anemaet.

On Aruba you can still hear pianist Padu del Caribe perform. He is regarded as the father of the island's music scene and his rhythms include tumba, danza, mazurka, merengue, mambo, and wals (waltz).

Tap water in hotels and resorts is generally safe to drink and mineral and bottled water is widely available, and so are soft drinks. There are good island beers, and a huge choice of fruit juices, and green coconuts with the top sliced off to make a drinking hole, provides a very refreshing and cheap drink, and an experience worthy of a souvenir photo.

Note: While many of the main tourist hotel restaurants offer excellent service, time does not have the same urgency as it does back home, and why should it after all, as you are on holiday. Relax, enjoy a drink, the company and the surroundings and do not worry if things take longer, the wait is generally worth it.

Mix Your Own

The Painkiller is a rum cocktail containing orange and pineapple juice, cream of coconut and a sprinkling of nutmeg. There are scores of different rum cocktails, and one of the most popular is the traditional Plantation Rum Punch.

To make **Plantation Rum Punch**, thoroughly mix 3 ounces of rum, with one ounce of limejuice and one teaspoon of honey, then pour over crushed ice, and for a little zest, add a pinch of freshly grated nutmeg.

Planter's Punch: Combine 2 ounces each of pineapple juice, rum, cream of coconut and half an ounce of lime in a blender for one minute. Pour into a chilled glass, add a sprinkle of grated coconut and garnish with a cherry and a slice of orange.

• Some island recipes •

Sopi di carco (conch soup)
You need: 1lb conch, 1 pint chicken stock, 2 tablespoons lime juice, cup of diced carrots, 1 peeled tomato, 1 sliced onion, 1 sliced green pepper, chopped clove of garlic, sprig of fresh basil, 4oz of vermicelli, Tabasco sauce and salt and pepper to taste.
Wash and trim conch, dry, then pound and flatten with a flour-coated wooden mallet. Rub in lime juice then cut into bite-size pieces. Bring the chicken broth to the boil, add tomato, onion, green pepper, garlic and basil and simmer for 20 minutes. Remove from heat and strain the liquid, setting aside the vegetables. Return the liquid to the heat, add carrots and simmer for a further 20 minutes, then add the conch, vermicelli, a few drops of Tabasco and salt and pepper. Simmer for about 10 minutes or until the conch is tender. Do not overcook.

Chicken with mango-papaya sauce
You need: 6 boneless chicken breasts, glass of fresh orange juice, 3 teaspoons of chopped fresh tarragon.
Sauce: 1 large mango, 1 large papaya, teaspoon of red pepper, juice of 2 limes, salt and pepper to taste.
Marinade the chicken in the orange juice and tarragon for three to four hours at room temperature, then grill breasts for 3 to 4 minutes each side. Peel, de-seed and mince the mango and papaya, add the pepper and lime juice and mix thoroughly, adding salt and pepper to taste. Serve the sauce cold on the grilled chicken.

Keshi yena

You need: 12oz thinly sliced Gouda cheese, 1 finely chopped onion,
3 tablespoons of unsalted butter, 2 cups of chopped cooked chicken or
shrimp, 1 chopped tomato, 1 chopped green pepper, 2 chopped dill pickles,
6 chopped green olives, a tablespoon of well drained capers, a small handful
of cashew nuts, 1 teaspoon finely chopped garlic, two tablespoons of raisins
soaked in water, 1 tablespoon of Worcestershire sauce, 1 teaspoon yellow
mustard, 4 tablespoons of tomato ketchup, 2 bay leaves and half a teaspoon
of dried thyme.

Line the sides and bottom of a large, deep cake tin with the cheese leaving a
few slices for later. In a frying pan cook the onions in the butter till golden
and soft. Add all the remaining ingredients, mix thoroughly and then
carefully pour into the cake tin. Cover with the remaining pieces of Gouda
and then place the cake tin in a larger container. Add boiling water to the
larger container so that it comes about halfway up the outside of the cake
tin, then bake in a preheated over for 30 minutes at 350°F (175°C). Let cool
for 15 to 20 minutes before serving.

Callaloo

Callaloo soup is synonymous with the islands and makes a delicious creamy
dish. As callaloo leaves are difficult to find outside the Caribbean, use fresh
spinach leaves instead.

1 cup minced onions, half a cup of finely chopped celery, 3 tablespoons
butter, 6 cups of water, 8oz diced smoked ham, 2 cups firmly packed,
washed fresh spinach leaves, 1 cup sliced okra, 1lb peeled shrimps, half a
teaspoon of dried thyme, salt and pepper to taste, dash of hot pepper sauce
(optional but recommended).

Sauté the onions and celery in melted butter in a large pan for three to four
minutes. Add the water and ham and bring to boil. Add the spinach, okra,
shrimps, thyme, salt and pepper, then reduce the heat and cook slowly and
uncovered for about 10 to 12 minutes and until the shrimps have turned
pink. Add hot pepper sauce to taste and serve. Serves four.

Aruba

The brilliant white sands and turquoise sea are unmistakably Caribbean, but the nineteenth-century windmills, cactus scrub and architecture sets it apart as something very different. It is a small island and many visitors never stray far from the fabulous beaches and luxury resort hotels on the south west coast, but pocket-sized Aruba is ideal for exploring, and as the car number plates proudly declare, it is 'One Happy Island'.

There are the shops and sights of Oranjestad, the rugged north eastern coast with its own beauty and secluded beaches, San Nicolas, Aruba's second city on the island's south eastern tip, picturesque fishing villages and the striking interior of cactus, aloe and dramatic rock formations. You can go diving or dune sliding, birding or land sailing. There are archaeological and wildlife tours, golf and hiking, mountain bike tours and moonlight cruises. It is a great destination for sun worshippers, honeymooners, snorkelers, sailors and,

even weekend gamblers.

Aruba is the most tourist-developed of the ABC islands, and the Arubans are genuinely warm and welcoming. Even the national anthem proclaims their hospitality with the words: *Grandeza di bo pueblo ta su gran cordialidad* (The greatness of our people is their great cordiality). The island's hospitality and friendliness is so appealing that hundreds of visitors return year after year. In recognition of this, the Government presents Certificates of Distinction to those who have made

many visits to the island. More than 1,000 people have received certificates for returning every year for at least 20 years, and hundreds more have received certificates for coming back annually for 10 years.

AN OVERVIEW

The island is 2.5 hours from Miami by air and 4 hours from New York. It is roughly 20 miles (32km) long and 6 miles (9km) across at its widest, and covers an area of 70 sq miles (184sq km), and is just 15 miles (24km) off the Paraguana peninsula on the north coast of Venezuela. The word Aruba is said to derive from the Arawak words *ora* meaning shell and *oubau* meaning island.

It has a year-round average temperature of 82°F (27.5°C) with low humidity, and average annual rainfall is less than 24in (60cm) that

'Fofoti' tree on Eagle Beach

accounts for the Caribbean desert vegetation of divi-divi (watapana) trees, cactus, sea grape, kwihi, aloe, palm and flamboyant trees. The island's pure drinking water comes from the world's second largest desalination plant.

There are wonderful beaches, luxury hotels, great restaurants and fascinating shopping in the capital of Oranjestad. The island does not have a very diverse animal life, but is rich in coral, tropical fish, lizards and birds.

The island's population of about 81,500 is made up of 43 distinct nationalities including Dutch, South Americans, North Americans, Europeans, Chinese and native Arubans, who have a mix of Dutch, Spanish and Arawak Amerindian blood.

On 1 January, 1986 Aruba left the Netherlands Antilles to become a *Status Aparte*, a separate entity within the Kingdom of Netherlands. The head of state is the Queen who is represented on the island by her appointee, the Governor. There is a 21-member elected parliament with executive power in the hands of the Council of Ministers headed by the Prime Minister.

The official language of the island is Dutch although the everyday language is Papoamento, while most Arubans also speak English and Spanish. The official currency is the Aruban Florin AFL (also called the Guilder) and it has an exchange value of US$1= AFL 1.78. US dollars are generally accepted.

Aruba is on Atlantic Standard Time that is four hours ahead of London and one hour behind New

York i.e. when it is noon on London it is 8am on Aruba and 7am in New York.

ARUBA
SETTLEMENT

Aruba was first settled by the peaceful Arawaks of the Caiquetio nation perhaps 4000 years ago and reminders of their presence can be still be seen throughout the island. Apart from the bloodline which many islanders proudly claim, there are cave paintings and petroglyphs on great granite boulders at Ayo and Arikok. The Arawaks made their dyes from the appropriately named paint wood tree and the paintings are still striking many centuries later, although the meaning of the inscriptions and symbolism continues to mystify the experts. Excavations have revealed beautiful pots and ceramics, and these have inspired many of the island's modern artists and craftsmen.

Significant European settlement is little more than 200 years old. The Dutch West India Company that controlled the island after wresting it from Spain in 1636, used it to raise cattle and pedigree horses. Immigration did not start until the end of the 1700s when the Dutch West India Company started to sell off parcels of land. It was at this time that Oranjestad was founded and named after the reigning Royal House of Orange. In 1805 during the Napoleonic Wars the English seized the island and they occupied Aruba until 1816 when it was returned to Dutch control. During the nineteenth century, many Venezuelans arrived, adding a decided Spanish influence to the small population.

Mineral wealth

In 1824 gold was discovered, and you can still see the remains of the smelting works at Bushirabana and Balashi. As the gold mines became less profitable – the last closed in 1916 – the Aruba aloe plantations were established and flourished. Then, in the 1920s, the oil industry arrived and two refineries were built to process the island's black gold. The Eagle Oil Refinery was built on the west side of the island, and the Lago Refinery, a subsidiary of Standard Oil, was established just outside San Nicolas. At the time it was the biggest oil refinery in the world and it remained the island's major employer until it closed in the spring of 1985. It was so strategically important that German U-Boats attacked it during the World War II. The refinery's influence remains because many American oil workers and others moved to the island and stayed on, and English is a prominent second language. And, the main thoroughfare that runs across the island, the L G Smith Boulevard, is named after Lago's former general manager. In 1991 the Coastal Oil Company reopened some of the refinery's capacity providing jobs and revenue.

The multi-cultural influence is evident as you travel around the island and this makes sightseeing even more interesting. There is the strik-

ing Dutch colonial architecture to be seen on Wilhelminastraat in Oranjestad, and Fort Zoutman and the William III Tower from the earliest days of the Dutch presence. In the *cunucu* (countryside) there are ancient undeciphered writings on the walls of the caves at Arikok National Park which are a memorial to Arawak's earliest residents, while the Church of Santa Anna, with its famous 115 year-old oak altar, represents more recent history.

Tourism on Aruba began in 1957 when the first cruise ship, the Tradewind, made a call. In 1959 the first hotel-casino, the Aruba Caribbean opened its doors and by the mid-1960s, tourism had taken off with hotels, casinos, restaurants, shops, amusements and attractions continuing to make their appearance. Today, tourism is Aruba's leading industry and it caters to its visitors very well. The island has undergone major development designed to expand and enhance its tourism product and facilities. This has, however, gone hand in hand with a careful plan to preserve the island's beaches, its intrinsic charm and to prevent over-development.

In January, 1996 the Aruba Government announced an ambitious US$800 million (£533 million) plan to transform one fourth of the island into a national park, develop the area of San Nicolas as a civic and cultural center, build circuit roads, heritage trails and bicycle paths and water treatment plants to cater for the growing number of tourists.

BEACHES

Generally the south coast beaches offer the calmest waters with safe swimming while the north-east beaches can have thundering waves which come crashing ashore and, in places, carve wonderful rock formations in the coral cliffs such as natural bridges and arches. Most of the island's resort hotels are concentrated along a seven mile (11km) stretch of beautiful white sand beach on the south-west coast that changes its name is you travel south from **Palm Beach** to **Eagle Beach** and then **Punta**, **Manchebo** and **Druif** Beaches. This stretch of coastline is rated as having among the world's most beautiful beaches. There are, however, many other fine, and more secluded beaches to seek out for a day's sunbathing, swimming and picnicking. There is **Andicuri** on the northern coast that many islanders consider to be the most beautiful, secluded beach. Also on the north coast is **Boca Prins** with its snow-white sand dunes although the seas can be rough making swimming dangerous. On the south coast is **Palm Reef Island** with **Rodgers Beach** and **Baby Beach and Lagoon**, at the island's southernmost tip, where the water is calm enough for the youngest and most inexperienced swimmers.

Children

Aruba is a perfect family-holiday destination with many miles of safe bathing, and most resort hotels offer family-friendly entertainment and facilities for children from kids' and teens' day camps, water and land-based sporting activities to qualified babysitting.

California Point

California Lighthouse

Arashi Beach

Malmok

Tierra del Sol Golf Course

ARUBA

Aruba Marriot Resort & Stellaris Casino

Holiday Inn Aruba Beach Resort & Casino

Hyatt Regency Aruba Resort & Casino

Radisson Aruba Beach Resort & Casino

Stauffer Hotel Aruba

Alto Vista Chapel

Church of Santa Ana

Caribbean Palm Village Resort

Noord

Bushiribana Gold Smelting Ruins

N
W E
S

Palm Beach

The Mill Resort

Amsterdam Manor Beach Resort

La Cabana All-suite Beach Resort & Casino

Eagle Beach

Palm Beach

Bubali Bird Sanctuary

Tanki Flip

Paradera

Ayo

Bucuti Beach Resort

Aruba Beach Club

Manchebo Beach

Divi Arba Beach Resort

Drufi Beach

La Quinta Beach Resort
Costa Linda Beach Resort
Best Western Manchebo Beach Resort

Historical Graves

Modanza

Dutch Village

Divi Village

Tamarijn Aruba Beach Resort

Bushiri Bounty Beach Resort

Oranjestad

Hoolberg Indian Rock Garden

Canashito

Santa

Aruba Sonesta Resort & Casino at seaport Village

Aruba Sonesta Suites & Casino

Best Western Talk of the Town Resort

Sonesta Island

Queen Beatrix International Airport

Bucuti Yacht Club

Spanish Lagoon

Barcadera

Arul Nautical Water Desalination Pla

De Palm Island

GAMBLING

Aruba has 11 casinos, the best known of which is the Alhambra Bazaar, across from the Aruba Beach Resort. The Alhambra combines casino and huge entertainment complex offering the Aladdin Theatre, dining and shops. The island's newest casino, the Royal Cabana Casino and Tropicana Showroom, is at the recently-opened La Cabana All Suites Beach Resort and Casino, and it is also the largest casino in the Caribbean featuring slots, blackjack, roulette, horseracing, craps, baccarat and Caribbean stud poker. Bingo and raffles are also a feature of the casinos. The other casinos are: Palace Casino, Americana Aruba Beach Resort; Casablanca Casino and Music Hall, Aruba Hilton; Stellaris Casino, Aruba Marriott Resort; The Palm Casino, Aruba Palm Beach Resort; Crystal Casino and Desires Nightclub, Aruba Sonesta Resort; Seaport Casino, Aruba Sonesta Suites, Seaport Village;

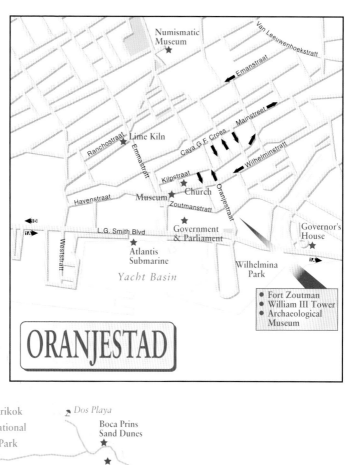

ORANJESTAD

- Numismatic Museum
- Van Leeuwenhoekstratt
- Emanstraat
- Mainstreet
- Lime Kiln
- Ranchostraat
- Emmastratt
- Cava G.F. Croes
- Wilhelminstratt
- Kilpstraat
- Church
- Museum
- Oranjestraat
- Havenstraat
- Zoutmanstratt
- Government & Parliament
- Governor's House
- L.G. Smith Blvd
- Weststratt
- Atlantis Submarine
- Wilhelmina Park
- Yacht Basin
- Fort Zoutman
- William III Tower
- Archaeological Museum

- Arikok National Park
- Dos Playa
- Boca Prins Sand Dunes
- Fontein & Guadirikir Caves
- Masiduri Cunucu House
- Pass
- Jamanota
- Guadirikiri Caves
- Huliba Caves
- Lourdes Grotto
- Aruba Golf Club
- Boca Grandi
- Savaneta
- San Nicolas
- Coatal Oil Refinery Company
- Commandeurs Bay
- Sero Colorado
- Colorado Caves
- Colorado Point
- Rodgers Beach
- Baby Beach

3 miles

3Km

Grand Holiday Casino, Holiday Inn Aruba Beach Resort; Copacabana Casino, Hyatt Regency Aruba Beach Resort; and Casino Masquerade, Radisson Aruba Caribbean Resort.

SHOPPING

Island shopping is another of the treats that awaits visitors. There are considerable savings, often 30% and more cheaper on big name brands than North American and European prices. The main shopping area is in Oranjestad but there are many shopping malls, and most hotels have their own stores and boutiques and duty free stores. Shops in Oranjestad are open from 8am to noon and 2pm to 6pm although some remain open over lunch. Shops in malls and shopping centers are open from 10.30am to 6pm. Some stores open on Sundays and holidays, especially if a cruise ship is in port.

Main shopping malls in and around Oranjestad are: Alhambra Shopping Bazaar, Midtown Mall, Port of Call Marketplace, Seaport Marketplace, Seaport Village Mall, Strada Complex 1 and 11, Sun Plaza Mall, The Atrium, The Dutch Crown and The Galleries. There is also the Centro Commercial Noord and San Nicolas Shopping District.

For island arts and crafts try the following:

Artesania Aruba, L.F. Smith Boulevard 178, opposite the Tamarijn Aruba Beach Resort, has pottery and other local handicrafts; **Bonbini Festival**, Fort Zoutman (see page 38); **Creative Hands**, Socotorolaan 5A, opposite the post office, has pottery, ceramics, porcelain, paintings and other local handicrafts. **Just Local**, Cashero 51, Santa Cruz, offers handmade souvenir items. Oranjestad

galleries include Artishock, Seroe Blanco 67c and Gallerie Eterno, Emanstraat 92.

Carnival

Weeks of preparation making costumes and rehearsing news songs and dance routines culminate in the Grand Parade in Oranjestad on the Sunday before Ash Wednesday. The whole island celebrates and two of the most popular – and photogenic – events are the Grand Children's Parade and the spectacular night-time Lighting Parade.

ORANJESTAD

The town was founded in 1824 and sits at the head of Paardenbaai (Horse's Bay) that offers a natural port for the many visiting cruise ships. The town was named in honor of the House of Orange, the Dutch Royal Family, and is smart and small, a mix of pretty, pastel colored old Dutch colonial style buildings and modern office blocks, traditional Caribbean bazaars and chic boutiques, and charming outdoor cafés where you can sit, sip a drink and watch the world go by. L G Smith Boulevard is the main road through town following the coast and running from the cruise ship terminal east to downtown, and then on past Harbour Town and Wilhelmina Park, and crossing over the Lagoon and heading out towards the airport. The waterfront area is the oldest part of town and further inland are the homes built during the oil boom of the 1930s and since.

Aruba is on the itinerary of most

• GETTING AROUND ON ARUBA •

The island's network of roads means you can visit all parts of the island, although some minor roads are unpaved. There is no road all the way around the island yet and tours often mean doubling back some way before heading to a new destination. Distances, however, are never great, and you can see a lot in a day and there should never be any reason to hurry.

A major redevelopment plan was announced at the beginning of 1996 that includes the construction and upgrading of many roads. The Island Circuit involves the improvement and expansion of existing roads together with a limited number of environmentally sensitive new connecting ones, to create a well-marked series of roads circumnavigating the island and linking Aruba's natural, historic and cultural sites. The Island Circuit will begin at the airport, includes a new parkway to improve access to and from San Nicolas, as well as a separate island-wide system of bicycle paths through scenic areas and linking towns, communities, beaches and attractions. Bike rentals are already available at several locations including Oranjestad, San Nicolas, Arikok National Park and many hotels.

Bikes and hire cars are necessary if you plan to do a lot of exploring, while buses and taxis are the best bet if you are just going to make occasional trips.

Buses are inexpensive and reliable and there are daily services between all the island's districts and between hotel areas although they do not run late into the evening. There are services from town to the main hotel areas, and from the airport to Oranjestad and many hotels also have their own shuttle buses to meet arriving air passengers. Bus stops are easily recognized by the word Bushalte. Some hotels operate their own shuttle buses into town.

Private mini buses also run on some of the most popular routes and are cheap, usually noisy and mostly crowded – but still fun.

Taxis. There are flat fares and taxis do not have meters, but always confirm the price before setting off. Most taxi drivers have participated in the government's Tourism Awareness Program and make excellent island guides. Tipping is at your discretion, but should be between 10 and 15% of the fare. Taxis are available for tours and excursions but agree a price first. It is obviously cheaper if a group shares the cost. There are taxis available at most resort hotels and the dispatch office is behind the Eagle Bowling Palace on the Sasaki Road ☎22116 or 21604.

Colibri Helicopters (☎931832) offer island tours.

Plasa Daniel Leo in downtown Oranjestad

cruise ship companies, and is also the home port of the Dolphin Cruise Line and the Seawind Cruise Line for their weekly turnaround cruises. The cruise ships dock along the jetty that is on the western side of town and a short walk from the heart of the town and the main shopping areas.

The **tourist information office** is in Arnold Schuttestraat that is off L G Smith Boulevard and lies between the Seaport Village Mall with its attractive shops and eateries and the Government offices. The Seaport Village is fun not just for its multi-level shopping but because you can also pop in to the Sonesta Hotel where guests are ferried by boat right from the lobby to their own private beach. You can also take the escalator from the hotel's atrium by the lagoon to the casino and disco, or enjoy a drink in the café overlooking the shops below.

The tourist office has information about current events, what to see and do, tourist maps and so on. Arnold Schuttestraat runs inland to connect with Zoutmanstraat, and

you should then turn right into Oranjestraat for **Fort Zoutman** and the **King Willem III Tower**. The Fort is the island's oldest structure and was completed in 1796 to protect the port, and the tower was added in 1868 both as a lookout post and lighthouse. The fort is now the home of the **Aruba Historical Museum** (Museo Arubano) that gives a fascinating insight into the island's history. After the tourist office this makes a natural second stop so that you can get a feel for the island and its past.

The fort is also the home of the **Bonbini Festival** which takes place every Tuesday night from 6.30pm to 8.30pm and features folk lore, arts and crafts, local foods, drink, music and dances. Bonbini is the Papiamento word for 'welcome'.

If you head towards the waterfront you can visit the small but

William III Tower at Fort Zoutman, houses Museo Aruba Historical Musuem

One Cool Summer is a packed series of summer activities featuring culinary, cultural, musical and sporting events that continue until October. There are lots of fun opportunities to join in, learn more about the island's culture, arts and crafts and to enjoy its hospitality.

They are normally launched before the Summer Jam at the end of April or beginning of May. Weekly Sunday events include yacht racing, volleyball tournaments, sunfish racing, windsurfing competitions, hobie cat regattas. The Sanni Fete is held every Friday in San Nicolas from 6.30pm to 10pm and features show, music, food and drinks.

Street Carnival

The Street Art Gallery takes place on the last Saturday of each month and showcases Caribbean and local art and music. It is held between the Protestant Church and The Cellar in downtown Oranjestad. And the Watapana One Cool Festival can be enjoyed every Thursday from 6.30pm to 8pm in the parking lot in front of the Parliament in Oranjestad, featuring entertainment, music, food, drinks, arts and crafts.

shaded **Wilhelmina Park** with a fine statue of the Queen after whom it is named. Head back up Oranjestraat and turn left into Zoutmanstraat with the Government and Parliament Buildings on your left.

The **Archaeological Museum**, on the corner of Zoutmanstraat and Wilhelminastraat, was opened in 1986 and showcases archaeological finds made on the island dating back to the earliest Arawak settlers. It includes two 2000-year old Arawak skeletons who were found buried in large clay pots.

The **Protestant Church** is opposite and was built in 1846 and re-built in the early 1950s in traditional Dutch-Aruba style. It overlooks the town's main plaza and pedestrian area bordered by well-maintained Dutch-colonial style buildings housing lots of fascinating shops. To the north of the square is Nassaustraat, the main commercial focus, while to the west is Havenstraat which is noted for its restaurants.

The main shopping streets are Wilhelminstraat and Nassaustraat (Main Street) that are also famous for their lovely old buildings. The Roman Catholic Church of St. Francis is on Hendrikstraat. Other sights include: the **Numismatic Museum** containing thousands of coins from more than 400 countries, including many from pre-Christian times from Rome, Egypt, Syria and Greece. The collection is on display at Zuidstraat 27.

The **Atlantis Submarine** leaves from the Marina Pier, opposite the

Sonesta Resort and Seaport Mall. It offers passengers hourly tropical underwater adventures along the 2-mile (3km) long reef. The 65-foot (20m) long submarine reaches depths of 150ft (46m) during the hour-long dive. For those less venturous, there is the **Seaworld Explorer**, a glass-bottomed boat that offers the best of both worlds. You can view the reef while getting a tan at the same time.

There is a very old but well-preserved **lime kiln** that can be seen in **Ranchostraat**. The **De Man Shell Collection**, Morgenster 18, is one of the world's finest private collections but can be viewed by appointment.

GALLERIES

The **Cas di Cultura** (Cultural Centre), Vondellaan 2, has a busy program of concerts, ballet, folklore shows and art exhibits ☎ 21010.

Gasparito Restaurant, Gasparito 3, has a changing exhibition of art by local artists and their work is on sale, ☎ 867044. Other galleries worth visiting are the **Artishock Art Gallery and Framework**, at Seroe Blanco 67c, ☎ 833217; Gallerie Harmonia, Main Street, San Nicolas, which exhibits the work of local artists, ☎ 842969, and **Eterno**, at Emanstraat 92, which is open Monday to Friday from 10am to 5pm or by appointment, ☎ 839484.

AN ISLAND TOUR

NORTH OF ORANJESTAD

The main roads run west from Oranjestad to the beautiful sands of **Druif Bay** and the main resort hotels; east to the international airport and southeast down to San Nicolas. Tours of the island are best made in a series of loops using the main roads with side trips off to reach the coast and other places of interest where necessary.

Manchebo Bay is next and apart from its fine beach and resort hotels, it is a popular area with experienced windsurfers with a fun slalom board area with small and choppy waves. Just inland is the island's small but modern hospital.

Eagle Beach is the first area of Druif Bay one comes to after leaving Oranjestad. This stunning stretch of coastline is among the most developed on the island with luxury hotels and resort, casinos, restaurants, watersports operators and dive shops.

Inland are the two manmade **Bubali Ponds**, former saltpans and now a bird sanctuary in an area of wetlands, and **De Olde Molen**, a nineteenth-century Dutch windmill, now a restaurant. The windmill was built in Friesland in The Netherlands in 1804 and shipped to the island and re-assembled in 1961. The windmill's sails are in store having been removed because the winds proved too strong for them.

Palm Beach is the other major resort area along another beautiful stretch of white sandy beach. The luxury hotels set in their lush tropical gardens contrast with the near desert-like landscape surrounding them. Visit the **Butterfly Farm**, opposite the Aruba Phoenix, and observe the life cycle of these beautiful creatures. If you get there early enough in the day you can usually see butterflies emerging from their chrysalises. It is a great place for close-up photographs. There are tour guides and the admission ticket is valid for the duration of your stay on the island. Open daily from 9am to 4.30pm.

Along the coast you arrive at **Malmok** that is popular with divers. The wreck of the German freighter *Antilla* is one of the island's great dive attractions. The freighter was scuttled just off the beach during the World War II and the diving is excellent in the warm waters with visibility often 90ft (27m) or more. Scuba lessons, reef excursions and other organized tours are available. **Arashi Beach** offers safe bathing and good snorkeling and scuba diving with nearby golf.

Championship golf course

The **Tierra del Sol golf course** is the island's first championship golf course. Designed by Robert Trent Jones, the course is on the north-west coast, near the California Lighthouse. The course was designed to combine the natural beauty of Aruba's indigenous flora of divi divi tree, cacti and rock formations, with the lush greens of the world's best courses. During the planning stage, the course was redesigned so that the home of a rare island owl would not be disturbed by construction, and the irrigation system was designed in consultation with local environmentalists so that it did not interfere with the local bird sanctuary. The irrigation system has its own desalination plant.

The 18-hole, par 71, 6811yd (6228m) course has multiple tees so that each hole can be played in a variety of ways. There is also a full-length practice range with double tees, as well as a practice putting green with separate chipping area and sand bunker. Tierra Del Sol is also the island's first master-planned golf community featuring low rise homes, restaurant and lounge in the clubhouse, a health club, 2 swimming pools and 8 tennis courts.

California Point is at the northern tip of the island and is dominated by the **California Light House**. It is named after the ship that foundered and sank just offshore in 1891 and which is now a popular dive site. The coastal area is noted for its rugged shore and dunes although the unpaved road along the coast can easily be traveled in a hire car. The coast road swings round to **Alto Vista**, the highest point in the area at 236ft (72m). It is the site of the **Chapel of Alto Vista** built in 1750. It is often called the Pilgrim's Church as it stands on top of the hill. Along the winding path to the summit are the Stations of the Cross.

The main road heads inland through the barren countryside and low, rolling hills then continues to **Noord** where you can visit the **Church of Santa Ana** with its famous 100-year old hand carved oak, neo-Gothic altar. The rectory, built in 1877, is the oldest on the island.

The **north-east coast** has a rugged boulder strewn shoreline and powerful waves, but it is fun to explore because of the contrast it offers with the resort areas just a few miles away on the north west coast.

EAST OF ORANJESTAD

To the east of Oranjestad is the distinctive round hill of **Hooiberg**, the island's third highest point at 541ft (165m). Its name means the haystack. The road that runs from **Tanki Flip** which is south of Noord,

'De Olde Molen' (The Old Mill), houses the Mill Restaurant

small museum ☎ 647366.

The whole area is noted for its strangely weathered rock formations, especially at **Casibari** to the north, while to the south there are Arawak petroglyphs in the caves at **Canashito**, and more to the north east at **Ayo**. How the huge boulders came to be strewn around Ayo and where they came from are still the subject of intense debate. There is a path through the boulders so that you can inspect them close up and the rich bird life that lives there. From Ayo there is a path that leads to the north-east coast at **Andicuri Bay** with a beautiful, secluded beach that makes a great day out with a picnic. The waves are not too rough and are good for bodysurfing.

To the north-west is **Bushiribana** where there are the remains of a

heads east passing to the north of Hooiberg before swinging south to Santa Cruz. About half way along this route you can detour south at **Paradera** to visit **Serioe Patrishi** a number of historic graves at Modanza.

There is almost a lunar landscape with huge boulders strewn about and the weird shapes of the divi divi trees, a result of the onshore winds. There are steps leading to the summit through squat drought resistant trees such as poui, which often bursts into yellow blossom after rain. The trees and dry scrub are home to several species of birds, and from the summit you can spot the coastline of Venezuela on all but the haziest of days. Close by is the **Indian Rock Garden**, a small tropical garden with tropical birds and a

*Above: **The picturesque Chapel of Alto Vista sits high above the sea** Opposite: **The largest natural bridge in the caribbean.***

National Park

The **Arikok National Park** stretches inland and down the coast. The Park currently consists of a triangle of land north of the road between Boca Prins and San Fuego and bounded on the east by the coastline as far as Boca Keto. The highest point is Mount Arikok at 577ft (176m), the second highest point on the island. The park is important because it is home to many of the species of trees and flora on Aruba, as well as large iguanas and the native hare. Rare species of trees include lignum vitae, known locally as wayaca, as well as aloe, widely planted throughout the island last century. Under the development plan announced in 1996, the park will be extended over the coming years to cover almost a quarter of the island with a series of projects to protect the habitat and extend visitor, educational and recreational opportunities. This will include upgrading and extending the existing network of hiking and cycle trails and roads, and establishing facilities for environmental preservation and agricultural research activities.

The Park Centre near **Dos Playa, Boca Prins** and **Fontein Cave** will be the focal point of the national park and will house facilities for interpretive activities, education and visitor information and food services. Other visitor facilities are planned at Fontein and Guadiriki Caves, the trailhead near Miralamar Pass and at each of the park entrances. Two areas within the park have been designated as 'research areas', one near **Spanish Lagoon**, and the other near the park's southeast entrance.

gold smelting works, and just along the coast to the southwest is the **Natural Bridge**. Some claim the 100ft (30m) long and 23ft (7m) high arch was formed over thousands of years by the relentless crashing of the waves against the coral rock, but it was more probably caused by rainwater steadily eroding the rock from the landside.

The village of **Santa Cruz** at the heart of the island has roads leading to the north-east coast at Boca Prins and south to San Nicolas. The road to Boca Prins runs through the Miralamar Passa range of higher hills and traditional farms with their pretty cunucu (countryside) houses.

Boca Prins with its impressive sand dunes is one of the gateways to the Arikok National Park, and relatively easily accessible **Fontein and Guadirikir Caves**. The former has some fine Amerindian drawings while the latter opens out into three large chambers, one of which is the home to large numbers of bats. There are other caves that can be reached with some effort, particularly **Huliba Cave**, also known as the Tunnel of Love and confusingly shown on some maps as two separate locations. Also of interest are the Fontein Gardens, an oasis of lush greenery where vegetables are grown in plots divided by large windbreakers made from salvaged driftwood.

THE EAST COAST

The eastern coastal zone including the coastal plain and escarpment from the National Park to Colorado Point has been declared a sensitive environment as well as recreational area, and under the development plan, a coastal preservation zone will be created extending 600ft (200m) inland from the escarpment, with no construction allowed within this zone or along the coast plain.

Inland is the 617ft (188m) **Mount Jamanota**, Aruba's highest point, which offers great views from the summit. The area is one of the best places to spot the large green and yellow Aruban parakeet. There are more gold mine ruins in this area.

The **Aruba Golf Club** claims to be one of the most unusual and challenging in the Caribbean with oiled sand greens, the trade winds and an occasional goat to contend with as a live hazard.

Just north of San Nicolas, off the road running to the north coast, is **Lourdes Grotto**, a shrine built into the rocks of **Seroe Pretoe** (Black Hill). The statue of the Holy Virgin weighs 1543il (700kg) and was placed in the grotto in 1958 – on the 150th anniversary of the vision during which the Virgin Mary appeared to the peasant girl Bernadette in Lourdes, France.

To the south-east is the wide **Boca Grandi** which attracts the most experienced windsurfers because of its high waves. Even if you don't fancy braving the waves, it is a great place for a picnic with the windsurfers providing the entertainment. Further south is **Colorado Point**, the southeastern tip of the island, with the **Colorado Lighthouse**, and **Punta Basora** just to the north, another scenic natural arch.

On the other side of the promontory is **Baby Beach**, which gets its name because the waters are so calm that it is safe for the youngest of children to swim and splash about, with supervision of course.

SAN NICOLAS TO ORANJESTAD

The road then heads back along the southern coast past the **Coastal Refinery** and secluded **Rodgers Beach** to **San Nicolas Bay**. **San Nicolas** (Sint Nicolaas) is Aruba's second city although it has a larger population than Oranjestad.

Plan for the future

San Nicolas is at the south western tip of the island, and a major plan has been launched to revitalize the downtown and waterfront area and transform it into the cultural heart of the island. The Lago Refinery Sports Park is being expanded, and Market Square will become the symbolic heart of the community with a new civic square planned with museums preserving and showcasing the history and culture of the region.

The San Nicolas Civic Spine will create a pedestrian link from the waterfront to the Sport Park and retail districts and then continue north to Arikok National Park. A Promenade is also being considered which would become an art district with galleries, working studios offering tours to visitors, sidewalk cafés, Caribbean restaurants with courtyard dining and specialty shops and boutiques featuring island crafts, clothing and jewelry. The plan also includes improving road links to other parts of the island, especially the major resort hotels at Palm Beach and Eagle Beach.

The town's fortunes grew with the Exxon refinery that was the largest facility of its kind in the world. It attracted thousands of workers from around the world, and these people and their families added to the already rich mix of culture, music and cuisine. The refinery that became part of Standard Oil, closed in 1986 after 60 years, and while some of the plant has been reopened by Coastal Petroleum and still refines oil, most of the site stands idle.

You have to stop in for a drink at the famous Charlie's Bar which attracts visitors from around the globe – as you can tell from the collection of souvenirs left behind.

Heading up the coast there is **Commandeurs Bay** and **Savaneta,** the island's first settlement with some very old homes. There are many nice picnic spots along the water's edge where you can watch the fishermen come in, or sample their catches in some of the town's fine restaurants. **Santo Largo** also has a fine beach and picnic area. If you follow the coast road you may see a sign for **Isla di Oro**. It is worth exploring because Isla di Oro is a large steamboat built of concrete – although you would never know it – on a reef and accessible by a small wooden pedestrian causeway that runs out through the mangrove swamps. It is used as a restaurant and disco and often caters for private parties. The road then continues to **Mangel Halto Beach** another popular dive beach.

A string of barrier islands run off the shore and extends almost as far as Oranjestad, and the inland waterway between them and the mainland

Continued on page 48

Aruba offers some of the best pristine diving in the Caribbean with lots of good dive sites, shipwrecks, reefs and a rich marine life. The waters are warm which permit longer dives, the seas are generally calm in most areas so are suitable for inexperienced divers, and the visibility is great. Many of the dive sites are in shallow waters in depths of 30–60ft (9–18m), and for shipwreck divers, Aruba is home to the *Antilla*, the largest wreck in the Caribbean. The 400ft (122m) long German freighter was scuttled by its crew during World War II. Divers can also visit the wreck of the *California*, which earned its place in history as the only ship known to have received distress signals from the *Titanic* and which failed to respond.

Aruba takes conservation, both above and below the water very seriously. In 1993 it launched the Reef Care Project that has become an annual event attracting hundreds of divers. Organized by Castro Perez, the ecotourism project manager with the Aruba Tourism Authority, it now involves more than 300 divers who monitor the condition of the reefs and clear away litter and other debris from the coral and beach sites. Each year the number of volunteers grows while increased awareness has led to a steady decrease in the amount of litter.

Island dive sites include:

Arashi – in 35–40ft (11–12m) is a perfect reef site for beginners or for those who have not dived for some time. The area just north of Malmok and on the west coast just south of the most northerly point, have impressive brain coral, large star corals and many sea fans.

Antilla **Wreck** – lies in 60ft (18m) of water and is known locally as the 'ghost ship'. The 400ft (122m) long freighter anchored offshore and demanded oil from the refineries. When this was refused the vessel was scuttled. The sheer size of the freighter makes it irresistible to shipwreck divers with many large compartments to explore and giant tube sponges, lobster and tropical fish.

Baby Beach Reef – in 20–60ft (6–18m) offers the chance to explore a shore dive with entry from Baby Beach. There are large formations of elk horn and sheet coral, and the chance to see crab, octopus and lobster.

Barcadera Reef – lies in 20–80ft (6–24m) and offers a beautiful seascape, and is especially rich in waving sea fans.

Cabez Reef – is an exhilarating dive in 50ft (15m) of water for advanced divers because of strong currents and often, rough seas. There are large schools of barracuda, amberjacks and rainbow runners, as well as stingray and other tropical fish.

California Wreck – at a depth of 30–45ft (9–14m) off the northern coast and surrounded by coral formations and rich shoals of tropical fish. The dive site is for advanced divers only because of the strong currents and choppy seas.

Commandeurs Reef – in between 40–90ft (12–27m) slopes into the deep formations of sheet and leaf coral, with extensive marine life such as snapper, grouper, grunts, French and queen angels.

Left: Diver at Antilla
surrounded by coral

Above: Sea anemones

Above right: Queen Angelfish

Harbour Reef – is a pleasant beginners dive in 20–40ft (6–12m) of water. The reef itself slopes gently and teems with plant life, especially sea fans and tropical fish.

Isla di Oro Reef – is a 90ft (27m) dive among coral crab, moray eels and schools of snapper to the reef with its tube sponges, sea anemones and rich marine life.

Jane Sea Wreck – in 80ft (24m) is a fantastic dive down to a freighter that stands up right on the sea bed.

Kantil Reef – is a dive for intermediate to advanced divers as it drops over a shelf and descends to 110ft (33m). The shelf is surrounded by gigantic stands of brain, star, leaf and sheet coral. You can see yellow tails, morays, grouper, manta and eagle rays. It is one of the best sites for reef photography.

Lago Reef – is Aruba's deepest dive at 120ft (36.5m) and for experienced divers only, offering impressive coral formations and teeming marine life.

Malmok Reef – is in 70ft (21m) of water, with many colored barrel sponges together with some huge lobster. It is a good place to see stingray, which inhabit the reef that is made up mainly of brain and leaf corals.

Mangel Halto Reef – descends to 110ft (33m) and for experienced divers. The site slopes to more than 100ft (30m) where deepwater gorgonea, sea anemones, tube and vase sponges abound. The area teems with marine life, especially octopus, seahorse and yellow tails.

Mike Reef – is a rock garden between 25–90ft (8–27m) and is packed with a wide range of corals such as brain, mountain, star and flower, as well as gorgoneas, all of which offer great opportunities for macro photography. You can also see rainbow runners and barracuda.

Continued over page

Natural Bridge Dive – is between 20–110ft (6–33m) and for very experienced divers only because of strong currents and rough waters. Majestic boulders rise from the depths of this dive site off the shoreline of the world-famous Natural Bridge. There are rare black and soft corals together with giant barrel sponges.

Pedernales **Wreck** – lies in 35ft (11m) of water, the victim of a German submarine's torpedo. The dive offers the chance to swim among the remains of the cabins of this oil tanker, which are now the homes of grouper and angelfish. The bow and stern of the vessel were salvaged, welded together and used during the Normandy Invasion later in the War II.

Plonco Reef – is in between 20–100ft (6–30m) and is the home of green moray eels, large lobster and giant coral formations.

Puerto Chiquito in 20–80ft (6–24m), is called 'snapper city' by locals because of the sea turtles that abound. There are also manta rays, and you can see star, pillar, flower, fingerleaf and sheet corals.

Santana Reef in 20–50ft (6–15m) is an easily accessible dive site and is an area rich in elk horn and sheet coral and shellfish. Because of the rough entry it is suitable for the more advanced diver.

Skalaheia – in 15–20ft (5–6m), is one of the island's only drift dive sites, and is along a giant slope full of gorgeous corals and is home to barracuda and manta rays.

Sonesta Reef – is a private dive site in 30–60ft (9–18m) of water. Two aircraft were deliberately sunk here on the sandy bottom to create an artificial reef and you can see many different corals and a wide range of marine life.

Tugboat Wreck – is a 40–90ft (12–27m) dive and one of the island's most spectacular. The dive drops through brain, star and sheet coral formations to an old tug boat where you can usually spot stingrays and spotted eagle rays. There are also two large green moray eels that live aboard the tug.

forms **Spanish Lagoon,** an area of mangroves, open water and rich in bird and marine life. It is also the home of Aruba's massive desalination plant. The **Aruba Nautical Club** has its headquarters here on the coast. The road from the airport runs to the coast at **Barcadera** and about 1700ft (520m) offshore, the reef starts before dropping off into about 90ft (27m) of water. **De Palm Island** is a private island just off the coast that has been developed as an entertainment village with

restaurant, entertainment and opportunities for a wide range of watersports, especially snorkeling, scuba and fishing. Another of the islands is **Sonesta Island,** the private domain of the Sonesta Hotel and guests are ferried to the beaches from the hotel's foyer cum boat dock in downtown Oranjestad.

Frenchman's Pass, is a pretty gully which runs inland from the southern end of Spanish Lagoon. The road is said to have got its name because of a battle between Spanish

and French pirates at the beginning of the eighteenth century. Off the road there is a trail that leads to more gold mine ruins at Balashi which date from the end of the nineteenth century, and to the north-east is the **Masiduri Cunucu House**, a well restored traditional country home.

Further along Spanish lagoon is the **Bucuti Yacht Club**, while inland the road passes the **Queen Beatrix International Airport** and runs back into **Oranjestad**. South of the airport is the **Kibaima Miniature Village and Park**. It has a miniature Aruba village, petting zoo, exotic birds, tropical plants and a playground.

ARUBA CALENDAR OF EVENTS

January

New Year's Day is an official holiday and a time for lots of celebrations with traditional display of midnight fireworks and firecrackers. Legend has it that the firecrackers ward off evil spirits. Another feature of the celebrations are the Dande's, groups of strolling musicians, who stroll from house to house, singing good luck greetings for the New Year.

Senior PGA Tournament at the Tierra del Sol Golf Course

25 January – Official holiday in memory of Betico Croes' Birthday

February

Carnival – one of the island's greatest spectacles and one in which everyone participates. There are colorful parades, steel bands, musicians and a Carnival Queen contest and Aruba's oldest social club, the Aruba Tivoli Club holds the spectacular

Lighting Parade on the weekend before Carnival's highlight, the **Grand Parade** which takes place on the Sunday before Ash Wednesday. The **Old Mask Parade** is held the following Tuesday, the day before the start of Lent, and is the finale of the Carnival festivities.

March

18 March – National Anthem and Flag Day with parades of flags, music and folklore events.

Aruba International Half Marathon

April

Good Friday, Easter Sunday and Easter Monday

International Bowling Tournament

Royal National – Car racing with teams from many countries takes place at Palo Marga racetrack.

International Marathon (10km)

30 April Queen's Day – the official holiday in honor of the Queen's Birthday. Festivities include official ceremonies, parades with national music and sporting events.

May

1 May Labor Day – official holiday

Ascension Day – official holiday (date varies)

June

Hi Winds Pro-Am Windsurfing Tournament

24 June St. John's Day celebrated with folk dancing and music.

Aruba International Triathlon

July

Latin Rhythm Festival

Underwater Awareness weekend

ABC National – international drag races

August

A series of concerts

September

Aruba International Theatre Festival

Aruba Culinary Exhibition – an annual event organized by the Aruba Gastronomic Association. It takes place at the Biushiri Bounty Aruba Beach Resort with more than 60 chefs and chef teams from various hotels and restaurants taking part in four categories – appetizer, soup, entrée and dessert.

October

International Dance Festival this bi-annual event attracts dancers and troupes from many countries performing a wide range of dance styles.

Deep Sea Fishing Tournaments – the yearly championships are held at the Aruba Nautical Club and attract competitors from the Caribbean, North and South America.

November

International Drag Races – an international field race at Aruba's Palo Marga racetrack.

Heineken Catamaran Regatta – attracts an international field.

Power Boat Races

December

5 December Sint Nicolaas Day – the birthday of Saint Nick who traditionally arrives with his Black Petes at the Horsebay Harbor just before his birthday to greet the children of Aruba. On 5 December, St. Nick and Black Peter reward children with gifts for their good behavior during the year.

25 December Christmas Day an official holiday celebrated with the season's special delicacies, foods, drinks, family traditions and exchange of gifts.

26 December Boxing Day is an official holiday, a tradition that has remained since colonial days.

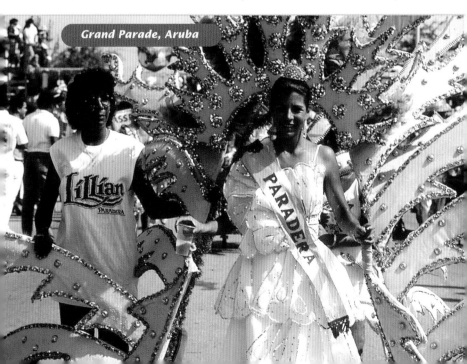

Grand Parade, Aruba

• ARUBA •

Aruba Historical Museum (Museo Arubano)

Fort Zoutman
Open: Monday to Friday from 9am
to noon and 1.30pm to 4.30pm.
There is a small admission charge.
☎ 826099.

Archaeological Museum

Corner of Zoutmanstraat and
Wilhelminastraat
Open: Monday to Friday from 8am
to noon and 1pm to 4pm
☎ 828979

Numismatic Museum

Zuidstraat 27
Open: Monday to Friday from
7.30am to noon and 1pm to 4.30pm
☎ 828831.

Atlantis Submarine

Marina Pier
☎ 836090.

Seaworld Explorer

☎ 886881.
Tickets for both attractions can be
bought at the De Palm Pier on
Palm Beach.

De Man Shell Collection

Morgenster 18
View by appointment, ☎ 24246.
Kibaima Miniature Village and Park
south of the airport.
☎ 851830.

EATING OUT

• ARUBA •

There are more than 100 restaurants
on Aruba offering an exciting and
eclectic range of island and interna-
tional cooking styles from French to
Indonesian and Italian to Japanese.
There are also fast food outlets
serving burgers, fried chicken and
pizza.

$$ Amsterdam Manor

Amsterdam Manor Beach Resort
J. E. Irausquin Boulevard 252
☎ 871492
Open daily for breakfast buffet, and
lunch and dinner with an interna-
tional menu.
Continental cuisine served nightly
from 6pm to midnight.

$$ Aquarius Restaurant

La Cabana All-Suite Resort
J. E. Irausquin Boulevard 250
☎ 879000
Open for lunch from noon to 4pm
and offering American fare.

$-$$ Astoria Bar and Restaurant

Crijnsenstraat 6, San Nicolas
☎ 845132
Good value Chinese restaurant open
daily from 11.30am to 11pm

$-$$ Balashi Bar

Hyatt Regency Aruba Resort
J. E. Irausquin Boulevard 85
☎ 861234
Open daily from 10am to 6pm for
snacks.

$$ Bistro 81

Radisson Aruba Caribbean
J. E. Irausquin Boulevard 81
☎ 866555
French cuisine with a Caribbean
accent served each evening between
6pm and 10.30pm.

$$ Bistro Aruba Restaurant

Best Western Manchebo Beach
J. E. Irausquin Boulevard 55
☎ 823444
International dining nightly from 6
to 10.30pm.

$$ Bistroquet

Play Linda Beach Resort
J. E. Irausquin Boulevard 87
☎ 861000
International cuisine served nightly
from 6pm to 11pm.

$ Boardwalk Cafe

Holiday Inn Aruba Beach Resort
J. E. Irausquin Boulevard 230
☎ 863600
American fare offered all day from
7am to 11.30am and 12.30pm to 11pm.

$$ Boonoonoonoos

☎831888
Dine in an original Aruba mansion
serving excellent traditional Carib-
bean and island fare. The property
has historic interest because the first
aloe oil exported to England was
extracted on the estate.

$$-$$$ La Bouillabaisse

Bubali 69, ☎ 871408
A seafood and French menu. Open
Wednesday to Monday from 6pm to
11pm.

$-$$ Brasserie Restaurant

Aruba Sonesta Resort
L. G. Smith Boulevard 9
☎ 836000
Continental cuisine served daily
from 7am to 11pm.

$$ Brisas Del Mar

By the waterfront in Savaneta
☎ 847718
A popular, lively restaurant offering
casual oceanfront seafood dining in a
former fisherman's home. The catch
is still landed daily close-by. House
specialties include Keri Keri, fish
sautéed in a variety of vegetables and
fresh herbs; Aruba fish cakes and
conch. The restaurant maintains its
seafood theme with fishermen's nets
hanging from the ceiling. It is open
for lunch from 12 noon to 3pm and
for dinner from 6.30pm to 10pm.

$$ Buccaneer

Gasparito 11c
☎ 866172
Good value seafood restaurant open
nightly for dinner.

$$ La Cabana Trading Company

Royal Cabana Casino, La Cabana All
Suite Beach Resort
J. E. Irausquin Boulevard 250
☎ 879000
Steaks served nightly from 7pm to
1am.

$$ Cafe Piccolo

Hyatt Regency Aruba Resort
J. E. Irausquin Boulevard 85
☎ 861234
Italian restaurant serving dinner
nightly from 6pm to 10.30pm, except
Sunday.

$-$$ Captain's Corner Restaurant

Aruba Sonesta Suites and Casino,
Seaport Village
☎ 836000
Open daily or breakfast buffet, lunch
and dinner with snacks, sandwiches
and specialty items.

$$ Captain's Table and terrace

La Cabana All-Suite Beach Resort
J. E. Irausquin Boulevard 250
☎ 879000
Open for breakfast buffet and dinner
with an international menu.

$$ Chalet Suisse

Irausquin Boulevard
☎ 875054
Open nightly for dinner and offering
French and International cuisine.

$$ Charlie's Bar and Restaurant

San Nicolas
☎ 845086
An Aruba tradition and a favorite
meeting place for islanders. It is
noted for its art and arty crowd as
well as its great seafood. The walls
provide display space for local artists
and writers who have used them to
pen verses and their thoughts over
the years. They also contain memo-
rabilia from around the world.
Specialties of the house include
savory jumbo shrimp, Creole
calamari and the fresh catch of the
day. The kitchen is open Monday to
Saturday from 12 noon to 9.30pm.

$$ Cheers Cafe Bistro

Port of Call Market Place
☎ 830838
International all day dining from
11am to 2.30am.

$$ Cherries

Caya G. F. Betico Croes (Main
Street), Oranjestad
☎ 832652
Traditional island cooking in a lovely
old restored Aruban house.
International dining nightly from
6pm to 11pm.

Open daily from 8am to
8pm with an American menu.

$$$ Chez Mathilde

☎ 834968
Aruba's most distinguished French
restaurant is in the heart of town
and set in a typical family homestead
from the nineteenth century, the
only dwelling on the island which
has been maintained in its original
state. It is noted both for its seafood
and the quality of its imported beef.
There are two small, elegant dining
rooms or you can eat in the garden
pavilion where lush flowers and a
fountain add to the romantic
tropical setting. Lunch is served
Monday to Saturday from 11.30am to
2.30pm and dinner is served nightly
from 6 to 11pm.

$$ Coco Plum

Caya G. F. Betico Croes (Main
Street), Oranjestad
☎ 831176
Patio dining off the main street with
thatched umbrellas over the tables
and traditional Aruba fare.

$$ De Dissel

Hospitaalstraat 1, ☎ 824229
A Dutch restaurant open from 10am
to 6pm.

$-$$ Dutch Pantry Deli

Aruba Palm Beach Resort
J. E. Irausquin Boulevard 79
☎ 863900
Open all day from early until late
and serving pizza, sandwiches,
snacks and ice cream.

$$-$$$ El Gaucho

☎ 823677
In an old Aruban home, famous for
its island dishes, steaks and Argen-
tinian specialties.

$-$$ **Fantail Deck**

Aruba Palm Beach Resort
J. E. Irausquin Boulevard 79
☎ 863900
Open from 11am to 10.30pm and
offering pizza, burgers, sandwiches,
southwest and Caribbean dishes.

$$ **Fisherman House**

Savaneta 258B
☎ 843030
Local dishes and seafood available
from noon to 3pm and 6pm to 11pm.
Open daily for breakfast, lunch and
dinner and offering an international
menu.

$$-$$$ **Flame Restaurant**

Noord 19a
☎ 864688
A good steak house open nightly for
dinner except Wednesday. Interna-
tional cuisine from 7.30pm to
10.30pm.

$$-$$$ **Gasparito**

Gasparito 3
☎ 867044 or 867144
A fascinating restaurant and art
gallery offering the best of island art
and cuisine with seafood specialties.

$$ **Grill House**

Zoutmanstraat 31
☎ 831611
Authentic mesquite grilled food and
seafood specialties. Open daily from
noon to 3pm and 6,30pm to 11pm.

$-$$ **Il Pescatore**

Wilhelminastraat 4
☎ 835090
Italian and seafood, open from
11.30am to 2pm and nightly for
dinner from 6 to 11pm.

$-$$ **Jocasa**

Dominicanessenstraat 10
☎ 839077
Seafood and grill open nightly from
6pm to 11pm.

$ **Joey's**

Savaneta 121
☎ 845049
Local specialties and seafood open
from 11am to midnight.

$$ **Kowloon**

Emmastraat
☎ 824950
Chinese dishes and open from 11am
to 10pm.

$$ **La Paloma**

Noord 39
☎ 874611
The menu specializes in seafood and
international dishes. Open daily
except Tuesday between 6pm and
11pm.

$$ **Mama Mias**

L. G. Smith Boulevard
☎ 836246
Italian
Open daily from 8am to 11am and
noon to 3pm with an international
menu.

$-$$ **Mamas and Papas**

Noord
☎ 867913
Aruban specialties available nightly
from 6pm to 10pm.

$$ **Mi Cushina**

Cura Cabai, on the main road about
one mile (1.6km) from San Nicolas
☎ 848335
Mi Cushina, which translated means
My Kitchen, specializes in local
cuisine with typical Aruba dishes,
such as fried fish with funchi
(cornmeal), black pudding and
stewed lamb with pan bati (local
pancake). The food is great and the
surroundings typically Caribbean
with a ceiling made of coffee bags,
light fixtures of old wagon wheels,
family photographs, and a small
museum that tells the history of aloe

processing until the 1930s. It is open for lunch from 12am to 2pm and dinner from 6 to 10pm. Reservations are recommended.

$$ Marabella

L. G. Smith Boulevard
☎ 826496
Spanish

$$-$$$ The Mill

Irausquin Boulevard
☎ 862060
French gourmet restaurant open nightly for dinner from 6pm to 11pm.

$$ Moonlight Grill

Best Western Talk of the Town Resort
L. G. Smith Boulevard 2
☎ 823380
Open daily from 6am to 2am for breakfast, lunch and dinner.

$$ Okura Dynasty Sushi Bar and Restaurant

Havenstraat 25
☎ 821349
Enjoy lunch or dinner at this elegant Japanese restaurant that also offers Thai specialties. It is open daily from noon to 2.30pm and 6pm to 11pm.

$$ Oriental

Zoutmanstraat 5
☎ 821008
Chinese

$-$$ Palms Bar and Grill

Hyatt Regency Aruba Resort
J. E. Irausquin Boulevard 85
☎ 861234
Open for leisurely light lunches and dinners from 11am to 2am offering mixed grill and seafood.

$$-$$$ Papiamento International Cuisine and Grill

Washington 61
☎ 874544

Close to all the major hotels and in a former nineteenth-century plantation residence, the restaurant is named after the island's Creole language, and offers fine, elegant dining inside or under the stars on the pool terrace. The menu features seafood such as jump shrimp and Caribbean-style lobster, and grilled specialties including wonderful lamb chops and chateaubriand. It is open for dinner between 6 and 11pm. Reservations are recommended.

$$ Pavarotti

Palm Beach 21a
☎ 860644
The menu offers Italian specialties and an Argentine grill. It is open for dinner only between 6pm and 10pm.

$$ Petit Café

Americana Aruba Beach Resort
J. E. Irausquin Boulevard 83
☎ 864500
International dining offered nightly from 6pm to 10.30pm.

$$ Pool Grill Restaurant

La Cabana All Suite Beach Resort
J. E. Irausquin Boulevard 250
☎ 879000
Open for lunch daily from noon to 4pm serving American fare.

$$ Porto Bello

Seaport Market Place
☎ 837316
Italian dishes, open nightly from 6am to 1pm.

$$-$$$Que Pasa?

Schelpstraat 20
☎ 833872
Italian and international dishes served from early evening until the early hours.

EATING OUT

$$ Red Parrot

Divi Aruba Beach Resort
J. E. Irausquin Boulevard 47
☎ 835000
International and Caribbean dining
nightly from 6.45pm to 10.30pm.

$$ Rigoletto

Bubali 16
☎ 873170
Good value Italian restaurant open
for dinner nightly except Monday.

$$ Roma di Notte

Palm Beach 17a
☎ 865163
Italian restaurant open for dinner
nightly except Monday.

$$ Roseland Buffet

Alhambra Casino and Shopping
Bazaar
J. E. Irausquin Boulevard 93
☎ 835000
Salads and roast beef nightly from
6pm to 9pm.

$$ Ruinas del Mar

Hyatt Regency Aruba Resort
J. E. Irausquin Boulevard 85
☎ 861234
Open daily from 7.30am for breakfast
buffet and Mediterranean-style
dining

$-$$ Sandra's

Irausquin Boulevard
☎ 871517
Steaks, ribs and seafood served
nightly from 6pm to 11pm.

$-$$ Seabreeze Poolside Snackbar

Holiday Inn Aruba Beach Resort
J. E. Irausquin Boulevard 230
☎ 863600
Open for burgers, barbecue and
sandwiches daily from 11.30am to
5pm.

$-$$ Seagull Restaurant

Casa del Mar Beach Resort
J. E. Irausquin Boulevard 51
☎ 827000
Open daily for breakfast, lunch and
dinner (closed Sunday evening) for
international fare.

$$ Seawatch Restaurant

Aruba Palm Beach Resort
J. E. Irausquin Boulevard 79
☎ 863900
Open daily for breakfast, lunch and
dinner (closed Wednesday evening)
for international fare, seafood and
steaks.

$-$$ Steamboat Buffet and Deli

J.E. Irausquin Boulevard 370
☎ 866700
Great value buffet-style restaurant
open daily from 7am to midnight.

$-$$ Sunset Grill

Radisson Aruba Caribbean Resort
J. E. Irausquin Boulevard 81
☎ 866555
Open from noon to 5pm for grilled
fare.

$$ La Taurina

Noord 82
☎ 66699
Seafood and steaks available every
day from 4pm to midnight.

$$$ La Taverna

Aruba Beach Club
J. E. Irausquin Boulevard 53
☎ 823000
Open nightly except Tuesday for
international dining.

$$ Trattoria El Faro Blanco

Tierra del Sol
☎ 860787
Italian.

$$-$$$ Tuscany's

Aruba Marriott Resort
L. G. Smith Boulevard
☎ 869000
Open nightly from 5pm to 11pm for
classic northern Italian cuisine.

$$ Twinklebone's

Noord 124
☎ 869806
Open 4pm to midnight. A lively, fun
eatery with the entertainment
provided by the singing waiters and
cooks.

$$ Villa Germania

Seaport Marketplace
☎ 836161
German restaurant open daily from
8am to 10pm.

$$-$$$ La Vista

Aruba Marriott Resort and Stellaris
Casino
L. G. Smith Boulevard
☎ 869000
Open daily from 7am for breakfast,
lunch and dinner with traditional
continental menu.

$$ Warung Djawa

Wilheminastraat
☎ 834888
Indonesian restaurant open for
lunch between 11.30am and 3pm and
for dinner between 6pm and 11pm.

$-$$ Waterfront Crabhouse

Seaport Marketplace
☎ 8835858
Seafood specialties. Open from noon
to 4pm and 5.30pm to 10.30pm.

NIGHTLIFE

Islanders claim that you can dance
in Aruba anytime, anyplace. Popular
nightspots include the Chesterfield
Night Club, San Nicolas; Cheers

Bistro, Port of Call
Marketplace; Cobalt Club,
Royal Plaza; The Cellars, Klipstraat;
Iguana Lounge, Royal Cabana; Club
City One, Italiestraat, Eagle Beach,
and Desires. The Aruba Sonesta
Resort, which offers dancing and has
a live band every night except
Sunday.

The Tropicana Showroom at the
Royal Cabana Casino offers live
entertainment and top performers
such as Gloria Estefan and Kenny G,
and there are live shows at the
Aladdin Theatre in the Alhambra
Bazaar. The privately owned De Palm
Island has the 300-seat Palm Terrace
theatre restaurant.

Most of the hotels offer their own
live entertainment, theme dinners
and special weekly events that range
from barbecues with live music and
limbo shows to carnival nights and
folklore festivals. There are also
dinner, sunset and party cruises.
The following offer dancing and local
entertainment: Alhambra Casino and
Shopping Bazaar, J.E. Irausquin
Boulevard 93 ☎ 835000; Jardin
Brasilien, Americana Aruba Beach
Resort, J.E. Irausquin Boulevard ☎
864500; Music Hall, Aruba Hilton
and Casino, J.E. Irausquin Boulevard
☎ 864466; Oasis Lounge, Aruba Palm
Beach Resort, J.E. Irausquin
Boulevard ☎ 863900; Best Western
Manchebo Beach Resort, J.E.
Irausquin Boulevard ☎ 823444;
Bushiri Bounty All Inclusive Beach
Resort, L. G. Smith Boulevard ☎
825216; Divi Aruba Beach Resort,
J.E. Irausquin Boulevard ☎ 823300;
Players Club and Lounge, Holiday
Inn Aruba Beach Resort, J.E.
Irausquin Boulevard ☎ 863600;
Royal Cabana Casino and Tropicana
Showroom, La Cabana All-Suite
Beach Resort, J.E. Irausquin
Boulevard ☎ 879000, and the Sun
Club, Costa Linda Beach Resort, J.E.
Irausquin Boulevard☎ 838000.

3 Bonaire

T his tiny island is one of the undiscovered jewels of the Caribbean. The island has changed little over the years and still has a yesteryear charm of an old world warmth and hospitality. Bonaire is the second largest of the ABCs, and has an area of 111 sq miles (289sq km) and lies 20 miles (32km) east of Curaçao and 86 miles (138km) east of Aruba. It is boomerang-shaped, just 24 miles (39km) long and on average five miles (8km) wide, and its highest point is Mount Brandaris at 787ft (240m).

Cruise ships dock at the pier just to the south of Kralendijk, and there are regular boats from Curaçao that bring in supplies and passengers. The arrival of either cruise ships or Curaçao boats transforms the usu-

fishing trips for tuna, wahoo, barracuda, king mackerel and swordfish.

On land, despite the dry and rugged landscape, there is fabulous birding – with many rare species and sometimes it seems almost as many flamingos as people – bicycle trails and mountain biking, caving, and lots of secluded bays for swimming and picnicking. There are towering stands of cacti, some more than 30ft (9m) high, great jumbles of volcanic rocks on which large iguana sunbathe while wild donkeys and goats roam free. The northern one fifth of the island is a dedicated nature reserve.

One of the few big changes over the years has been the development of hotels and resorts to accommodate the growing numbers of visitors, but even these low-rise properties nestling on the beach generally blend harmoniously into the landscape.

Bonaire is 50 miles (80km) north of Venezuela, 1720 miles (2770 km) from New York and, as the islanders will tell you, it is light years away from the ordinary!

HISTORY

When the Spanish 'discovered' Bonaire in 1499, it was occupied by Arawak Indians who named it 'bo-nah', meaning low land, and the Europeans adopted the name. Although attempts were made to settle the land, there was little permanent settlement until 1636 when it was taken over by the Dutch West India Company who extracted salt, raised cattle and grew corn. African slaves

ally near deserted waterfront into a bustling mass of people, taxis and vendors.

It is a snorkeling and diving paradise and the surrounding waters offer truly world class diving and deep sea fishing – it has been voted among the world's top three dive sites. There is also great sailing, sea kayaking, windsurfing and swimming from the dazzling white sand beaches. Many of the resort hotels have their own yachts and other operators offer half- and full-day trips as well as half- and full-day

were imported to work on the saltpans and ranches, and many slaves were also sent off to the slave market in Curaçao. Apart from a short spell during the Napoleonic Wars when Bonaire was under British occupation, it has been Dutch for more than 350 years, either under the control of the Dutch West India Company or since 1815 part of the Kingdom of the Netherlands.

The Bonaire National Flag consists of a yellow triangle depicting the sun and the island's natural history as most of Bonaire's flowers are yellow; the white stripe symbolizes peace and liberty; the blue triangle is the sea; the black ring with four points represents the compass used by Bonaire sailors to navigate the world, and the red six-pointed star depicts the blood of the six traditional regions which form together the people of Bonaire.

THE BONAIRE MARINE PARK

It was in the 1960s that the islanders with great foresight recognized the enormous natural treasures that lay offshore and took steps to preserve them. A group of experts from the World Wildlife Fund, the International Union for the Conservation of Nature and Natural Resources and the Netherlands Antilles National Parks Foundation (STINAPA) helped plan the reserve and secured funding to set it up.

In 1979 all the waters surrounding Bonaire, including Klein Bonaire, were declared the **Bonaire Marine Park.** The park runs from the high water mark to the 200ft (60m) depth contour. Anchoring boats over the reefs was banned and more than 70 mooring buoys have

been provided. Spear fishing and collecting are also forbidden.

The STINAPA, a non-governmental, non-profit making organization, now manages the park, holds weekly slide shows and employs park rangers who patrol, enforce regulations and provide information and guidance. It also carries out research and monitoring programs.

As a result of these measures, the waters offer the most spectacular and pristine diving to be found anywhere. The reefs ring the island and offer scores of great dive sites. In many places you can swim right from the shore to the coral reefs teeming with dazzling arrays of tropical fish. The calm, warm waters and excellent visibility are suitable for beginners and novices. And, as there are very few currents there is no need for drift diving. In order to dive you must have the necessary certification and an admission permit to the Marina Park that costs US$10 and is valid for one year. It is available from the Marine Park headquarters (☎ 8595) and at dive shops.

There are deeper dives and some spectacular drop offs among the 86 charted dive sites, but one of the great attractions of diving on Bonaire is that the waters gently slope offering a gradually changing marine environment with different depths supporting different corals and species of tropical fish and other marine life. You can see sea turtles and huge spiny lobsters, delicate sea horses and a vast array of fish from darting needlefish and butterfly fish to the brilliantly hued angel fish, and many more.

And, above all, there is the coral itself. Many people who see coral for the first time cannot believe that the

• GETTING AROUND ON BONAIRE •

There are some mini buses operating irregularly around the capital and between Kralendijk and Rincón, but the best way to get around is by taxi, hire car, scooter or bicycle. There are taxis at the airport and they can be quickly booked through hotels. They don't have meters and there are fixed fares on most routes, but always confirm the price before setting off. Jeeps or similar are best for exploring the island, as most of the secondary roads are not paved, and some of the smaller roads are little more than tracks.

There is a good road from Kralendijk that runs north for about 9 miles (14km) along the coast to the national park boundary where it forks. One branch of the fork continues round the coast to Nukove where there is fabulous snorkelling, while the other fork heads inland past the observation point and flamingos on Goto Meer (meer is Dutch for lake) to Rincón where there are several options. The road to the left, heads into the north of the island and the entrance of the national park. You have to enter the park to explore the northern part of the island where, apart from the bird life, there are several fine beaches to enjoy. There are two roads running back to the south coast, one arriving at the sea at Karpata near the water distillation plant, and the other rejoining the coast road further south, while the road ahead runs through the hills to the north coast and then swings inland to cross the island taking you back to Kralendijk. There are filling stations in Kralendijk, Rincómn n and Nord Salina. They are usually open Monday to Saturday from 7.30am to 9pm. The filling station in Kralendijk also opens on Sunday from 9am to 4pm.

The south of the island can be toured on a paved road which runs from the capital past the airport to Pink Beach, Pekel Meer and the salt pans and then it follows the coastline round to Sorobon and Lac Nay before heading back inland for Kralendijk.

Cycling

There is a network of bicycle trails around the island, many of them following the coastline and offering spectacular views. Trails vary in length from a few miles to almost 20 miles (30km). Always take a lot of drink with you and as you are never far from the sea, take advantage of the waters for a cooling off swim.

BONAIRE

North Point
Boca Cocolishi
Playa Funchi
Washington-Slagbaai National Park
Boka Slag Bay
Playa Grandi
Playa Frans Nukove
Gotomeer Lake
Boca Onima
Indian Rock Paintings
Fontein
Indian Rock Paintings
Flamingo Observation
Rincón
Gruta de Lourdes
Karpata
Devil's Mouth
The Thousand Steps
Barcadera
Seru Largu
Diversion Bonaire
Captain Don's Habitat
Buddy Beach & Dive Resort
Klein Bonaire
Kralendijk
Fort Oranje
Flamingo Airport
Bell Air Apartments
Lac Bay Resort
Lac Bay
Cai Beach
Sorobon Beach
Sorobon
Sorobon Beach Resort
Pink Beach
Solar Salt Works
Pekelmeer
Flamingo Sanctuary
Willemstoren Lighthouse

N
W — E
S

0 3 miles
0 3Km

colors are real and think someone must have painted them for the tourists. In fact, corals can be every color of the rainbow and often are and this is one reason why reef diving is so exhilarating. It is not just the spectacular shades but the shapes and growths that are also fascinating. Towards the surface the colors are brighter and intense with lots of red, yellow and orange. The corals also tend to be more delicate as they grow upwards as if stretching to reach the sunlight. As one dives deeper, the corals tend to become squatter and thicker and the colors change to blues, purples, brown and black. At night, the coral reefs offer a completely different picture with bright tube corals and a new cast of nocturnal fish and marine creatures.

The park boasts more than 80 species of soft and hard coral, with spectacular growths of elk horn, brain, stag horn, pencil, star, leaf

and gorgonians. There is also the white tipped fire coral, often found in 3–13ft (1–4m) of water, which should be avoided at all costs. The reefs are also home to more than 270 species of tropical fish.

Today, there are more than 70 dive site moorings and diving facilities and services are state of the art. The Bonaire Marine Park has a visitor information center at the Ecological Centre in Karpata that

offers brochures, audio visual presentations and lectures. And, even if you cannot dive, you can experience the wonders of the reefs by taking in a trip in a glass bottom boat with Bonaire Dream, ☎ 7080.

THE ISLAND TODAY

On land, the island divides into three natural zones, the greener, hilly north with its national park; the flatter central region which many people have likened to the landscape of semi-arid American southwest, and the southern end with its saltpans, mangroves and rolling sand dunes. The main vegetation of the island is cacti and divi-divi trees that used to be 'farmed' for their pods and timber, which were used in the tanning industry. Nestling in the bend of the 'boomerang' and about a mile (1.6km) offshore is the island of Klein Bonaire. It is flat and uninhabited and it acts

*Above left: **Pink Beach** Above Right: **Slave huts** Below: **Gotomeer***

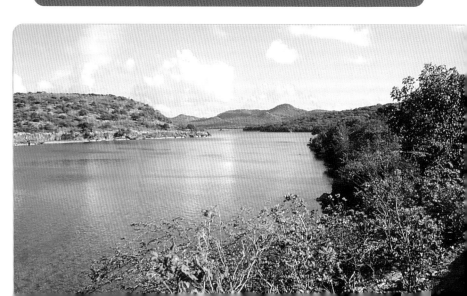

as a barrier island protecting the leeward coast of Bonaire around Krelandijk. The southern leeward coastline offers the best swimming beaches with generally calm, sheltered waters, while the northern coast often has large waves that crash in to the volcanic and limestone coral rock, and which over the millennia have carved out caves and fascinating rock formations. Some of the caves have petroglyphs painted by the Arawak Amerindians, the island's first settlers.

Accommodation ranges from small, casual dive hotels to luxury resorts and it is a wonderfully, casual, relaxed island where you really can get away from it all, either along the miles of stunning beaches or beneath the sea.

Climate

Bonaire boasts year-round sunshine – the sun usually does shine every day and average year-round temperature is 82°F (27.5°C) with a pleasant and cooling sea breeze.

The island has many festivals and annual tournaments with its lively Carnival before the start of Lent, Easter Parades and National Day celebrations. The Bonaire Sailing Regatta is the island's premier event taking place in October and attracting entries from throughout the Caribbean and North America.

The Simadan Festival is the annual harvest that takes place from February and culminates at the end of April. The harvest being celebrated is the ripening of the sorghum seeds that are gathered, dried and ground to make the flour used for funchi and special pancakes called repa. Most of the islanders turn out to help gather the harvest that is followed by a feast, which includes okra soup, goat stew, beans, funchi and repa. It is also a time for lots of singing and dancing, including the festive Wapa dance. Although it is not possible to harvest the sorghum every year, the festival takes place whatever happens.

BEACHES

There are lots of near-deserted beaches around the island with sand in a variety of shades from dazzling white to pink from shells and black from crushed rock coral. Most of the beaches are small coves and reef protected which offers safe swimming in the warm, amazingly clear waters. The north-east coast tends to have rough seas and large waves, which makes swimming inadvisable. There are the fine **Sorobon** and **Cai** beaches around **Lac Bay** and a superb stretch of sandy beach on the south-west coast of the island – **Pink Beach** that runs from just north of **Pekel Meer** to the southern tip of the island. Apart from the hotel beaches, there are no facilities available and you must take in all food and drink. It is also a good idea to acquire a beach umbrella if you can to give some protection from the fierce sun.

KRALENDIJK

Kralendijk (pronounced Kra-len-dyke) means coral dyke in Dutch. The charming island capital is a tiny gem of Dutch colonial architecture with attractive orange- and ochre-colored houses, buildings and churches many with their neat white trim and red roofs, lots of trees and the occasional small herd of goats crossing the almost traffic-free streets. Gardens are often a delight with flowering plants, flamboyants, palms, some banana plants and other fruits and vegetables.

The capital is small and easy to walk around with a small grid of main streets that include the historic old district, fort, government buildings, churches, cafés, restaurants and bars, and most of the shops.

Kaya Hellmund and Kaya Craane form one thoroughfare, a one-way street that runs along the waterfront with Kaya Grandi inland and parallel to it and one way in the other direction. At right angles and intersecting with them are Kaya Gerharts and Kaya Brion. The fifth road is Simon Bolivarstraat that runs

Government House with its sweeping flight of stone steps, and by the Customs Office near the pier on the waterfront.

Close to Government House is Fort Oranje, which was built in the late 1630s to protect the port, and its four cannon taken from an English man o'war, still face out to sea although they were never fired in anger. It is now the home of the island's small folklore museum that has exhibits about the island's past from its earliest Amerindian times. The small lighthouse tower was built in 1932. You should also visit the nearby rather ornate waterside Market. It now sells fruit and vegetables landed by boats from Venezuela, but it used to be the island's fish market, always busy in the afternoon after the day's catch had been landed. There are a number of galleries and stores that offer paintings and local handicrafts.

diagonally from Kaya Grandi, one of the main shopping streets with the small Harbourside mall, and then across Gerharts and Brion. There are more duty free shops and stores along Breedestraat.

On the eastern side of town and close to the water's edge is the small Wilhelminaplein, Queen Wilhelmina Park, which is surrounded by some of Kralendijk's prettiest and most historic buildings. The park itself has a number of monuments. In the middle of the park is a monument as a reminder of the 1634 landing of Van Welbeek of the Dutch West Indies Company. There is a war memorial that commemorates Bonaire servicemen who lost their lives during World War II, and another which commemorates the visit of Eleanor Roosevelt in 1944 when US troops were stationed on the island. The park is bordered on one side by the town's eighteenth century church, and on the other, by

Dutch influenced church

Shopping on Bonaire

Bonaire has competitive prices but it does not have the range of shops offered by either Aruba or Curaçao. The best shopping is along Kaya Grandi and the small Harbourside mall by the sea. The shops, housed in smart, Dutch colonial style buildings, offer a range of goods from perfume, crystal and china to jewelry, sportswear, and leather goods. Island arts and crafts include hand painted T-shirts, handmade jewelry and paintings.

Most hotels also have their own gift shops and boutiques. Shops are usually open 8am to noon and 2pm to 5pm or 6pm, although some stay open over lunch, and many open on Sundays and public holidays if a cruise ship is in port. Supermarkets generally open from 8am to 8pm Monday to Saturday and some open from 11am to 2pm on Sunday.

ISLAND TOUR

THE NORTH OF THE ISLAND

The road north from Kralendijk heads along the coast with incredible displays of cacti and rolling hills inland. The uninhabited **Klein Bonaire** lies less than a mile (1.6km) off shore. It is a tiny, flat rocky island covered with cacti but it has fine sand beaches that make a good day out, and its offshore reefs offer superb diving. If you fly into Bonaire you can look down on picture postcard

Klein Bonaire, a round island fringed with white sand and circled by stunning turquoise seas. The reefs are part of Bonaire's Marine Park and offer shallow water gardens close to the shore sloping off to dense coral in 40–60ft (12–18m) of water. This is one of the best sites for the rare and protected black coral, and one site is so thick with black coral it is known as The Forest. You can also see elk horn, star and brain corals, huge sponges and gorgonians. There are daily boat trips to the island.

The mainland coastline here has many of the island's hotels and several beaches, such as **Playa Lechi** that is great for swimming and watersports with lots of amenities. The coastline consists mostly of black coral rock, and at **Barcadera,** almost opposite the Radio Nederland Antilles tower there are **The Thousand Steps,** a popular walk-in dive site that is steeped in local folklore. There is a cave with a small entrance that, according to locals, was used to trap wild goats. Barcadera is also the home of the **National Parks Foundation and Ecological Centre,** which specializes in marine research.

As you continue north along the coast, the rocks have been sculpted into fantastic shapes by the weather and sea, and one collection is known as **The Devil's Mouth.** The coast road continues to **Karpata,** a former plantation. The estate house that is now being renovated might become a museum or a refreshment stop for visitors traveling north as there are few facilities in this area.

From Karpata you can head inland for **Rincón,** Bonaire's oldest settlement, although our route continues along the coast to the huge

oil storage tanks where the road forks. This is not a refinery but a trans-shipping depot. Because the waters off Venezuela are too shallow for large tankers, small tankers bring the oil to Bonaire where it is stored before being loaded on to huge supertankers that can anchor right off the coast because the waters are so deep.

The left hand track continues along the coast to **Nukove** and **Playa Frans** where there are good swimming beaches and some caves to explore. There is good snorkeling here and further along the coast at **Boca Slagbaai** although this beach together with **Playa Funchi** and **Boca Cocolishi** have to be accessed via the national park's main entrance.

Flamingo lake

The right hand fork heads inland, past the beautiful **Goto Meer**, a large lake on the southwest fringe of the national park. The lake, fed by springs, used to have an outlet into the sea but is now land locked, and home to huge numbers of pink West Indian flamingoes that are a magnificent sight either feeding at sunset or silhouetted in flight. The area with its semi-desert vegetation of cactus, scrub acacia, mesquite, divi divi trees and squat shrubs is rich in other bird life and you can usually see and hear the island's squawking vivid green and yellow parakeets.

The road continues past **Dos Pos** with its windmill driven water pump and hedges of cactus, to Rincón. It was founded in the sisteenth century as the first permanent settlement on the island because nestling in the hills it was protected to some extent from the pirates who mainly raided the coastal areas. Today it is a quiet village with a pretty church and some lovely Dutch colonial homes with their traditional red tiled roofs, and it is the gateway to the island's national park. It is also famous for Prisca's delicious home-made ice-cream, a tradition now carried on by the creator's daughter. Just outside the village there is the open-air shrine at **Gruta de Lourdes**. The road from Rincón runs north-west to the park entrance about 3 miles (5km) away.

From just south east of Rincon there is a road to the north coast so that you can visit the beach at **Playa Grandi** and the caves at **Onima** and **Fontein** with their Indian rock paintings to the east. The coast has a rugged beauty although it is mostly made up of coral rock that has been sculpted in strange shapes by the pounding waves, or eroded to form caves. Early Arawaks decorated the roofs of some of these caves with their petroglyphs and the best can be seen at Onoma and Fontein. At Onima there are also paintings on rocks quite close to the dirt road. The paintings on the underside of the overhang have been dated as at least 500 years old. The Arawaks often painted in this sort of place so that their work was visible but protected from the rain and wind.

The area to the east of Rincón and north of Kralendijk is the central lowlands or cunucu (countryside), an area of isolated hills, arable land and farms with their characteristic Dutch colonial houses and barns. There is a good road from Rincon that runs southeast through the

cunuca back to the capital. Just north of Kralendijk is the 500-foot (152m) Seroe Largo. There is a side road from the northern Kralendijk to Rincon Road that takes you up the hill and from the top there are magnificent views from Mount Brandaris in the national park to the north to the saltpans and their salt mountains at the southern tip of the island and almost everything in between.

SOUTH OF THE ISLAND

The southern part of the island is flat and dry, and in sharp contrast to the hilly north. The road leaves Kralendijk and runs down the west side of the island with the Flamingo International Airport inland to **Witte** **Pan** or **Pink Beach** which stretches south along the coast for several miles. The beach runs along the thin spit of land that separates **Pekelmeer,** a five-mile (8km) long lagoon from the mainland. After heavy seas the sands are sometimes washed away leaving behind a rocky beach, but it usually returns as more sand is deposited by the waves.

To the south of the salt works at **Cabaje** are two clusters of tiny stone huts which were built around the middle of the nineteenth century to house the African slaves brought in to work the pans. The first group is known as the white huts and further along the road is the second cluster known as the red huts. Each

Saltpans

The main features of this area are the huge saltpans that have been producing salt for export for centuries. The salt industry closed down after Emancipation because it could not be produced cheaply enough without slave labor, but after a gap of 100 years or so, the pans were re-opened and largely automated by a Dutch company and the salt is now exported round the world. About 400,000 tons are produced every year. The salt is transported and loaded on to the ships by the huge conveyor belts that are another feature of this strip of coast. Seawater is introduced into the shallow saltpans through a system of sluices and lock gates and it can take a year or more for the water to evaporate leaving behind the salt which is collected, washed and piled up in the salt mountains that are an island landmark. The saltpans all have different colors – from purple and lilac to white – and this depends on which stage of the evaporation process has been reached.

Above: Arawak petroglyphs at Boca Onima

Right: Flamingo lake

hut accommodated up to four adult males who slept in them during the week. At weekends they were allowed to visit their wives and children who live around Rincón – a round trip on foot of more than 40 miles (64km). Beside each group of slave huts is the house of the saltpan manager.

As you drive along this stretch of coast you will also notice a number of obelisks by the water's edge. In the old days the ships would use these obelisks as markers so that they could anchor closest to the point where the salt had been gathered. Today because of sophisticated transport systems, the ships can anchor at the modern terminal where the salt is loaded. Further around the coast there are more obelisks built by fishermen as markers for the fishing grounds.

The island's second flamingo sanctuary lies between the saltpans and Pekelmeer, and the 135-acre (54 hectare) reserve is the breeding ground for about 5,000 birds. Visitors are kept well back from the breeding area so binoculars are a good idea if you want a closer look from the edges of the saltpans and along the shores of the lagoon.

The **Willemstoren Lighthouse** stands at the southernmost tip of the island. It was built in 1830 and is Bonaire's oldest lighthouse.

The road then runs north up the coast to **Sorobon** and pretty **Sorobon Beach**, which is popular with naturists, although you can keep your clothes on if you wish. There is a small fee to use the private beach and facilities that belong to Soroban Beach Resort The beach is at the southern end of sweeping **Lac Bay** which has **Cai Beach** at its northern end reached by a side road. Apart from the mountains of discarded conch shells by the sea, this beach is

a very lively place at the weekends and a popular spot with islanders with its food stalls and often a merengue band. As you drive along this stretch of coast you will also notice a number of sculptures built from driftwood.

Lac Bay is one of the island's best locations for windsurfing and there are two windsurfing companies there that will pick you up at your resort hotel and return you afterwards. The waters are very shallow close to the coast making it an ideal place to learn to water ski because if you do fall off, you simply step back on board. You then return to the mainland for the short journey inland through the cucucu back to Kralendijk.

ANNUAL EVENTS AND PUBLIC HOLIDAYS

January
1 January New Year's Day official holiday

February
Carnival
March/April
Good Friday, Easter Sunday and Easter Monday
International Deep Sea Fishing Tournament

April
30 April Coronation Day

May
1 May Labor Day Official holiday

June
24 June St. John's Day
29 June St. Peter's Day

September
6 September Bonaire Day Official holiday

October
Regatta

December
25 December Christmas Day Official holiday
26 December Boxing Day Official holiday
31 December New Year's Eve

Willemstoren Lighthouse

WASHINGTON-SLAGBAAI NATIONAL PARK

The Park covers 13,500 acres (5,400 hectares) and in 1974 became the first nature reserve established in the Netherlands Antilles. The park encompasses the greenest part of the island and much of the land was formerly an aloe and divi-divi plantation. The Dutch Government started to sell off the land in 1868 so that plantations could be established. Many of the smaller plantations were merged over the years to form the Slagbaai Estate and the northern area was then sold off to become the Washington Plantation. In the 1960s, the Washington estate was sold to the government on the proviso that it never be developed commercially, and in 1969 it was designated as a national park. In 1972 the owners of the Slagbaai Plantation offered to sell their land to the government, and two years later the combined Washington-Slagbaai National Park was formed.

The area covers a wide range of habitats and vegetation from shoreline to woodlands, and lakes to rolling hill countryside, and it takes in Bonaire's highest point **Mount Brandaris**, 787ft (240m). The hill is a useful landmark because it is visible from almost everywhere in the park so it allows you to keep your bearings.

The park is a Mecca for birdwatchers with more than 150 species recorded, some special to the island and others visitors from thousands of miles away on their annual migration. It is the home of the Bonaire parakeet that can often be seen sitting on the branches of mesquite, and the Lora, or Bonaire parrot.

The vegetation is more verdant than the rest of the island with towering cactus, prickly pear, divi divi and acacia, and the area often explodes with greenery after heavy rains.

If you are interested in wildlife you could happily spend your entire vacation exploring the park, but if you have less time or have other things to do, plan at least one trip to the park, which is open daily from 8am to 5pm. Only cars are allowed into the park with bikes and scooters banned. Remember that apart from the wildlife, there are several secluded beaches to enjoy and you can spend your day swimming, picnicking, beachcombing and snorkelling. There is a small admission charge to enter and at the entrance you should pick up the free leaflet that explains the two routes that can be followed with basic information about the park. There is more detailed information on sale for those with special interests.

There are two circular routes, mostly unpaved, through the park. The **green route** is the shorter of the two and marked by a series of green arrows, and which runs for about 15 miles (25km). The green route heads inland towards the west coast and runs past the start of the 1.5 miles (2.5km) trail which leads to the summit of Mount Brandaris. Remember to wear stout shoes and a hat. The temperatures can be deceptive because of the onshore breezes, and although it is hardly a tough climb you should still take precautions against too much sun exposure and drink lots of liquid. Exercising in these temperatures can also be more tiring than back home, so take the opportunity to catch your breath, admire the views and take your photos.

A little way past the trailhead there is a track that leads to **Put Bronswinkel**, another of the park's watering holes that acts as a magnet for birds, especially parakeets. The route then arrives at the coast at **Playa Funchi** that was used as the

port for the Washington Plantation. Produce to be exported would be taken out by boat to the ships anchored in the bay. The area is now one of the best places to spot lizards, geckos and iguanas, and the creatures show little fear of man if approached quietly and seem to pose obligingly for pictures.

The green route then runs south down the coast to the near-idyllic **Boca Slagbaai** although its peace and tranquillity today is a far cry from its bloody past. Slagbaai is the island word for slaughter, and the bay gets its name because sheep and goats from the plantation would be driven down to the wide sandy beach where they would be killed. Their carcasses were then ferried out to the ships waiting in the bay. The bay was also used by the Slagbaai Plantation to export salt that was produced from the salt pans on the estate. The old storage buildings and customs office can still be seen on a spit of land that was built to separate the bay from a specially created large salt lake, **Salina Slagbaai**.

One of the restored buildings is now home to a small fish restaurant serving catches landed on the beach each day. The beach makes an ideal base for exploring the offshore waters and is popular with swimmers, snorkellers and scuba divers. In the southern parts of the park you are most likely to see wild donkeys and goats, and watch out for the lizards, especially the large iguana. The route then winds its way back to the park entrance.

The **yellow route**, with its yellow arrows, is about 22 miles (35km) and takes in the flamingo pond at **Salina Mathijis**, although the salt lake usually only has these exotic waders during the rainy season between the end of September and January. Continue for about a mile (1.6km) and then there is a short detour on your right to **Playa Chiquito**, a small beautiful sandy beach surrounded by coral rocks where the sea comes crashing in. The waves make swimming very dangerous but it is a great place for a picnic. There are tracks along the coastline to where the waves are even rougher and the spray is sent rocketing many feet into the sky.

The yellow route then continues to **Boca Cocolishi** that is at the northern end of the park, and close to the most northerly point of the island. Cocolishi is the local word for shells while boca is the Spanish word for an opening and is used to mean a cove. Boca Cocolishi is really two coves in one separated by a coral ridge running out to sea. To the seaward side of the ridge the waters tend to be rough and deep, while the water is shallow and calm on the landward side and offers safe swimming from the black sand beach. The sand is black because it is made up of tiny pieces of crushed coral rock and the basin is shallow because it is slowly being filled with more rock and shell particles. It is a good beach for exploring because it has a rich marine life among the rocks and teems with tiny hermit crabs.

The route then runs inland past more salt lakes including **Salina Bartol** to **Poos di Mangel**, a small, shallow pond that attracts large number of birds that come to drink there. Close by on the coast is **Boca Bartol** which is a fine dive site with many species of coral, sea fans and tropical fish to be seen close to the shore. The yellow route then meanders its way back to the park entrance.

Apart from the green and yellow routes, there are many other footpaths and trails that can be followed that will get you closer to the wildlife.

S hore dives only: Boca Bartol, Petries Pillar, La Machaca (Habitat), Reef Scientifico (Habitat), Buddy's Reef (Buddy Dive), Bari (Sand Dollar), Front Porch (Sunset Beach), Calabas Reef (Dive Bonaire), Aquarius, White Slave, Red Beryl, Atlantis, Vista Blue, Sweet Dreams, Willemstoren Lighthouse, Blue Hole and Cai.

Boat or shore dives: Playa Benge, Playa Funchi, Boca Slagbaai, Nukove, Karpata, Ol'Blue, 1000 Steps, Webber's Joy/Witches Hut, Jeff Davis Memorial, Andrea 1 and 11, Small Wall, Something Special, Town Pier, Eighteenth Palm, Windsock, North Belnem, Bachelors' Beach, Chez Hines, Lighthouse Point, Punt Vierkant, The lake, Hilma Hooker, Angel City, Alice in Wonderland, Larry's Lair, Jeannies Glory, Salt Pier, Salt City, Invisibles, Toni's Reef, Pink Beach, Margate Beach and Red Slave.

Boat dives only: Bise Morto, La Dania's Leap, Rappel, Bloodlet, Country Garden, Bon Bini Na Cas, Oil Slick Leap, Barcadera and Cliff.

Klein Bonaire

Boat dives only: No Name, Ebo's Reef, Jerry's Reef, Just a Nice Dive, Nearest Point, Keepsake, Bonadventure, Monte's Dive, Rock Pile, Joanne's Sunchi, Captain Don's Reef, South Bay, Hands Off, Forest, South West Corner, Munk's Haven, Twixt, Sharon's Serenity, Valerie's Hill, Mi Dushi, Carl's Hill Annex, Carl's Hill, Ebo's Special, Leonora's Reef, Knife and Sampler.

Snorkelling

The Bonaire Guided Snorkelling program is an island-wide initiative. Participants enjoy a series of 12 different guided tours to carefully selected sites around the island and the tiny sister island of Klein Bonaire. Each tour starts with a 30-minute entertaining and informative slide show about the island, its reefs, marine life and fragile eco-system, and thorough review of equipment and snorkelling techniques such as mask clearing and safe entry and exit. The tours are led by one of a team of 30 trained snorkel guides, who are also trained underwater naturalists and proficient in lifesaving, water rescue and first aid. All tours are conducted in 15ft (4m) of water or less in fringing reefs rich in many species of coral and fish, and sites include Playa Funchi, Nukove, 1000 Steps, Cliff, Windsock, Invisibles and Mangroves off Bonaire, and No Name, Leonora's Reef. Jerry's Jam, Munk's Haven and Just A Nice Dive off Klein Bonaire. Bonaire Guided Snorkelling operators are: Sand Dollar ☎ 5433, Buddy Dive Resort ☎ 5080, Dive Inn ☎ 8761, Great Adventures ☎ 7500, Sea and Discover ☎ 5322, Wanna Dive ☎ 8880, Bon Bini Divers ☎ 5425, and Bonaire Boating ☎ 5353.

• BONAIRE •

Folklore Museum

Fort Oranje
Near Government House
Open: Monday to Friday from 8am to
noon and 1pm to 5pm
Admission is free.

Bonaire Marine Park

All the waters surrounding the
island and Klein Bonaire.
In order to dive you must have the
necessary certification and an
admission permit to the Marina Park
that costs US$10 and is valid for one
year. It is available from the Marine
Park headquarters (☎ 8595) and at
dive shops.
Trip in a glass bottom boat with
Bonaire Dream, ☎ 7080.

**Bonaire offers fabulous
snorkelling and Diving, see
feature box opposite**

Washington-Slagbaai National Park

Open: daily from 8am to 5pm.
Small admission charge, includes
free information leaflet.

The island has a good choice of restaurants offering the freshest of seafood to fine continental dining. Some restaurants are open only for dinner and a number close at least one day each week, often Sunday, so check first.

$$ Amadeus

Kaya Bonaire
☎ 2888
Steakhouse

$$-$$$ Beefeater

Kralendijk
☎ 7776
Great steaks, the freshest of fish and Caribbean dishes with a difference are offered in this fine restaurant in an old Bonaire townhouse surrounded by locally produced handicrafts, or dine out in the tropic garden. A band plays local music on Sunday evenings. It is open daily from 4pm.

$$-$$$ Blue Moon

Kaya C. E. B. Hellmund
☎ 8617
French and International cuisine.

$$-$$$ Chibi Chibi

Divi Flamingo Beach Resort
☎ 8255
Casually elegant waterfront, open-air dining with seafood, pasta and island dishes.

$$-$$$ China Nobo

Emerencianastraat 4
☎ 8981
Cantonese and local fare. Open daily except Tuesday from 11am to 11pm with delivery available nightly.

$-$$ Cozzoli's Pizzeria

Rose Inn, Rincón
☎ 5195
Open air dining by the sea with snacks, sandwiches and pizzas.

$$-$$$ Croccantino

☎ 5025
Eat in or in the courtyard and dine from a truly international menu from local dishes to South American, American and East Indian. Open for lunch from Monday to Friday and daily for dinner.

$$ Den Laman

Near Sand Dollar Beach
☎ 8955
A lovely open air waterside setting close to a huge tank full of fish, eels and turtles and another with lobsters. The menu specializes in fish and seafood and it is open from 6pm to 11pm.

$$ Divi Divi

Kaya Dr. J. G. Hernandez
☎ 8863
Good value local fare.

$$ Green Parrot

Sand Dollar Beach Club
☎ 5454
Delightful waterside dining watching the dive boats coming in and the yachts anchored in the bay. It is open all day for good value hearty breakfasts and lunches and dinners with a choice of fish, seafood, grilled meats and Mexican dishes. Happy hour is from 5pm to 7pm and each night features a dinner special.

$$-$$$ Kasa Coral

Harbour Village
☎ 7500
Open-air gourmet dining with seafood specialties and a fine wine list.

$$ Mi Poron

Kralendijk
☎ 5199
Vegetarian plus island fare. Open daily for lunch and dinner.

$$-$$$ Mona Lisa

Kaya Grandi
☎ 8718
International cuisine and open for lunch and dinner.

$$-$$$ Oceanfront

Coral Regency
☎ 5580.
Open all day with memorable Sunday brunch and live Reggae on Friday night.

$$ Peking Bar and Restaurant

Kaya Korona
☎ 7170
Cantonese and Peking cuisine plus local dishes and seafood. Open daily from 11am to 11pm.

$$-$$$ Rendezvouz

Kralendijk
☎ 8454
Island and international dishes served in the small dining room or on the veranda.

$$-$$$ Richards

Kralendijk
☎ 5263
On the waterfront and serving great home made Island dishes, fish and seafood.

$$ Rose Inn

Rincón
☎ 6420
Local fare served all day.

$$-$$$ Rum Runners

Captain Don's Habitat
☎ 7303
Open all day every day with love music on Thursday evenings.

$$ Spanhoek

Kaya L. D. Gerharts,
☎ 6686
Surinam specialties served for lunch and dinner.

$$ Swiss Chalet

Kaya Lib
☎ 3316
Swiss specialties, open all day.

$$ Surinamse Bar and Restaurant

Kaya A. Cecillia
☎ 2127
Surinam restaurant open for lunch and dinner.

$$ Yue Hau

Papa Cornes
☎ 2180
Chinese, open for lunch and dinner.

$$-$$$ Zeezicht

Kaya Craane
☎ 8434
This is one of Bonaire's oldest and best restaurants and was established in 1929 overlooking the water in Kralendijk. It offers excellent seafood, Dutch and Indonesian dishes plus live music.

NIGHTLIFE

There are opportunities to let your hair down at night, but many people go to bed early so they can be up at dawn and ready for another day's diving. Best nightspots include E Wowa, the island's long time disco and nightclub on Kaya Grandi. There are many lively bars such as Karel's on the waterfront in the middle of Kralendijk, and there is also a casino on the island – Dive Flamingo Beach Hotel, – with a minimum admission age of 18.

Curaçao

Curaçao offers a different kind of Caribbean adventure with secluded, sandy coves, warm, crystal clear turquoise sea, world-class diving, windsurfing and sailing, glorious weather plus great accommodation, shopping, entertainment and nightlife.

The island lies 35 miles (56km) north of Venezuela and is 30 miles (48km) west of Bonaire and 42 miles (68km) east of Aruba. It is one of the most southerly of the Caribbean islands lying 1,710 miles (2750km) south of New York, about 38 miles (61km) long and between 2 and 7 miles (3 and 11km) wide.

It is a hilly island of volcanic origin whose low annual rainfall supports a dry vegetation which consists mostly of cacti and scrub although there delightful pockets of flowering plants and shrubs, especially in the towns and resort areas. The island enjoys an average year-round temperature of around 80°F (26°C) and less than 23 inches (58cm) of rain a year. The onshore

Cas abao Beach

trade winds blow all the year and provide welcoming cooling breezes, although one must not forget how hot it really is.

History of the Island

Although discovered by the Spanish, Curaçao has been in Dutch hands since 1634 except for two brief spells during the Napoleonic Wars when the island was in British hands – 1800–3 and 1807–15. In 1815, it returned to The Netherlands under the Treaty of Paris. For centuries it was the seat of power for all the Dutch possessions in the Caribbean. In fact, the islands were often referred to collectively as Curaçao. Curaçao is the largest of the Dutch Antilles and for many decades it was a major slave center selling hundreds of thousands of slaves for transportation to other parts of the Caribbean and across the Atlantic to Spain. According to old records, there were sometimes as many as 14,000 slaves on Curaçao waiting to be sold. After Emancipation, Curaçao switched to more respectable trading, although smuggling and dealing in contraband brought huge rewards. There were a few large plantations, notably Savoneta and Knip, but the low rainfall often meant the island was short of food and it had to be imported. All that changed with the discovery of oil, and more recently with the development of the tourist industry.

THE ISLAND TODAY

Today the Island is a prosperous self-governing member of the Netherlands Antilles with elections for Parliament held every four years in the spring. It is the largest island in the Dutch Antilles covering 174 sq miles (453sqkm) and has a population of about 170,000 Curaçaoans, most living in or around the capital city of Willemstad, which is the government, business and cultural heart of the island. In 1997 because of its many historic buildings the UNESCO World Heritage Committee placed the inner city and quayside of Willemstad on the World Heritage List

Spanish Water Bay is noted for its sailing and windsurfing, there are scores of dive and snorkelling sites, deep-sea fishing, dive and water-sports centers and marina services and facilities for those arriving by private boat. There are yachts for charter and even classic sailing ships, such as the 129ft (40m) two-mast schooner *Insulinde*, which offer day, weekend and five-day cruises.

On land, there is a 9-hole course at the Curaçao Golf and Squash Club, and the new 18-hole championship Blue Bay course. There is also lots to see and do when the sun goes down. There are casinos and discos, open-air bars and gourmet restaurants, and many nightclubs featuring live music, from tumba and reggae to the latest pop hits.

There is a range of accommodation from quaint hotels in the heart of historic Willemstad to inns set in

the countryside, and from dive resorts to luxury hotels set on stunning beaches. There are about 2,020 hotel rooms on the island and this is set to double very shortly.

CARNIVAL

This is the biggest annual event and a true island party in which everyone joins. Although Carnival itself lasts only a few action packed days, preparations get under way in earnest at the beginning of the year and reach their brilliant, musical crescendo on the Tuesday before Ash Wednesday and the start of Lent. The **Tumba Festival** is one of the main events featuring fantastic

Tumba

Tumba should not be confused with tambu music and dance that also originates from the rhythms of Africa, especially the Yoruba, Dohoney and Bantu tribes. It is also the name of the drum that beats out the rhythm as well as the dance itself. The plantation owners banned drums because they believed the slaves used them to communicate with each other, so the Africans improvised and made their own drums using old boxes and containers with sheep – or goatskins stretched over them. The Tumba rhythm is very complicated as is the hugely expressive dance in which the body sways sensuously but the feet hardly move. The Catholic Church even banned the dance after Emancipation because they thought it was the work of the devil.

costumes and a parade of floats that winds its way through the streets of Willemstad and ends with the crowning of the Tumba King. Tumba is named after the drum on which the rhythm is beaten and originates from Africa. The music has been contemporized and there is great competition to win the best Tumba accolade.

Other Carnival highlights include the Children's Carnival, Parade and Tumba Festival, and the election of Carnival Queen, Prince and Pancho (helper). Many local groups and hotels organize special Carnival street parties or jump-ups throughout February and there can be several on one night. And, while Carnival is mostly concentrated in Willemstad, there are activities around the island.

Willemstad also hosts the monthly **Ban Topa Street Fair** that is a giant block party with singing, music, dancing, dining and wining, and every summer the **Curaçao Salsa Festival** celebrates the increasingly popular Latin rhythms. The **Curaçao Jazz Festival** is held each autumn and features top jazz artists from around the world.

BEACHES

There are 38 public and private beaches on the island, many in secluded sandy coves surrounded by towering limestone cliffs, and others surrounded by exotic flora and fauna. Generally the northern coast is not recommended for swimming or scuba diving because of the strong waves and currents, but the whole of the south coast offers lots of safe bathing, especially around Westpunt, Knip Beach and Playa Jeremi. **Westpunt Beach** is best known for

• GETTING AROUND ON CURAÇAO •

Buses – there are buses around Willemstad and to the western end of the island. They are cheap and cheerful and only stop at bus stops. There are two bus terminals in Willemstad, one near the market and post office in Punda which serves the town and the east of the island, and the other south of Riffort in Otrabanda with buses going west and north to the airport. There are also private mini-buses that ply fixed routes.

Taxis – there are taxis at the airport, major hotels and stands in Willemstad. Taxis are not metered and there are fixed fares for most trips that are posted. There is a 25% surcharge for journeys after 11pm. If you don't have your own rental car, you can tour the island by taxi but agree the price in advance. Expect to pay about US$20 an hour for tours.

Trolley – Before setting off to explore Willemstad on foot it is quite useful to take a trolley tour of the historic districts that will help you get your bearings. The tour in open sided cars pulled by a silent 'locomotive', starts from Fort Amsterdam and takes in the waterfront, floating market, upmarket Scharloo with its magnificent homes, the historic synagogue, Queen Wilhelmina Park, Waterfort Arches and then back to Fort Amsterdam. The tour lasts 75 minutes and take place at 11am on Monday and 4pm on Wednesday, ☎ 4628833. Old City Tours, ☎ 4613554, conduct walking tours in Punda and Scharloo on Tuesday morning and Thursday afternoon, and there are guided tours of Otrabanda on Wednesday, ☎ 7378718.

Note: As you wander around downtown Punda you will notice a number of men and women dressed in burgundy uniforms. These are members of Curaçao Hospitality Services and are on call to assist visitors, ☎ 4617991. A major signposting initiative has recently been completed and now almost all the main attractions are clearly marked.

the huge cliffs that frame it and the island divers who entertain beachgoers by jumping from the cliffs into the ocean below. It is a free public beach, popular with islanders and visitors alike.

Knip Bay Beach is just south of Westpunt Beach, and is probably the most photographed beach on the island because of its beautiful setting. At weekends, live music and dancing turn the area into one huge beach party. There are changing facilities and refreshments.

Player Abao, also on the north-ern tip of the island, is quieter than the above, but still popular because of its fabulous sands and turquoise water.

Daai Booi Bay, near St Willibrordus, nestles on the southern side of the island. It is a romantic little beach surrounded by high cliffs that give it seclusion and trap the sun.

Cas Abo is the island's most developed beach with refreshments, changing facilities, thatched umbrellas for shade and a large car park.

Blauw Bay is one the largest and most spectacular beaches with a small

North Point
Watamula
Lighthouse North point
Westpoint
Playa Kalki ⊿
Westpoint ⊿
Bay
Playa Aboa ⊿
Knip Bay ⊿
Playa Jeremi ⊿
Lagun

Boca Diega
Boca Mansalina
Boca Plate
Boca Kortalein
Boca Wandomi
Shete Baka Park
Boca Tabla
★ Boca Tabla Cave

Savonet ⌂
Indian Inscriptions Caves

⌂ Kip
Christoffel
Park

Weg naar Santa Cruz

Klein Santa Marta ⌂
Barber

Boca Pos Spano ⊿
Santa Marta Bay
San Nicholas ⌂ Soto
Groot Santa Marta
Dokerstuin
⌂ Ascension

Boca Santa Marta ⊿ Santa Marta
Playa Hund
San Juan Bay
Boca San Pedro

Boca Grandi ⊿
Playa Mansalina ⊿
⌂ Cas Aboa
Cas Aboa
San Sebastion
San Sebastion
Boca San Pedro

Playa Botu ⊿
Playa i Shon ⊿
Portomari Bay ⊿
Daaiboot Bay ⊿
San Willibrordo
⌂ Jan Kok
⌂ Daniel
Weg naar San Willibrordo
Weg naar West

Rif Bay
Salina St. Mary

Bullen Bay

| 0 | | 3 miles |
| 0 | | 3Km |

Blauu
Pisca

CURAÇAO

Two aerial views
of Willemstad

Hotel Holland
& Casino

nal

Hato

Hato
aves

nta
aria

Boca Playa Canoa

Boca Santu Pretu

Roosevelt weg

Brievengat

Boca Labadera

Boca Grandi

Ronde
Klip

Santa
Catharina

Boca Mangel

Bonham weg

Boca Tabla

Trupial Inn
& Casino

Ronde Kip weg

Emmastad

Schottegat weg

Weg naar Santa
Catarina

Santa
Rosa

Hofi Pachi Sprokel

Sint
Jorisbaai

abanda

Schottegat

Santa Rosa weg

Punda

Chobolobo

Klien Sint
Joris

heid

Een Strat

Br. Mr. Kon blv.

Lagun
Jan Thiel

t Nassau

Avila Beach
Hotel

Sea Aquarium

Santa Barbara

Jan Thiel
Bay

Spanish
Water

Princess Beach
Hotel & Casino

Spanish
bay

Caracas
bay

Santa Barbara
▲ Tabel
Mountain

Fuik

Lions Dive Hotel
& Casino

Fuik

Lighthouse
Punt Kanon

★ Punt Kanon
(Point Cannon)

Fort Beekenburg

Laguna
Blancu

Awa Blancu

admission price for use of the umbrellas, showers and changing facilities.

Playa Kalki is in a small, protected cove and one of the island's most popular snorkeling spots because of its calm waters and rich marine life.

Santa Barbara Beach is the best beach east of Willemstad, and busy with locals at the weekend, although much quieter during the week.

There are also a number of manmade beaches at resort hotels. The best of these include the Sonesta Beach Hotel and Casino, Princess Beach Resort and Casino and the Curaçao Sea Aquarium.

CASINOS

Gambling is one of the island's main attractions and many of the larger hotels have casinos –Curaçao Plaza Hotel and Casino, Otrabanda Hotel and Casino, Casino Porto Paseo, Holiday Beach Casino, Curaçao Sheraton, Hill Ross, Hotel Holland, San Marco Casino, Princess Beach Hotel and Casino and Curaçao Marriott Resort and Casino.

SHOPPING

Downtown Willemstad, both Punda and Otrabanda, and Salinja to the east of the city, all offer a wide range of shopping, from local goods to internationally known names in fashions, perfume, jewelry, cameras, crystal and cosmetics. Most prices are duty free and there is no sales tax. Heenstraat and Madurostraat are traffic-free shopping areas. Otrabanda's main shopping street is Breedestraat/Roodeweg. Other good shopping malls outside the city center include Bloempot, Saliña Galleries, Promenade and Jan Noorduynweg. Many resort hotels have their own shops and boutiques. Most stores are open from Monday to Saturday between 8am and noon and 2pm to 6pm, although some now stay open over lunch. Local souvenirs include ceramic models of buildings, handmade dolls in local costumes, hanging hand-painted planters, and paintings by local artists.

WILLEMSTAD – A WALKING TOUR

It is a delight to walk around the streets and waterfront of Willemstad with its red tiled, gabled roofs and rococo-style facades, pastel-hued shops, shady courtyard cafés and well-tended town houses. Some of the street scenes could have been transplanted from Amsterdam the only difference being the blazing sun and the turquoise seas. Much of the land now built on was formerly saltwater marshes and Dutch engineers used their skills developed back home to reclaim huge areas from the sea.

HISTORY

When the Dutch first arrived in 1634 they settled on De Punt, or the point on the east side of St Anna Bay. Over the years De Punt has changed to **Punda,** a well-planned district of centuries-old merchants' buildings that had their stores on the ground floor, living quarters above and space under the saddle roof for storage. The eastern shore of St. Anna Bay was fortified and the defensive walls restricted growth and so the decision was taken to expand on the other side of the water. **Otrabanda,** which in Dutch literally means 'other side', was founded although its development was less orderly with twisting alleys and streets. Rich

merchants who wanted bigger houses and more land, moved from Punda, as did others who could not find homes in the crowded east bank.

WILLEMSTAD TODAY

The town straddles St. Anna Bay with the most historic area in the Punda district on the east of the bay, and the cruise ship terminal in Otrabanda on the western side plus residential suburbs. Connecting both areas is the **Queen Emma Pontoon Bridge**. The town is small enough to explore on foot and there is lots to see. Willemstad is still a very busy port and its sheltered deepwater plays host to vessels from around the world. Cruise ships and cargo vessels have to sail through the narrow neck of St Anna Bay to reach the port and cruise ship terminal, but it is a memorable 4,000ft (1220m) channel past historic forts and splendid old waterfront Dutch Colonial buildings.

Otrabanda is mainly residential and not as glamorous as the neighboring Punda district, but it has many fine buildings including **Landhuis Habaai,** a seventeenth-century plantation house and all that remains of the original Jewish Quarter that was founded by the early Sephardic settlers. The second floor and original cobbled courtyard are common to most country homes in the area. Many of the houses in Otrabanda were built at the end of the seventeenth century and later, when the craze to copy Dutch styles was on the wane, the houses started to incorporate Caribbean features such as wooden shutters, and large rooms with wide doors so that the sun could be kept out but the breezes funneled through. The houses tend to have wide frontages with overhanging upper levels, wooden balconies and carved railings, rather than the narrow three-floor buildings with their saddle roofs across the water. The early eighteenth-century **Sebastopol Mansion**, on Sebastopolstraat near the bus station, is a good example of combined Dutch and Spanish styles, and there are many large mansions, such as the Belvedere, which is a classic pre-Civil War Southern States great house.

ARCHITECTURAL DIVERSITY

The wide diversity of architectural styles was matched by the cultures of the people who moved into this area. Otrabanda is known as Curaçao's cradle of culture because of the large numbers of writers, poets, musicians, craftsmen and teachers who lived there and who had enormous influence on the island's artistic and political development. In the 1930s a steady exodus started as people started to move out of the city and build new homes in the outlying suburbs. Many mansions fell into disrepair, others were converted into apartments, and the district became run down and neglected. At the beginning of the 1980s, however, Platforma Otrabanda was set up as a non-profit foundation to revitalize the area, and 500 buildings were recognized as having historical importance. A major program of renovation is now under way, and the results can already be seen. Old mansions have been rescued and are again homes and areas such as Sanchi, Frederikstraat, Shon Toms and Hoogstraat have been restored to their former glory. It is a fascinating area to stroll round,

especially the shopping area of Breedestraat, before heading for the cruise ship terminal.

THE CRUISE SHIP TERMINAL

The terminal and adjoining newly renovated **Prince Hendrik Wharf**, are in the deep water port of St Anna Bay and are used by a number of leading cruise companies throughout the year, including Carnival, Crystal Cruises, Costa Cruise Lines, Norwegian Cruise Lines, Regent Cruises, Royal Caribbean and Cunard Lines. In the terminal you can visit **Arawak Craft Products** which sells local handicrafts and pottery. It is the only ceramic factory in the Dutch Caribbean and produces images in relief of local historic Dutch style houses, tiles, and plates with historic views, as well as commemorative items and handmade pottery. A specially designed walkway allows you to see the artists and craftsmen at work. Upstairs is the Arawak Art Gallery. Whose pottery is a little further along the waterfront.

Opposite the terminal is **Porto Paseo**, a collection of fine old buildings that have been restored as part of the area's rejuvenation initiative, and just beyond and quite unmistakable is the **Kas di Alma Blou**, the stunning blue house. The mansion, which has been beautifully restored, was built at the beginning of the nineteenth century, and is a fine example of the Dutch-Caribbean architectural style. It now houses a gallery and gift shop offering products, all hand made, by local artists who also display their paintings and sculptures.

ALONG THE BAY TO THE WEST

From the cruise ship terminal take De Rouvilleweg and follow the water past the ferry port to **Koral Agostini**, a row of historic 1730s' buildings that have been faithfully restored and now house shops, restaurants and bars. Next to the Queen Emma Bridge in Plaza Brion is the **statue of Admiral Pedro Luis Brion**, the Curaçao lieutenant of Simon Bolivar. The square is a popular meeting place and every New Year's Eve the Bishop of Willemstad delivers his blessing as the clocks chime midnight.

Across the bay there are lovely views of the beautiful Dutch colonial buildings along the Handelskade waterfront. Inland there is Otrabanda's main shopping center along Breedestraat. If you head up Breedestraat crossing Arubastraat, you can take a left into Rifwaterstraat to visit the **Four Alleys**, a museum and restaurant in one. The historic house with its very low doorway (so be warned) has a restaurant downstairs offering snacks and local specialties and a small museum upstairs.

Then continue past the pontoon bridge keeping the bay on your left to visit **Riffort**. The fort was built in 1828 to protect both the approaches to the port and the homes of the wealthy merchants in Otrabanda. The fort is still being restored but houses a restaurant and cocktail terrace overlooking the port entrance. Opposite is the electricity plant and further south is the **Rif Stadium** where soccer or baseball is played most nights and at weekends. Also worth visiting in Otrabanda is the **Santa Ana Basilica**, one of the smallest in the world. It is in Breedestraat

Above left/right: **Dutch influenced architecture in Punda**

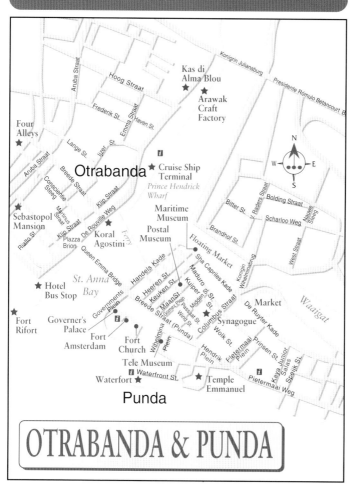

OTRABANDA & PUNDA

and dates from 1752. It is the oldest Roman Catholic Church still in use on Curaçao.

St. Elizabeth Hospital, also in Otrabanda, is the island's main hospital and one of the most modern in the Caribbean. It has two recompression chambers for divers. Further round the coast is the huge desalination plant which supplies much of the island's drinking water, and then there is the **Rif Recreation Area** with its 3 mile (5km) long **Koredo jogging track** which is very popular every evening. There is also a fitness center and nearby is the **International Trade Center** with the Sonesta Beach Hotel and Casino opposite and the Sheraton Resort and Casino just up the road.

The Seaworld Explorer

This was developed in Australia for use on the Great Barrier Reef and is a state of the art semi-submersible submarine that means the vessel does not completely submerge but the passengers in the hull are five feet below the surface of the water. It gives passengers a close up look at the coral reefs and the sea life that teems around them. The narrated trips include a visit to the Saba shipwreck site where a diver enters the water to feed the fish, which quickly gather. Seaworld Explorer passengers are picked up at the dock in Willemstad for the three-mile coach trip to the Curaçao Sheraton Hotel and Casino where they board the submarine, ☎ 4628986.

THE EASTERN END OF THE BAY

Retrace your route and cross the **Queen Emma Pontoon Bridge** (Koningin Emmabrug) into the Punda district. The floating bridge, designed by American Consul Leonard B. Smith in 1888, swings aside up to 30 times a day to allow ships to enter the deep water harbor. The pedestrian-only bridge, known affectionately as the 'swinging old lady', also swings as you walk across it and is an experience not to be missed. Apart from the strange gait that you are forced to adopt as you cope with the swing, the crossing offers great views of the waterside homes on both sides of bay. When the bridge is open for shipping, a free ferry operates to carry pedestrians across the bay. The ferry runs from beside the bridge on the Punda side diagonally across the bay to just south of the cruise ship terminal. The new Punda ferry terminal has public toilets with full handicap access.

After crossing the bridge, turn left into **Handelskade** with its lovely brightly painted Dutch waterfront gabled buildings and cafés, and almost immediately you see the **Penha Store** that dates from 1708. It is the city's oldest building and was modeled on Amsterdam-style architecture with a colonnaded corridor added to keep the sun out of the living quarters. It is now a department store. Alongside, are two other buildings based directly on the typical architecture of Dutch cities.

Continue along Handelskade and Heerenstraat with the bay on your left and follow it round into the **Sha Caprileskade** waterfront area. You can detour along Kuiperstraat to visit the **Postal Museum**, which is

housed in Willemstad's oldest wood and stone building which dates from 1693 and was beautifully restored in the early 1990s. It has a priceless complete collection of stamps from the Netherlands Antilles as well as changing displays from other countries and other post-related artifacts.

The Floating Market

This is on Sha Caprileskade in Punda and gets its name because every day schooners from Venezuela, Colombia and other Caribbean islands dock here to sell fresh fish, fruits, spices, and vegetables and other goods. It is a good place to discover more about the huge range of tropical produce that is available on the island, and it is a great place for pictures because of the exotic produce, and the colorful awnings which the vendors hang over their stalls to protect their wares.

Close to the Floating Market is the **Maritime Museum** housed in a restored 1729 mansion. Exhibits and videos depict Curaçao's long and colorful maritime history. There is a café and the museum also offers boat tours of the harbor. Scharloo

Carry on to the **Wilhelmina Footbridge** that leads across the Waaigat to the picturesque **Scharloo**, once home to Curaçao's wealthy merchants. Many of the mansions have been beautifully restored and are now offices. They include the ornate **Bolo de Bruid**, known as the Wedding Cake House, on Scharlooweg,

which is the home of the National Archives. The green mansion with its sweeping steps, white facade, elegant moldings and Corinthian columns, was built in 1918 by Da Costa Gomez as an exact copy of the Spanish Embassy in Caracas. Inside are housed thousands of ancient rare documents, old slave registers and newspapers, and a fascinating collection of historic photographs and drawings. In 1915 all official documents dating from before 1846 were sent back to the National Archives in The Netherlands, but copies of these, many of them on microfilm, have been returned and can now be studied.

While in Scharloo, visit **Hofi Pastor** (Priest's Orchard), famous for its 100-year old kapok tree. There are two short walking trails and this is a charming area for a picnic.

THE MARKET PLACE AREA

Cross back over the bridge and turn left for the new **Market Place** that is usually a hive of activity. Close by is **Plaza Biejo** and the Old Market where tens of thousands of slaves were sold. This is a great area for sampling local fast food and there are some great cafés and stands offering traditional soups, rice and peas and hearty stews. The **post office** is just beyond on De Ruyterkade, and the bus terminal is on Waaigat.

From the central market you can walk towards the sea along Columbusstraat to the **Mikve Israel Emanuel Synagogue and Museum**. Built and dedicated in 1732 it has a beautiful interior and is one of the oldest synagogues in continuous use in the western hemisphere.

The island's Jewish heritage dates back to 1651 when 12 Jewish

Curaçao Sea Aquarium

families from Amsterdam crossed the Atlantic to establish a new congregation. Soon after, Jews from Portugal and Brazil who were escaping religious persecution joined them, and by the early 1700s, Curaçao's Jewish population numbered more than 2,000. Today there is an active congregation of about 350 with about half that number members of the orthodox Congregation Shaarei Tsedek.

The Mikve Israel Emanuel Synagogue

This is thought to be modeled on the Portuguese Synagogue in Amsterdam and features a pastel yellow facade and gabled roof, with a Spanish tiled courtyard leading to richly carved mahogany doors and paneling. The floor of the synagogue is strewn with sand which is said to symbolize the Sinai desert which the Israelites had to cross on their long journey to freedom but in reality, it is more likely that the sand was used to muffle the sounds of worship especially in Spain and Portugal where Jews were harshly oppressed during the Inquisition and often put to death. Whatever the reason, the plain sandy floor is in striking contrast to the ornate ceiling decorated with silver and brass.

Next door in the restored eighteenth-century house of the original rabbi, there is the **Jewish Cultural Historical Museum** with a priceless collection of ritual objects and memorabilia from the island's Jewish community, including the original mikvah (the ritual purification bath), ancient prayer books, and silver from the seventeenth and eighteenth centuries. The museum also has a gift shop selling religious items. Visitors are welcome to tour the synagogue and museum. Men and boys are requested to wear a head covering when inside the synagogue and kippot (skullcaps) are provided for this purpose. The synagogue has two cemeteries, Bet Chaym Cemetery being the oldest existing cemetery in the New World, having many beautiful tombstones.

Continue along Columbusstraat to the small **Wilheminaplein** (Wilhelmina Park) that has a statue to Queen Wilhelmina, and is the venue for a number of cultural and musical events. Across from the park stands the Jewish **Temple Emanuel**, no longer in use, and the yellow **Parliament Building** with the **Courts of Justice**. The Bank of Boston is housed in a former Georgian style Masonic Temple built in 1869. Also on Wilhelminaplein is the **Tele Museum** in another beautifully renovated building. It houses a permanent collection that traces the history of telecommunications on Curaçao from the first telephone introduced in the 1880s to the latest innovations. The museum is owned and operated by the island's telecommunications company, Setel NV.

THE WATERFRONT

Here is **Waterfort** that was built in the seventeenth century to protect the entrance to the port. The defensive stone wall with its ramparts and vaulting which were added in the early nineteenth century, runs along the water, and was 30ft (9m) high, a quarter of a mile (0.4km) long and barrel vaulted both for strength and to provide storage for munitions and supplies. The vaults were later used as cells and during the World War II it was used as barracks for troops and for storage. During times of trouble, a huge iron chain was stretched across the harbor mouth to deter hostile ships from entering, and parts of this chain can still be seen attached to the sea wall. Today **Waterfort Arches** is one of the most delightful parts of town housing boutiques and breezy waterside restaurants and cafés. It is a great place to watch the spectacular sunsets as you sip a drink or enjoy a fruit-flavored Lovers ice cream, a Curaçao specialty.

THE MIDDLE OF TOWN

Head back inland past the Court and police station to the very heart of the original settlement. **Fort Amsterdam** was started in 1635 to protect the port from attack by raiding ships and was used as the island headquarters of the Dutch West Company. It was one of 8 forts built around the walled city. Today its spacious courtyard houses the Colonial-style **Governor's Palace**, government offices and historic **Fort Church** with its fascinating museum. The church was consecrated in 1769 and is a lovely example of eighteenth-century Punda architecture with its saddle roof, and still has an active Protestant congregation. It is also the oldest church still in use on the island. A cannonball is still embedded in its wall, a legacy of Captain Bligh's attack in 1806. The steeple was replaced in 1903 after a storm and the clock in the ceiling center, was donated by a sea captain.

The church was probably built on the site of the original small wooden church that was the fort's garrison. Although small in area, the church is very tall and the high loft was used to dry the sails of ships in port, while the basement was used to store cargo. The pulpit and Governor's Chair, both made from mahogany, date from 1769. The museum has old maps, photographs and Dutch Protestant church memorabilia. It is open Monday to Friday from 9am to noon and 2 to 5pm. There is a small admission charge. For information about concerts ☎ 4611139.

You can also visit the **Numismatic Museum** on nearby Breedestraat.

The museum has coins that have been used in the Netherlands Antilles over the centuries as well as changing displays of coins and bank notes from other countries. It is owned and operated by the Central Bank of the Netherlands Antilles. There is also a display of precious and semi-precious stones. It is open Monday to Friday from 8.30am to 11.30am and 1.30pm to 4.30pm. Admission is free, ☎ 4613600.

OTHER THINGS TO SEE:

The **Bolivar Museum**, Penstraat 126-8, was the home of Simon Bolivar's sisters and his refuge while in exile. The octagon-shaped building has some of his personal effects plus antiques and artifacts from Central and South America.

Curaçao's **Botanical Gardens and Zoo** are on Chuchubiweg in the Mahaai residential area north of the city. Refreshments are available and there is a souvenir shop.

Curaçao Museum, Van Leeuwenhoekstraat in western Otrabanda, is set in delightful grounds in the old seamen's hospital and cannot be missed because of the carillon and clock on top of the building. It has local history exhibits, sculptures, antiques and antique furnishings, including some magnificent mahogany pieces from the eighteenth and nineteenth centuries. It also features work by traditional and contemporary local and foreign artists, and contains the Children's Science Museum that has hands-on exhibits.

Kura Hulanda, Klipstraat 9, is a museum dedicated to the infamous slave trade, relating how the slaves – those from whom most of the islanders are descended – were captured, transported and treated, ☎ 4621400.

ISLAND TOUR

The arched 185ft (56m) high Queen Juliana bridge carried road traffic from Willemstad across St. Anna Bay to the ring road that runs round the northern edge of the bay allowing easy access to the main routes which serve all parts of the island. Side roads are often unpaved and care needs to be taken after heavy rain when they become muddy.

A main feature of the cunuco or countryside, are the marvelous centuries old **landhuizen**, the old plantation houses nestling in the hills. There were more than 80 dotted around the island and over 40 remain, some well restored and others, unfortunately, in ruins. Some have been converted into museums or restaurants while others are privately owned although they can still be viewed from the road.

SOUTH OF THE ISLAND

Cross Queen Juliana Bridge and take the ring road. After a short distance you pass the **Autonomy Monument**. The monument has six birds, one for each of the islands of the Dutch Antilles, leaving the nest of their mother, The Netherlands.

Just past the monument you turn left for the **Amstel Brewery** in Rijkseenheid Boulevard. This traditionally brewed Dutch beer is exported throughout the Caribbean and is believed to be the only one made from desalinated seawater. There are tours at 10am on Tuesday and Thursday.

The road then passes the new Saliña Shopping Mall to the Curaçao distillery. No visit to the island is complete without a visit to the seventeenth-century **Landhuis Chobolobo**, the home of the **Senior Curaçao Liqueur**

Factory. The world-famous liqueur, which celebrated its centenary in 1996, is made from the peel of island-grown, sun-dried Laraha oranges which grow only on Curaçao. Visitors can tour the factory and watch the procedure step by step in producing this liqueur and the company's other products.

History of the liqueur

I ronically, the discovery of Curaçao liqueur came about as the result of an agricultural disaster. When the first Spanish settlers landed on the island in the early 1500s, they planted hundreds of Naranja orange trees. Neither the soil nor the low rainfall suited the citrus trees, and the fruit was inedible and bitter. The islanders, however, discovered that the peel of the orange, when dried in the sun, could be crushed to produce aromatic oil that could be used in a variety of foods and drinks.

In 1896 commercial production of Curaçao liqueur began in the converted seventeenth-century plantation house just outside the island's capital. The same secret recipe and spices are still used today as well as the original distilling equipment, and apart from the traditional Curaçao orange flavor, it is also available in rum, raisin, chocolate and coffee flavors. The factory is open for tours with a free tasting at the end of the visit – and, of course, the chance to buy the product if you want to.

You now enter Curaçao Industrial Free Zone with its container terminal, and huge dry dock, and then reach **Bapor Kibra**, which means Broken Ship, a reference to the steamer Oranje Nassau that sank in 1906. The area is now home to the Curaçao Sea Aquarium complex that also includes the Seaworld Explorer, underwater park, hotel and rental bungalows, fitness center and long stretch of fine beach with Mambo Beach club, watersports, dive club and lots of other facilities.

The **Curaçao Sea Aquarium** displays a huge array of corals and tropical fish. Opened in 1984 on a reclaimed mangrove swamp and rubbish dump, the 75 hexagonal tanks contain more than 150 different types of soft and hard coral and about 400 species of fish and sea creatures, almost every species of marine life found in the offshore waters. The aquarium also offers a chance to feed reef, nurse and lemon sharks by hand at the new outdoor Animal Encounters exhibit, and next door, divers can mingle with and feel stingrays, angel fish, tarpon and more in Stingray Encounter. There is an underwater observatory with large glass portholes for those people who do not want to get wet. There are also glass-bottom boat rides to the nearby Underwater Park and rides in a semi-submersible.

The **Underwater Park** consists of a series of preserved reefs that extend for more than 12 miles (19km) and offer great diving and snorkeling. The area was designated a marine park in 1983 and it runs from Willemstad to East Point. Many of the pristine reefs are accessible by shore entry dives from Caracas Bay, Santa Barbara Beach or Jan Thiel Bay. **Jan Thiel Bay** is a popular beach

close to an upscale residential district that uses it as its beach club. There are changing facilities, toilets and snack bar, and a small admission charge for visitors.

Caracas Bay offers a deep anchorage for large vessels, including some cruise ships, and the round tower of **Fort Beekenburg** still stands guarding the bay.

Spanish Water is a large sheltered lagoon reached by a narrow inlet that offers a natural harbor surrounded by hills. The shoreline is indented with small coves and there are a number of tiny islands, some of which have holiday homes built by people from Willemstad. The area is the heart of the island's boat building and repair industry with a number of marinas. It is also the home of the Curaçao Yacht Club, and the safe anchorage and facilities make it popular with visiting yachts. **Santa Barbara Beach** is the best one along this stretch of coastline and very popular with locals at weekend. It is just east of the entrance into Spanish Water.

Table Mountain (Tafelberg) can be seen inland. It rises to 637ft (194m) and is an island landmark. The mountain has long been used for the excavation of phosphate although this is now mined on a much smaller scale. The road then runs north round the eastern shores of Spanish Lagoon and past **Landhuis Santa Barbara** to a crossroads.

If you turn left you can visit by appointment the **Curaçao Ostrich and Game Farm** at Groot St. Joris. The farm is open by reservation every day from 8am to 5pm and there are guided tours that show the development of the ostrich from an egg to becoming the world's biggest and most powerful bird.

The right turn leads to **Fuik** where the main road east runs out, and almost all the land to the east is privately owned. Here there are the ruins of **Landhuis Fuik**. The countryside to the east of Fuik as far as **Punt Kanon** (point Cannon) and **East Point** and its lighthouse is very rugged and desolate.

Little island

About three miles (5km) off the eastern tip of the island is tiny **Klein Curaçao** only 1.8 miles (2.5 km) long and only 800yd (750m) wide. The unmanned lighthouse and two buildings beside it dominate the flat, barren landscape. The island, with a few resident wild goats, was virtually ignored until 1871 when phosphate, a natural fertilizer, was discovered in huge quantities. Mining continued until 1913 and during this period the top 10ft (3m) of the island was removed. There are some fishing shacks that are used at the weekend by Curaçaons, and there are boat trips to the island so that you can enjoy the stunning white coral sand beaches, offshore reefs and wrecks.

You can visit **Den Paradera**, Seru Grandi Kavel, Band'ariba. This fascinating herb garden has an interpretive center explaining local culture, health and healing. The organic herb garden has dozens of local plants preserved and catalogued according to their traditional medicinal and culinary uses. In the back of the property there is a reconstruction of a rural settlement

Town Houses

with several small huts and life size figures depicting scenes of yesteryear. Try one of the many special beverages on sale – aloe, ginger and lemon, as well as medicinal wines, herbal teas and exotic fruit juices. Visit is by appointment only.

If you go straight over the crossroads you pass the turning for **Landhuis Klein Sint Joris**, while the main road swings westwards to another crossroad. Straight over takes you to **Santa Rosa**, while the right hand turning heads up to the north coast past a number of Landhuise – **Groot Sint Joris, Ronde Klip** and **Santa Catharina**.

There are a number of beaches along this coastline such as **Boca Mangel, Boca Playa Canoa** noted for its seafood and fresh fish, and **Boca Santu Pretu.** The seas along this stretch of coast, however, can be rough with strong currents and swimming is not advised.

Inland from the coast you can visit **Hofi Pachi Sprockel,** a former plantation orchard and now the home of three windmills and a collection of slave huts, old buildings and equipment from the slave days in a lovely woodland setting. A small yard recreates the former living and working conditions of the plantation slaves. Folk shows are also held here from time to time. It is open by appointment and admission is free, ☎ 7369957.

Landhuis Brievengat

Further along, the beautifully restored eighteenth-century **Landhuis Brievengat** was the center of an aloe plantation of more than 1,275 acres (500 hectares). The estate is said to take its name from an old tree that stood near where the house was built. There was a hole in the tree in which pirates were said to have hidden letters for their accomplices to pick up later. Brievengat means letter hole and the name stuck. The house was badly damaged by a rare hurricane in 1877 and never really recovered. It fell into such disrepair that the property was demolished in 1950, but four years later work started on rebuilding the landhuis. It has been faithfully rebuilt and is noted for its open arcade gallery along the front of the building and the flanking towers.

It is now a museum and cultural center. On display is elegant antique furniture and household effects from the eighteenth and nineteenth centuries. It also has a bar that serves snacks and on Wednesday and Friday nights there is dancing and live music. Sunday is open house with Indonesian and island fare, folk music and dancing and displays of arts and crafts that can be bought.

The road then heads south through **Emmastad** to **Fort Nassau.** This was perhaps the most prominent of all the forts built around Willemstad. Constructed in 1797 it is located on one of the highest hills overlooking the city, and has been preserved in almost its original state, with even its tower intact. Today, the fort is home to a very good restaurant and apart from the food, the views are also stunning. It is then a short drive back to Willemstad.

NORTH OF THE ISLAND

From Willemstad head west out of town through Otrabanda to **Fort Waakzaamheid** which is set in the hills overlooking Otrabanda near the Juliana Bridge. Its main claim to fame is that in 1804 after a 26-day siege it surrendered to Captain Bligh of Mutiny on the Bounty fame. The fort is now in ruins but it is worth a visit for its history, and for the nearby dining tavern.

To the north is the massive refinery, once the biggest in the world and still operating but at a much reduced level, and on its western fringe is **Beth Haim Cemetery** , one of the oldest in the Americas, with tombstones dating back to the mid seventeenth century. You then take the airport road to **Juliana Dorp** and then turn left for the north of the island past the **University of the Netherlands Antilles.**

To the south on the coast is popular **Piscadera Bay** protected by a fort built in 1744 and captured briefly by the British in 1804. They used it to bombard Willemstad for a week until being ousted. The fort's ruins are in the grounds of the Curaçao Caribbean Resort and Casino.

The main road, however, runs through the center of the island to **Landhuis Daniel,** one of the island's oldest plantations, although the current house was built in the early eighteenth century. It was used as an inn for travelers with stabling

for their horses. It is conveniently located in the middle of the island and has a tempting restaurant that specializes in seafood, as well as 10 comfortable but unpretentious guest rooms and a recently opened dive shop. And, if you have ever dreamed of driving a Harley Davidson, you can rent one here, ☎ 7648400.

Then take the left hand fork that leads south-west to **Landhuis Jan Kock**, near Sint Willibrordus. It was built in 1650 and is one the island's oldest buildings. The plantation produced salt that was exported for the Dutch fishing industry. The house, said to be haunted, was restored and opened as a museum in 1960. Some of the original furniture is made of mahogany cut on the estate. It is open for tours on weekdays by reservation only and on Sunday when Dutch-style pancakes and other local specialties are served.

To the south is **Salina St. Marie** and the Flamingo Sanctuary. **Habitat Curaçao** is one of the island's newest dive resorts located beside the water in Rif St. Marie. It is the sister resort to Bonaire's world-famous Captain Don's Habitat Resort. Facilities include a PADI five star dive center with multi-lingual tuition, private beach, pool, restaurant, bar, boutique, convenience store, photo shop and accommodation. There are side roads down to the beaches at **Rif Bay, Daaibooi Bay** and **Portomari Bay**.

The main road, however, heads north past **Landuis San Sebastiaan**, and then west where you can detour off to visit **Landhuis Cas Abao** with restaurant, bar and private beach, and the many beaches along this stretch of coast. These include **Playa I Shon, Playa Bota, Playa Largu, Playa Mansalina**, and **Boca Grandi**.

The main road continues westwards to **Soto** and **Santa Marta Bay**, another popular anchorage for yachts. Again there are many delightful and secluded beaches to explore in the area, including **Boca Santa Marta, Plaua Hundu** and **San Juan Bay** on the eastern side of the Bay.

The main road skirts the northern edge of the bay past **Landhuis Groot Sta. Martha**. Built in 1700 it now houses an arts and crafts center employing physically and mentally handicapped craftsmen and women.

Next is **Landhuis Klein Santa Martha** and the village with the pretty **Santa Martha** church, then take the left turning that runs past **Landhuis San Nicolas** and more beaches. **Boca Pos Spano** is really a series of three small beaches. The second Playa Hulu is reached by stone steps, is secluded and sandy, and the third, Boca Santu Pretu (Black Sand Bay) is more difficult to reach and the sand, which is crushed volcanic rock, seems to absorb the heat getting very hot. Another word of caution, there are lots of machineel trees in this area so be careful what you touch and where you sit.

Every time you detour down to the beaches you have to retrace your route back to the main road before continuing west. **Lagun** offers good snorkeling and the high cliffs offer shaded areas on the beach that can be a relief during the hottest times of the day. This is a lovely stretch of coastline that takes in **Playa Jeremi, Klein Knip, Knip Beach, Playa Abao** and **Westpunt Beach**, all of which offer great swimming. **Knip Beach** is popular with islanders and visitors alike and is often packed and noisy at weekends.

Inland from Knip Beach there is **Landhuis Knip (Kenepa)** that was built in the late 1600s and was the scene of the historic slave uprising in 1795. There is a permanent display of old household artifacts, and it is the venue for occasional cultural and art exhibitions. Guided tours are available.

Because the beaches are popular there are lots of roadside food stalls as well as small bars and restaurants where you can eat in or take food away for a picnic. **Westpoint** is an old fishing village set among the rocky cliffs on a small sheltered beach, and the road then continues north past **Watatamula** to the lighthouse at **North Point.**

Retrace your route a little and then turn left to head eastwards for the national park entrance detouring on the way to visit the rugged north coast. There is an almost moon-like landscape around **Boka Tabla** and this northern coastline is dotted with caves.

The **Christoffel National Park** was opened in 1978 and covers 4,500 acres (1800 hectares) and includes caves and a wide range of habitats, flora and fauna. The park entrance is at **Landhuis Savonet,** the island's oldest plantation house dating from the mid-sixteenth century. It was formerly three large plantations and is now the home of the rare and small Curaçao white-tailed deer, as well as rabbits, donkeys, monkeys, large numbers of iguana and many species of exotic birds. There are between 150 and 200 deer in Curaçao, and about three-quarters live within the park's boundaries. Historians have traced the deer to Indians that brought them from South American coastal areas, particularly Columbia and Venezuela in the fourteenth and fifteenth centuries. Since 1926 the deer have been protected on Curaçao.

The park surrounds Mount Christoffel, the island's highest point at 1,230ft (375m), an oasis of green vegetation. There are 20 miles (32km) of one-way driving trails abundant with flora and fauna, including prickly pear cactus, divi divi trees and tropical flowers. There are four color-coded routes, three road routes and the path to the summit of Mount Christoffel, a three-hour

Newest National Park

Y ou can visit the rugged landscape of the **Shete Baka Park**, Curaçao's newest national park. The park begins at the Boka Tabla where huge waves crash against the rocks and the underwater caves. It is possible to enter one of these caves, by steps cut into the rocks from the landside, to watch and listen to the crashing and roaring of the waves as they enter from seaward. There is a walking trail that runs east along the limestone bluffs and longer trails which must only be undertaken with a park guide. A dirt road accessible by jeep runs round part of the north coast taking in the inlets and coves of Boka Wandomi, Boka Koratlein, Boka Plate, Boka Mansaliña, Boka Djegu and Dos Boka. The coves are turtle nesting grounds and you can join park rangers who monitor turtle activity each morning.

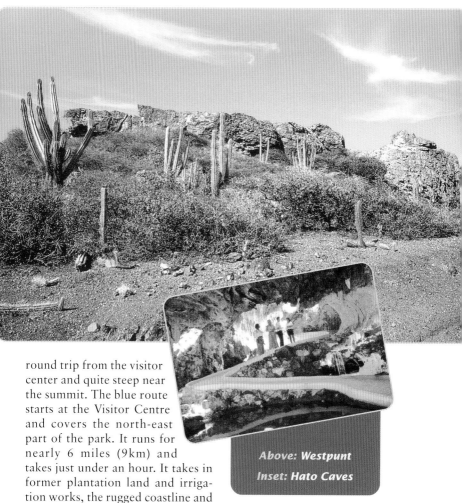

Above: **Westpunt**
Inset: **Hato Caves**

round trip from the visitor center and quite steep near the summit. The blue route starts at the Visitor Centre and covers the north-east part of the park. It runs for nearly 6 miles (9 km) and takes just under an hour. It takes in former plantation land and irrigation works, the rugged coastline and Boka Grandi where you can visit the caves with their Indian rock drawings.

The green mountain route takes in the central area and Mount Christoffel. The 7.5-mile (12 km) route takes about an hour and a half, and includes the ruins of Landhuis Zorgvlied and incredible panoramic views from the mountain. There is a shorter green route covering 4.6 miles (7 km) if you are pressed for time, which bypasses the landhuis ruins and heads directly to the trail

at the foot of the mountain. The climb to the summit and back down takes at least 2 hours.

The yellow route covers the hilly area to southwest with side tracks down to the west coast beaches. This route, known as the orchid trail, is 3 miles (5 km) long and only takes 15 minutes to drive, but plan on spending a lot longer as it is worth stopping along the view to admire the views, and it is worth hiking the orchid trail if you have time (see page 101).

The park is a great place to explore either by car or on foot, and walking tours are popular. There are also guided tours, and for an unforgettable sight take a sunrise tour.

The **Savonet Natural History Museum** in the old warehouses of the landhuis close to the park entrance has exhibits showcasing the island's nature and a collection of ancient tools and artifacts, and archaeological finds dating back to early Amerindian settlements.

Old-style cottage

The road back to Willemstad again runs down the center of the island through **Barber** with its historic cemetery to **Kas di Pal'i Maishi** and **Landhaus Ascension**. Kas di Pal'i Maishi (the sorghum stalk house), on Dokterstuin, is a typical traditional rural cottage that has been well restored. It was the sort of dwelling that most of the islanders lived in 100 years ago with its thatched roof and adobe walls. The fence of cactus provided protection against herds of goats. Inside the house is a small museum containing household items from the past and tours are available on request. The small souvenir shop sells local handicrafts.

Landhuis Ascension, a little further along the main road, dates from 1672 and is one of the oldest plantation houses on the island. It was well restored in 1963 and is now used as a recreation center for Dutch marines stationed on the island. It

is open to the public on the first Sunday of each month with local music, handcrafts and refreshments.

There are side roads off to the left to visit places like **Boca San Pedro** but the main road continues east past **Landhuis Daniel, Landhuis Seru Grandi** and **Landhuis Papaja**. Landhuis Papaja is a charming, small country house with an interesting collection of old photographs of the island. There is a barbecue and live music every Sunday.

Turn left at the major junction, head for the international airport and follow the road round the coast to visit the **Hato Caves**. As you travel through this area keep an eye out for iguanas that like to lie in the shade of rocks or under the trees. There are lots of these prehistoric creatures that can grow up to 4ft (120cm) long and weigh 4–6lb (2-3kg). The iguanas can live to be 30 years old and their color changes according to their surroundings, which makes them difficult to spot.

The Caves are ancient limestone caves that were originally coral reefs. The caves were formed during a landmass uplift that coincided with a drop in sea level, leaving them stranded above water. They have recently been re-opened to the public after extensive renovations including improved lighting and ventilation and gravel lined paths. They are set among the cliffs on the rugged north coast of the island and are the subject of countless myths and legends. Runaway slaves used to hide in the caves and long before that the Amerindians used them for religious ceremonies. The caves are said to be the home of a sleeping giant, the haunt of pirates and several other magical creatures, as well as the famous Madonna statue.

In order to protect the caves unescorted visits are not allowed but there are hourly-guided tours. These multi-lingual tours take visitors through the different chambers, past a waterfall and ancient cave paintings to a shimmering pool surrounded by unusual stalagmite, stalactite and other limestone formations (stalactites are the ones that hang down so they have to hold on 'tite').

In the half-light these formations take on strange shapes and you can pick out all sorts of human and animal forms – from a slumbering giant and pirate to a sea turtle and the head of an iguana. There is a snack bar overlooking the Caribbean.

Head south from the caves through **Santa Maria** and back into Willemstad.

• HIKING IN THE CHRISTOFFEL PARK •

There are eight main hiking trails through the park, and further details can be obtained from the park office.

Plantation and Boka Grandi Trail ($1^1/_2$ hours). The walk passes through the old plantation grounds, past a mahogany grove, irrigation wells and dams, salt marsh and limestone terraces to Boka Grandi where you can picnic before returning.

Short White Tail Deer Trail is a lovely 20-minute shaded walk through woodland past the Dos Pos (two wells) picnic area.

Long White Tail Deer Trail is a 40-minute walk past Dos Pos to the deer observation tower inside the deer sanctuary.

White Tail Deer-Boka Grandi Trail (allow at least $1^1/_2$ hours). The walk takes in the picnic area of Dos Pos, the deer observation tower and leads to the north coast and Boka Grandi.

Zorgvlied Trail (allow $1^1/_2$ hours). The walk leads to the ruins of Landhuis Zorglied and spectacular panoramic views, and passes through areas of typical flora and Roori Beru, a dry riverbed.

Santa Cruz Rooi Trail (allow $1^1/_2$ hours). The walk offers the chance to see how the plantations were watered, passing the old irrigation works and wells, many interesting geological formations and the Zeveenbergen ruins.

Orchid Trail (allow 2 hours). A fascinating walk but quite challenging in places through Shete Seru (The Seven Hills), one of the most beautiful areas of the park and famous for its orchids, bromeliads and lichens. It takes in the manganese mine and offers great views over Landhuis Kenepa and the park. There is a short 10-minute side trail to Seru Bientu (windy mountain) where rare sabal palms grow.

Christoffel Mountain Trail (allow 2-3 hours for the round trip from the visitor center). This is a tough but rewarding hike to the summit through rich flora, past interesting geological formations and stunning views from the top.

• SCUBA DIVING AND SNORKELLING ON CURAÇAO •

S cuba diving and snorkeling is one of the great attractions of Curaçao. The waters are warm and exceptionally clear, and many of the pristine reefs can be reached a short distance from the shore. The island's road system means that all beaches are accessible, and for deeper offshore dives, there are state-of-the-art dive schools and dive operators. Dive shops offer the full range of courses from open water certification for beginners to advanced, rescue, first aid and cave diving. There are two recompression chambers at the St. Elizabeth Hospital in Willemstad.

Curaçao maintains strict conservation rules and there is no harpooning, spear fishing or disturbing or gathering of coral.

There are more than 100 dive sites, many of them marked by mooring buoys, and Curaçao's national marine park, established in 1983, runs for more than 12 miles (19km) east from Willemstad and includes many of the island's best preserved reefs. Other attractions are the spectacular Curaçao Wall that drops away like a cliff into the depths, and the Blue Wall. Klein Curaçao, off the island's East Point is another popular dive site with walls, caves, drop offs and a rich marine life.

Because of the warm, nutrient rich waters, the coral is spectacular both for its colors and size. There is giant elk horn, and 5ft (1.5m) high stag horn, and brain corals more than 7ft (2m) across. At deeper depths there are gorgonia in all shapes and sizes, spectacular black coral and fire coral.

The waters also boast more than 400 species of fish, crabs, anemones and sponges. Among the more interesting are the multi-colored Flamingo tongue snail which feeds among the soft gorgonia sea fans, the purple and yellow Royal Gramma which has been dubbed the world's most expensive fish, and the beautiful and curious Angel fish which will swim up to divers and nuzzle them.

The following are some of the best dive sites:

Boka di Sorsaka – is a deeply undercut ledge formed by the surf more than 5,000 years ago.

Car Pile – lies off the Princess Beach Hotel. It is an artificial reef created by dumping old car bodies into the water. The marine life has already taken over, and it is a great way of getting rid of unsightly wrecks.

Hell's Corner – is a steeply shelving reef covered with large sea fans and pillar coral, and frequented by barracuda, moray eels and large spiny lobster.

Klein Curaçao – is an hour's boat ride off the East End and this uninhabited desolate, volcanic island offers near unbeatable diving. In the inshore shallow waters there is a vast garden of anemones that teems with fish, shrimp and crab. In the deeper water around 20 feet (6m) there is the edge of a wall which is home to many species of coral, and then the wall plunges down about 100 feet (30m) to a different world of large, orange elephant ear sponges, purple tube and rope sponges, huge gorgonia and black coral trees, and frogfish, eagle rays and sea turtles.

Mike's Place – is off San Juan and is noted for a huge sponge that is so large that it is known locally as 'the double bed'.

The Mushroom Forest – is thought by many to be the most beautiful section of the Banda Abao Underwater Park. It is a gently sloping reef covered with huge mushroom-shaped coral formations.

Oranje Nassau – is the wreck site of a Dutch steamer that ran aground on Koraal Specht at the beginning of the last century. The site is in shallow water off the Curaçao Seaquarium and is ideal for underwater photography.

Piedra di Sombre – is between Caracas Bay and Jan Thiel Bay and offers a spectacular steep wall dive past sponges and forests of black coral. It is also a good snorkelling site.

Playa Lagoen – is at the end of the Mushroom Forest, and is a white sand beach nestling between two massive rock formations. The reef is only 450ft (137m) off shore and is ideal for shore dives and snorkelling.

The Sponge Forest – boasts some of the most spectacular sponges to be found in the Caribbean. The giant breaker sponges are often 4ft (1.2m) across and up to 6ft (2m) high.

Superior Producer – is one of the island's many wreck dives. The sunken cargo vessel rests completely intact upright and parallel to the reef in about 100ft (30m) of water. It can be reached from the shore near the Curaçao Waterworks. Further west are the scattered fragments of a crashed seaplane off Coral Cliff Beach.

Tow Boat – is the wreck of a small tug boat that lies in 17ft (5m) of reef protected water in Caracas Bay, which makes it ideal for inexperienced divers and snorkellers.

Wata Mula – is the northern most dive spot on the island and offers very rugged submarine terrain for experienced divers. The rock crevices are home to large numbers of moray eels, and there is an underwater cave that can be explored.

There are more than 100 dive sites around Curaçao

Arawak Art Gallery

Cruise terminal
Open: from Monday to Saturday
between 8.30am and 5.30pm and on
Sunday when a cruise ship is docked
☎ 4627249

Kas di Alma Blou

Cruise terminal
Open: from Monday to Saturday
from 9am to 12.30pm and 2pm to
5.30pm
☎ 4628896

Four Alleys

Rifwaterstraat
Open: Monday to Friday from 9am to
5pm and admission is free
☎ 4628702

Postal Museum

Kuiperstraat
Open: from Monday to Friday from
9am to 5pm and from 10am to 3pm
on Saturday. There is a small
admission charge.
☎ 4658010

Maritime Museum

Near the Floating Market
Open: daily from 10am to 5pm
☎ 4652327

Jewish Cultural Historical Museum

Columbusstraat
Visitors are welcome to tour the
synagogue and museum. Men and
boys are requested to wear a head
covering when inside the synagogue
and kippot (skullcaps) are provided
for this purpose. There is a small
entrance fee to help pay for upkeep.
Open: weekdays from 9am to
11.45am and from 2.30 to 4.45pm.
☎ 4611633

Tele Museum

Wilhelminaplein
Open: from Monday to Friday
between 9am and noon and 1.30pm
and 5pm.
Admission is free.
☎ 4652844

Curaçao Botanical Gardens and Zoo

Admission is free
☎ 7378500

Curaçao Museum

Van Leeuwenhoekstraat in western
Otrabanda
Open: Monday to Friday from 9am to
noon and 2 to 5pm, and Sunday from
10am to 4pm. There is a small
admission charge.
☎ 4623873.

Senior Curaçao Liqueur Factory

Open for tours weekdays from 8am
and noon and 1 to 5pm.

Amstel Brewery

Rijkseenheid Boulevard.
There are tours at 10am on Tuesday
and Thursday.
☎ 4612944

Curaçao Sea Aquarium

Open: daily from 8.30am to 5.30pm.
☎ 4616666

Curaçao Ostrich and Game Farm

Groot St. Joris
Open: by appointment every day
from 8am to 5pm.
There is an admission charge.
☎ 7472777

Den Paradera

Seru Grandi Kavel, Band'ariba.
Visit is by appointment only and
there is a small admission charge.
☎ 7675608.

Landhuis Brievengat

Cultural center open daily from
9.30am to 12.15pm and 3 to 6pm.
Museum open from Monday to
Friday between 9.15am and 12.15pm
and 3pm and 6pm.
There is a small admission charge.
☎ 7378344

Landhuis Jan Kock

Near Sint Willibrordus
Open: for tours on weekdays by
reservation only and on Sunday from
11am to 8pm. There are guided tours
by appointment
☎ 7648087

Landhuis Groot Sta. Martha

Open: on Friday from 8am to 4pm.
☎ 8641950

Landhuis Knip (Kenepa)

Guided tours are available.
Open: Monday to Sunday from 9am
to 4pm. There is a small admission
charge.
☎ 8640244.

Shete Baka Park

Open: daily from 8.30am to 5pm.
A small admission charge is made to
reach the cave, payable to the park
warden on duty on the approach
road.
☎ 8640363

Christoffel National Park

Deer watching is available year
round and sessions are usually held
between 4pm and 6.30pm when
guides lead small groups (maximum
of 8) on a ten-minute walk to the
observation tower. If you want to go
on one of these tours, you must book
in advance (☎ 8640363).
Park open: Monday to Saturday from
8am to 5pm and on Sunday from
6am to 3pm.

Savonet Natural History Museum

In the old warehouses of the
landhuis close to Christoffel Park
entrance
Open from Monday to Saturday
between 8am and 4pm and on
Sunday from 8am to 3pm. Admission
is included with park admission.
☎ 8640363.

Kas di Pal'i Maishi

On Dokterstuin.
Open: Tuesday to Friday from 9am to
4pm, weekends from 9am to 5pm.
There is a small admission charge.
☎ 8642742

Landhuis Papaja

Open: weekdays from 10am to 6pm
and at weekends from 10am to 9pm.
There is a barbecue and live music
every Sunday.
☎ 8695850

Hato Caves

Open: daily between 10am and 6pm
with the last tour leaving at 5pm.
There is an admission charge.
☎ 8680379

Three street scenes

• CURAÇAO •

$$ Awa di Playa

Piscadera Bay
☎ 4626939
An open-air restaurant on a narrow inlet of the bay specializing in truly traditional island fare with great value fresh fried fish and steaming bowls of seafood soup, the ingredients of which are supplied by the fishing boats moored along the small pier. Every Sunday there is a fishermen's party. It is open daily from noon to 7.30pm.

$$$ Belle Terrace

Avila Beach Hotel
☎ 4614377
Elegant waterside candlelit dining with local and international cuisine plus theme nights. It is open nightly from 7pm to 10pm.

$$-$$$ Bistro Le Clochard

Riffort, Otrabanda
☎ 4625666
Elegant dining in the old fort with great views across the bay to the Waterfort Arches and the delightful buildings along Punda's waterfront. The restaurant in its historical setting offers French and Swiss cuisine. It is open for lunch and candlelit dining from Monday to Friday and on Saturday for dinner only. Reservations recommended.

$-$$ Blues

Avila Beach Hotel
☎ 461377
Café and seafood specialties.

$-$$ Cactus Club

Van Staverenweg 6
☎ 7371600
Very popular and offering good Tex-Mex food in stylish surroundings, plus burgers and steaks.

$$ Calypso

Curaçao Sheraton
☎ 4625000
Local specialties

$$ Chinatown

Jan Noorduynweg
☎ 8694888
Chinese.

$$-$$$ The Cliff House

Kadushi Cliffs, Westpunt
☎ 8640200
Good local cuisine in a charming setting.

$$-$$$ The Cockpit

Hotel Holland and Casino
F. D. Rooseltweg Boulevard
☎ 8688044
An international menu and the biggest salad bar on the island.

$$ De Taverne

Groot Davelaar
☎ 7370669
A great setting surrounded by antiques and great food. The menu changes regularly and features the finest international cuisine for lunch and dinner and late snacks. It is closed in Sunday.

$$ Downtown Restaurant

Gomezplein, Punda
☎ 4616722
Open air terrace dining for late breakfast, lunch and early dinner. Good seafood specials.

$$ El Entablao

Indjuweg 47
☎ 4614855
Chilean specialties.

$$ El Marinero

Schottegateweg Noord
☎ 7379833
Seafood.

$$-$$$ Emerald Bar and Grill

Marriott Hotel and Emerald Casino, Piscadera Bay
☎ 7368800
Creative and traditional cuisine in an elegant club-like setting, with unique appetizers, steak and seafood specialties, and made to order desserts and soufflés.

$$ Fisherman's Wharf

Martin Luther King Boulevard
☎ 4657558
Seafood specialties.

$$$ Fort Nassau

Fort Nassau
☎ 4613450
Spectacular panoramic views to match the great food, impeccable service and impressive wine list. The menu is very much New World incorporating wonderful fish and seafood with island fruits and vegetables. Open for lunch Monday to Friday from noon to 2pm, and dinner nightly from 6.30 to 1am.

$$-$$$ Four Alleys

Rifwaterstraat 2-4, Otrabanda
☎ 4628702
Mind your head as you enter the downstairs restaurant that has a wonderful old world feel. It offers drinks, snacks and island specialties while upstairs there is a small museum featuring antique furniture and small artifacts.

$$ Green Mill

Saliña Galleries, Willemstad
☎ 4658821
Good value dishes from around the world from pizzas and pastas, steaks to fajitas and tandoori to Oriental dishes.

$$ Harbour View

Hotel Otrabanda
☎ 4627400
Eat in or outside on the terrace overlooking the water. Creole and international dishes are offered.

$$ Hard Rock

Keukenplein, Punda
☎ 4656633
A very lively haunt offering snacks, fish, seafood and steaks.

$$ Ho Wah

Satumusstraat 93
☎ 4615745
Chinese cuisine.

$$ Jaanchie's

West Point
☎ 8640126
Good value local dishes.

$$ Kura Hulanda

Klipstraat 10
☎ 4621800
Local specialties.

$$-$$$ Le Touresol

Plaza Hotel
☎ 4612500
Gourmet dining and spectacular views from the fifteenth-floor restaurant.

$$ Martha Koosje Cafe

Kleine Berg
☎ 8648235
An open air restaurant on a 160 year old estate serving Colombian and local fare with many specialties and great prices. Try the red snapper with coco, or octopus vinaigrette.

$$-$$$ Memories

Landhuise Zeelandia
☎ 4614688
An award-winning bistro with good value 4-course gourmet daily specials.

$$ Oasis

Savonet 79
☎ 4640085
Local specialties

$$ Ole Ole

Saliña Shopping Center
☎ 4617707
Seafood specialties.

$$-$$$ L'Orangerie

Princess Beach Resort and Casino
☎ 4655955
Fine international dining with a view
of the sea and an international
gourmet menu.

$$-$$$ Portofino

Sonesta Beach Hotel and Casino,
Piscadera Bay
☎ 7368800
Elegant, informal dining with good
service and authentic northern
Italian cooking including soups,
salads, pastas, fish, gourmet pizzas,
nightly specials and delicious
desserts. Try the Bruschetta
Portofino, pizza rustico or salmon
alle erbe fine. You can dine inside or
on the small patio.

$$ Promenade Caféand Restaurant

Saliña
☎ 7376784
A fun, trendy Caribbean café-
restaurant with an extensive menu.
Good value for money, and great
Sunday brunch from 11am to 3pm.

Restaurant Larousse

Penstraat
☎ 4655418
Seafood, fish and steaks, lovely home
made desserts and a good wine list.

$$ Texas Alaparia

Brievengat Shopping Complex
☎ 4616616
Great value and great tasting char-
grilled baby back ribs, chickens,
fajitas and more. Try the mixed
platter.

$$-$$$ Zambezi

Juan Louise
☎ 7472777
Gourmet dining.

NIGHTLIFE

Nightlife starts early with Happy
Hour which often lasts longer than
60 minutes, and then there is a huge
choice of nightlife from casinos to
discos, intimate romantic restau-
rants to resort hotels and their
singing, dancing folklore shows. You
can even go bowling, play pool or
take in a local softball game.
Lively spots include Landhuis
Brievengat with its live music and
dancing under the stars, Baya Beach
Club, Landhuise Chobolobo, Living
Room, Studio 99 and Club Façade.

5

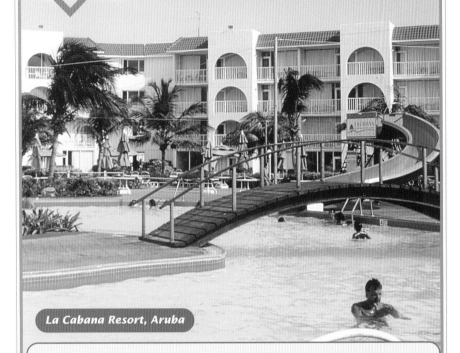

La Cabana Resort, Aruba

SECTION 1 ACCOMMODATION

The islands have a wide range of accommodation to suit all tastes and pockets, from the five star all-inclusive resorts to inns, and modest but friendly, family-run guesthouses, self-catering apartments and beach cottages.

All-inclusive resorts are just that, the price covers everything including drinks and all facilities. The service is first class and prices reflect this.

If you want to eat out and explore quite a lot, it may pay to stay in a hotel offering part board, or one of the many inns on the island, some of them converted plantation homes, and generally offering excellent value for money. There are also apartments, holiday villas and beach cottages available for rent offering you the privacy of your own accommodation and the flexibility to eat in or out.

Prices guide – prices are winter rates for single occupancy and are exclusive of the 10% Hotel Room Tax. Summer rates are usually lower. $ represents inexpensive accommodation, $$ moderate, and $$$ deluxe.

ARUBA

$$-$$$ Allegro Aruba Beach Resort and Casino

J E Irausquin Boulevard 83
☎ 864500 and 1-800-203-4475
A luxury 421-room resort with casino, 3 restaurants, showroom with live entertainment, spacious beach, free form swimming pool with swim up bar and jacuzzi, tennis, watersports, shopping arcade, meeting and banqueting facilities.

$$-$$$ Amsterdam Manor Beach Resort

J E Irausquin Boulevard 252
☎ 871492 and 1-800-766-6016
A Dutch style all suite resort with 72 one- and two-bedroom units with kitchenettes or full kitchens, across the street from Eagle Beach with restaurant, bar and pool and mini market.

$$-$$$ Aruba Beach Club

J E Irausquin Boulevard 53
☎ 823000/827000 and 1-800-346-7084
A family oriented beachfront property with 131 suites with kitchen facilities, with restaurants, pools, shops, mini-market, adults and children's activities schedules and casino across from the resort.

$$-$$$ Aruba Grand Resort and Casino

J E Irausquin Boulevard 79
☎ 863900 and 1-800-345-2782
On beautiful Palm Beach and set in tropical gardens, the resort has 200 large rooms with a choice of restaurants and bars, casino, watersports, activity schedule, nightly entertainment, tennis and meeting facilities.

$$$ Aruba Marriott Resort and Stellaris Casino

L G Smith Boulevard
☎ 869000
A large, luxury beachside resort with 413 rooms with large balconies, casual and formal dining, free form swimming pool with swim up bar, spectacular beach, casino, health spa, watersports, golf, meeting and banqueting facilities.

$$$ Aruba Phoenix Beachfront Resort

J E Irausquin Boulevard 75
☎ 861170
Luxury beachside property with 101 oceanfront studios and apartments, waterside bistro, French market and deli, pools, jacuzzi, fitness center and watersports.

$$-$$$ Aruba Sonesta Resort and Casino

Seaport Village
L G Smith Boulevard 9
☎ 836000 and 1-800-SONESTA
A lovely resort set in 40 acres (16 hectares) of tropical gardens with 300 rooms, 2 restaurants, bars, 6 beaches, watersports, tennis, fitness center, beach bar, nightclub, casino, more than 70 shops, entertainment, meeting and banquet facilities.

$$-$$$ Aruba Sonesta Suites and Casino

Seaport Village
L G Smith Boulevard
☎ 836000 and 1-800-SONESTA
A 250 all suite hotel on the beach with restaurant, pools and swim up bar, waterfront casino and 50 unique shops and boutiques.

$$-$$$ Best Western Manchebo Beach Resort

J E Irausquin Boulevard 55
☎ 823444 and 1-800-528-1234

The newly-renovated property has 71 large rooms with patio or balcony overlooking tropical gardens and the stunning white sand beach with 3 restaurants, bars, pool, live music and dancing, theme nights, watersports and dive shop.

$$ Best Western Talk of the Town Resort

L G Smith Boulevard 2
☎ 823380 and 1-800-223-1108
There are 63 comfortable rooms around a palm fringed courtyard with 2 pools and 3 jacuzzis, with fine dining restaurant and open air Moonlight Grill, private Surfside Beach Club and watersports center.

$$-$$$ Bucuti Beach Resort

J E Irausquin Boulevard 55B
☎ 831100 and 1-800-223-1108
The resort has 63 large rooms with a choice of restaurants, bars, shops and nearby casino.

$$-$$$ Bushiri Beach Resort

L G Smith Boulevard 35
☎ 825216 and 1-800-GO-BOUNTY
This recently-renovated luxury resort has 155 oceanfront rooms on a huge, secluded beach with 2 restaurants, 3 bars, pool, hot tubs and fitness center, sports activities and entertainments with Camp Bounty for kids.

$$-$$$ Caribbean Palm Village Resort

Noord 43E
☎ 862700 and 1-800-992-2015
A very elegant property with 170 luxury rooms and one- and two-bedroom suites with kitchen, set in lush tropical gardens, with gourmet restaurant, pools, pool bar, jacuzzi, tennis, and beach club.

$$$ Costa Linda Beach Resort

J E Irausquin Boulevard 59
☎ 838000 and 1-800-992-2015
A luxury resort with 155 spacious two- and three-bedroom suites with full kitchen and ocean view balconies and roman tubs. The resort has a choice of restaurants and bars, nightclub, tropical pool, whirlpool spas, children's pool, tennis, fitness center and nearby casino.

$$$ Divi Aruba Beach Resort

J E Irausquin Boulevard 45
☎ 823300 and 1-800-554-2008
Set in lush surroundings, the resort has 203 rooms beside the stunning beach, with restaurants, bars, nightly entertainment, 2 pools, tennis, complete watersports, Alhambra Casino and Shopping Bazaar.

$$-$$$ Divi Village

J E Irausquin Boulevard 47
☎ 835000 and 1-800-367-3484
The attractive resort is set in tropical gardens around the large pool with 132 elegant apartments, restaurant and bar.

$$ Dutch Village

J E Irausquin Boulevard 47
☎ 824150 and 1-800-367-3484
Each of the 97 townhouse apartments has its own jacuzzi, with pools, tennis, shops, restaurant, bar and beach.

$$-$$$ Holiday Inn Aruba Beach Resort and Casino

J E Irausquin Boulevard 230
☎ 863600
A large, tropical beachfront resort with 600 rooms with restaurants,

bars, pools, tennis, watersports, fitness center, sauna and massage, casino, shopping arcade and children's games room.

$$$ Hyatt Regency Aruba Resort and Casino

J E Irausquin Boulevard 85
☎ 861234 and 1-800-233-1234
There are 360 luxury rooms, 4 restaurants and 2 lounges, multi-level pool complex with whirlpool, watersports, and Red Sail sports, health and fitness facility, tennis and golf, Casino Copabana, meeting and banqueting facilities.

$$-$$$ La Cabana All-Suite Beach Resort and Casino

J E Irausquin Boulevard 250
☎ 879000 and 1-800-835-7193
803 luxury suites with whirlpool and kitchenette, and private balcony or patio, with casual and formal dining, pools, watersports, theme nights, fitness and rackets center, floodlit tennis, Royal Cabana Casino, indoor and outdoor meeting facilities, shopping arcade, beauty care center, with daily activities schedule, tours and supervised children's schedule.

$$-$$$ La Quinta Beach Resort

J E Irausquin Boulevard
☎ 875010 and 1-800-223-9815
A very laid back resort with 54 luxury apartments, 2 pools, night-club, mini market, tennis and watersports nearby.

$$$ Marriott's Aruba Ocean Club Resort

L G Smith Boulevard 99
☎ 869000
Located next to the Aruba Marriott Resort, the Ocean Club features 311 rooms in one- and two-bedroom

villas set in tropical gardens, with restaurant, bar, pools, spa, sauna, fitness center, tennis and watersports.

$$-$$$ The Mill Resort

J E Irausquin Boulevard 330
☎ 867700
There are 71 units, with tennis, beach shuttle, exercise room and sauna, mini market, pools, breakfast and lunch facilities and pool bar.

$$$ Playa Linda Beach Resort

J E Irausquin Boulevard 87
☎ 861000 and 1-800-223-6510
The glamorous resort has 194 luxury suites each with their own terrace, plus tropical restaurant, pool with waterfall and jacuzzi, mini market, fitness center, tennis, beach bars, and shopping arcade.

$$$ Radisson Aruba Caribbean Resort and Casino

J E Irausquin Boulevard 81
☎ 866555 and 1-800-333-3333
This large beachside resort has 386 rooms with balconies or patios, large pool area, 6 bars and restaurants, theme dinners, casino, watersports, tennis, shopping arcade, health and fitness center, meeting and banquet facilities.

$$-$$$ Stauffer Hotel Aruba

J E Irausquin Boulevard 370
☎ 860855
Close to the beach with 100 rooms, watersports, casino, restaurants and nightclubs.

$$$ Tamarijn Aruba Beach Resort

J E Irausquin Boulevard 41
☎ 823300 and 1-800-554-2008

An all-inclusive, waterfront resort with 236 rooms with private balcony or terrace. There are five restaurants and 4 bars, beach, pool, tennis, windsurfing and watersports center, nightly entertainment, shops and nearby casino.

$$$ Wyndham Aruba Beach Resort and Casino

J E Irausquin Boulevard 77
☎ 864466 and 1-800-HILTONS
A 444-room luxury high rise resort with 3 restaurants, pool, beach bar, night club, casino, large free form pool and spacious beach, shopping arcade, fitness center and large meeting and banqueting facilities.

BONAIRE

$$-$$$ Bel-Air Ocean-front Apartments

PO Box 333
☎ 6130
12 luxury, fully furnished, two-bedroom, two-bathroom apartments on the waterfront in a delightful residential area, with private terrace overlooking the Caribbean. Bike rental and babysitting available

$$ Bonaire Sunset Villas

PO Box 115
☎ 8291
A choice of fully furnished, fully equipped one-bedroom efficiencies, studios and two- and three-bedroom villas, most on the waterfront in or near Kralendijk. Bike rental and baby sitting available

$$-$$$ Buddy Beach and Dive Resort

PO Box 231
☎ 5080
Located just north of Kralendjik with 40-luxury studio, one- and three-bedroom, fully equipped waterfront apartments. The resort has a PADI five star training facility and also offers NAUI and CMAS certification. There are special 8-day dive packages, boat dive packages and car rental

$$$ Captain Don's Habitat

PO Box 88
☎ 8290
Oceanfront rooms, villas and cottages, some with rooftop solaria. The resort features the Rumrunners Restaurant, Kunuku Terrace Bar, pool, Habitat Dive Center and shop. Five and eight day dive packages are available

$-$$ Carib Inn

PO Box 68
☎ 8819
Very much a dive resort with 9 lovely oceanfront apartments and daily maid service, with freshwater pool and full scuba facilities including sales and instruction

$$$ Caribbean Court

J.A. Abraham Boulevard
☎ 5353
21 oceanfront one-, two- and three-room spacious apartments with pool, watersports and scuba.

$$$ Club Nautico Bonaire

Kaya Jan N.E. Cranne 24, Kralendijk
☎ 5800
On the waterfront promenade in the center of town with 5 star colonial-style luxury suites and penthouses and a yacht club atmosphere, plus ocean-view bar and terrace, dining, freeform pool and large sundeck, private marina, watersports, boating, deep sea fishing, diving, snorkelling and water skiing with lessons

$$ Diversion Bonaire

PO Box 333
☎ 6130
There are 7 modern, fully furnished
one-bedroom, one-bathroom
apartments in the residential area of
Hato, with bike rental and baby
sitting available

$$ Divi Flamingo Beach Resort and Casino

J.A. Abraham Boulevard
☎ 8285
On the beach and overlooking
Calabas Reef with 145 rooms and
studio apartments, two freshwater
pools, jacuzzi, tennis, the Chibi
Chibi restaurant on stilts over the
water, Calabas Terrace restaurant
and bar, Flamingo Casino and pool
bar, entertainment and Club
Flamingo timeshare/studio apart-
ments. It is the home of Peter Huges
Dive Bonaire and Photo Bonaire, and
has gift shop. Dive packages are
available

$$ Eden Beach Resort

Kaya Gob
☎ 6720
38 units with pool, beach and
watersports.

$$$ Harbour Village Beach Resort

Kaya Governador N. Debrot
☎ 7500
Across from Klein Bonaire on a
private beach and nestled in a lush
tropical setting with full service
marina and European spa. There are
70 spacious rooms and suites with
large patios or terraces, plus two
restaurants and bars, pool, Great
Adventures Bonaire dive shop,
watersports, tennis, meeting and
banqueting facilities

$$ Kaya Amsterdam

Kaya Amsterday 23, near Harbour
Village Marina
☎ 8143
19 spacious apartments and studios
close to beach, shops and restaurant.

$$ Lac Bay Resort

PO Box 261
☎ 5706
Tucked away on the south east coast
near the sandy beaches of Sorobon
and Lac Bay, the complex has studios
and one- and two-bedroom apart-
ments each with patio or balcony.
There is a restaurant and bar, and
windsurfing and other packages are
available

$$$ Lions Dive Hotel

Kaya Gob
☎ 5580
An all-suite beachside resort with 31
one- and two-bedroom units with
private balcony or patio. There is an
open air waterside restaurant and
bar, freshwater pool and sun deck,
with Neil Watson's Undersea
Adventures offering a full service
dive facility

$$$ Port Bonaire Resort

PO Box 269
☎ 2500
On the waterfront and featuring 23
one- and two-bedroom apartments
with fully fitted kitchens, balconies
and patios with ocean view, plus pool
and sundeck, pier and snorkelling
trail, and enjoying all the facilities of
the Plaza Resort Bonaire of which it
is now part. It offers diving and
honeymoon packages.

$$$ Plaza Resort Bonaire

Abraham Boulevard 80
☎ 2500
A luxury, five star resort on a
beautiful sandy beach five minutes

from Kralendijk, with 224 spacious suites and one- and two-bedroom villas overlooking the beach or lagoon. There is a dive shop, a wide range of watersports activities, 3 restaurants and bars, tennis, squash, basketball, jogging and exercise classes, shops, mini market, and rental center, and several schedules for children. Dive and honeymoon packages are available

$$-$$$ Sand Dollar Beach Club

PO Box 262
☎ 8738
Luxury, ocean view studio, and one-, two- and three-bedroom apartments and townhouses. Facilities include Sand Dollar Dive and Photo, a full service dive and photo operation right on the water and close to Bari Reef, and the waterside Green Parrot Restaurant. There is also tennis, freshwater pool, pool bar, grocery store, ice cream parlor, sailing, sport fishing and gift shop. Dive packages and babysitting are available.

$$$ Sorobon Beach Resort

☎ 8080
Thirty luxury bedroom ocean view chalets

$$ Sun 'N Sand Villas

Kaya Industria 17
☎ 4550
Six well furnished apartments away from the main tourist area with private garden in a quiet and traditional neighborhood

$$ Sunset Beach Hotel

PO Box 333
☎ 8291
A 145-room hotel on Bonaire's finest beach with casual dining at the Beach Hut or Sunset Terrace, plus

pool, whirlpool and spas, dive center, watersports, indoor and outdoor games, floodlit tennis, theme nights. Dive packages, car rental and sightseeing tours available

$-$$ Sunset Inn

PO Box 115
☎ 8291
An intimate and friendly 7-room (5 rooms and 2 suites) inn within walking distance of the town and next to the Dive Inn dive center. It is available for block bookings by parties of 14. There is a small beach across the street. Dive packages, bike rental and babysitting are available

$$-$$$ Sunset Ocean-front Apartments

PO Box 115
☎ 8291
A complex of 12 one- and two-bedroom apartments within the city limits, and close to restaurants and shops, with freshwater pool and sun deck. Bike rentals and babysitting available

The following offer good value villa, bungalow, apartment or guest room accommodation: Aqua Viva Apartments ☎ 5845, Avanti Bungalows ☎ 8405, Baranka Villas ☎ 2200, Bernabela Apartments ☎ 5158, Black Durgon Inn ☎ 5736, Bonaire Beach Bungalows ☎ 8581, Bonaire Caribbean Club ☎ 7901, Carabella Apartments ☎ 8065, Club Lamon Caribe ☎ 6840, Cyndany Lodge ☎ 7075, Fishing Pier Village ☎ 6284, Gain Luxury Apartments ☎ 8514, The Great Escape ☎ 7488, Happy Holiday Homes ☎ 8405, Ibi's Apartments ☎ 8346, Leeward Inn ☎ 5516, Marina Oceanfront Bungalow ☎ 8405, Meralney Vacation Village ☎ 6873, Palm Studio Apartments ☎ 5862, Raigellis Vacation

Apartment ☎ 8582, Rose Inn ☎ 6420, The Blue Iguana ☎ 6855, The Sitting Coconut Apartments ☎ 7620, Sun Rentals ☎ 6130, Turquoise Paradise ☎ 5550, and Villa Pamboe and Apartments ☎ 4260.

CURAÇAO

$$ Avila Beach Hotel

Outskirts of Willemstad
☎ 4614377 and 1-800-CURAÇAO
Situated on a private beach, this small charming hotel was built in the 1880s as the country house of the island's governor. The addition of two wings – La Belle Alliance and the Western Pier – has more than doubled the number of rooms to 100. There is an open-air restaurant and bar overlooking the beach, and the hotel is tastefully decorated with antiques.

$$$ Blue Bay Curaçao Golf and Beach Resort

Landhuis Blauw
☎ 8681755
One of the island's newest resorts with 10 luxury units open and more under construction. It is also the home of Curaçao's only 18-hole golf course. Rocky Roquemore designed the championship course. The resort has restaurant, bar, clubhouse, tennis and golf.

$$ Bulado Inn

In the fishing village of St. Michaels
☎ 8695731
17 suites, restaurant, pool and dive center.

$$$ Chogogo Resort

Jan Thiel Beach
☎ 7472844
A luxury resort with 60 rooms in bungalows and apartments set in tropical gardens, with pool and watersports.

$$ Club Seru Coral

In the hills close to Santa Barbara
☎ 4678276
An intimate, friendly hotel and ideal for those lovers of the cunucu, set in hills behind the scenic seaside area of Santa Barbara and a short ride from the beach. Individual cottages cluster around an attractive terrace with an informal restaurant and the island's largest freshwater swimming pool.

$$$ Curaçao Marriott Beach Hotel and Emerald Casino

Next to the International Trade Center
☎ 7368800
The 248-room, five star hotel opened in 1992 has its own private beach and is set in lovely gardens. Facilities include 3 restaurants - Portofino with fine Italian cuisine, club-like Emerald Bar and Grill and Palm Café – freeform pool with swim up bar, wading pool, two large whirlpools, casino, floodlit tennis, health club and fitness center, massage, watersports, daily activity schedule, children's club, shopping arcade, ballroom, and meeting and conference rooms and honeymoon packages.

$$-$$$ Habitat Curaçao

Coral Estate, Rif St Marie
☎ 8648800
This is a sister property to Bonaire's well known dive hotel Captain Don's Habitat. The 56 room (all oceanfront deluxe junior suites) and 20-cottage dive hotel is 20 minutes to the west of Willemstad, and has pool, multiterraced bar and restaurant, fitness center and spa. There is a state of the art PADI certified dive center and 24 hour unlimited shore diving, plus boutique, convenience store and photo shop.

$$-$$$ Holiday Beach Hotel and Casino

Close to Willemstad
☎ 4625400
Recently completely renovated, all 200 rooms have private balcony overlooking the water. There is a new beach bar and restaurant and facilities include private beach with safe swimming, pool, floodlit tennis, playground, shops, casino and boutiques, and complete watersports center.

$$ Hotel Holland and Casino

Close to Hato International Airport
☎ 7688044
This friendly, family run 45-room hotel combines the best of the island's Dutch atmosphere with the convenience of an airport hotel and sea views. Facilities include the Cockpit Bar and Restaurant, intimate casino, pool with terrace and dive shop. There is a free shuttle to Willemstad and guests have free admission to the nearby Hato Caves.

$$$ Hotel Kura Hulanda

De Rouvilkweg 47
☎ 4627878
New 150-room property with restaurant, pool and shops.
Howard John Plaza
Otrabanda
A luxury 90-room property is currently under construction.

$$$ Kadushi Cliffs $$$

Playa Kalki
☎ 8640200
This all-villa luxury resort sits on the cliff overlooking beautiful Playa Kalki, a small sandy cove. Each of the 22 two-floor villas has all facilities including kitchen, sundeck, terrace and jacuzzi, and there is an open air restaurant, pool and dive shop.

$$ Landhuis Daniel and Dive Center

☎ 8648400
Conveniently located in the middle of the island with 10 comfortable but unpretentious guest rooms, seafood restaurant and a recently opened dive shop.

$$$ Lions Dive Hotel and Marina

Next to the Seaquarium Complex
☎ 4618100
Billed as the 'complete dive resort', this friendly hotel is on the island's largest white sand beach and features a range of diving programs supervised by the professionally trained staff of Underwater Curaçao. There are 72 rooms with private balcony or terrace and ocean views, and facilities include 3 restaurants, shops, freshwater pool, beach, and watersports, including a professional wind surfing school.

$$-$$$ Otrabanda Hotel and Casino

Otrabanda
☎ 4627400
This 45-room hotel is in historic Otrabanda with views of passing cruise ships and Dutch gables architecture across the bay in Punda. Large picture windows have been installed in the guest rooms for even better views. The hotel has open-air restaurant and bar, coffee shop and casino. It is close to the heart of Willemstad and its business, sightseeing, shopping, dining and nightlife areas.

$$ Plaza Hotel and Casino

Willemstad
☎ 4612500
This 254 room high rise hotel rises from within the walls of the 150-

year-old fort overlooking Willemstad Harbour, and is very close to downtown. Facilities include pool, beach access and a variety of restaurants, casino and nightclub featuring nightly entertainment. There are meeting and conference facilities.

$$ Porto Paseo Hotel

Otrabanda
☎ 4627878
A new hotel perched on the water-front overlooking the red roofed buildings of Punda across the bay. The complex is built around a restored seventeenth-century mansion and has 47 rooms, a two-floor casino, dive center, pool and pool bar, all laid out in gardened courtyards connected by charming lamp lit walkways.

$$$ Princess Beach Hotel and Casino

Dr Martin Luther King Boulevard close to the Seaquarium
☎ 7367888
This recently renovated low-rise hotel has two new ocean view wings with 341 rooms, all with balconies. Facilities include two restaurants, theme nights, pool and pool bar, boutiques, a new Peter Hughes full service dive shop, watersports, tennis, daily activities schedule, tropical gardens, casino and meeting and conference rooms.

$$ San Marco

Columbusstraat 7
☎ 4612402
An 84-room downtown hotel with casino and close to all amenities.

$$$ Sheraton Curaçao Resort and Casino

Piscadera Bay
☎ 4625000
The 197 large rooms and suites have private balconies overlooking the Caribbean Sea and Piscadera Bay. Facilities at this self contained resort include four restaurants, private beach, pool, tennis, daily activity schedule, complete watersports center, dive shop, boutiques, casino, nightclub, beauty salon, meeting and convention facilities. The resort is across from the International Trade Center and five minutes from Willemstad.

$$ Sunset Waters Beach All Inclusive Resort and Casino

Santa Marta Bay
☎ 8641610
The resort is on Santa Marta Bay and offers secluded tranquility on a 600ft (183m) long stretch of spectacular beach with a backdrop of mountains and cliffs. There are 120 rooms and suites overlooking the sea, the open-air restaurant, bar and pool. Facilities include tennis, water sports and casino.

$$ Trupial Inn and Casino

☎ 7378200
An informal inn in a tropical setting with 74 recently renovated and redecorated bungalow-style rooms, pool and poolside bar, tennis, sauna and Sombrero Restaurant.

SECTION 2 – SPORT

For the visitor, there is a huge range of sporting opportunities from swimming and scuba diving, to horseback riding and hiking, to golf and tennis. Most hotels offer a variety of sports and water activities, and there are diving schools where you can learn what it is all about and progress to advanced level if you have the time.

SPORTS FACILITIES

BOWLING

Aruba

The Eagle Bowling Palace at Pos Abou, just east of Oranjestad, is open from 10am to 2am. ☎ 835038.

Curaçao

Curaçao Bowling Club, Chuchubiweg ☎ 4379275.

FITNESS GYMS/ EXERCISE CENTERS

Many of the resort hotels have fitness centers, gyms and spas.

Aruba

Body Frictionb, L G Smith Boulevard ☎ 824642, Natural Health Center, Helfrichstraat ☎ 842010, SOS Fitness Center, G G Croes ☎ 832555.

Bonaire

Joe's Health Bar, Les Galleries Shopping Mall ☎ 2842, and Sportschool Body Work, Kaya Nikiboko, Noord ☎ 4184.

Curaçao

Candido Daal Fitness Center, Amandelweg ☎ 4618153, Hans Alaart Fitness and Physical Therapy Center, Begoniaweg, Santa Rose ☎ 7378879; Sundance Health and Fitness Center, Riftwater ☎ 4462774; Ooms Sports Institute, Lions Dive Hotel ☎ 4657969.

GOLF

Aruba

The Aruba Golf Course is one of the most unusual in the Caribbean with oiled sand greens and occasional goats as live hazards. The Tierra del Sol is the island's first championship course, an 18-hole, par 71, Robert Jones Trent designed course overlooking the Caribbean. ☎ 860978.

Curaçao

There is a 9-hole course at the Curaçao Golf and Squash Club that offers a challenge to putters as the greens are like no other anywhere in the world. Because of the shortage of water on the island, the course's greens are actually made of tightly packed sand, although the tees and fairways, which require less watering, are made up of drought resistant grasses. The club is open daily from 8am and there is a fully stocked pro shop. The Blue Bay Golf Club, Blauwbaai, is the island's only 18-hole golf course. The championship course was designed by Rocky Roquemore. ☎ 8681755.

HIKING AND CYCLING

Walking and cycling are great fun and there are lots of trails especially in the national parks. On all the islands it is possible to hire a guide through the tourist office and this ensures you get the most out of your trip and don't get

lost. If planning to walk, have good stout, non-slip footwear a hat and a waterproof, and remember to drink lots of water to compensate for the heat. Protect yourself against insects, carry adequate drinking water and keep an eye on the time, because night falls quickly and you don't want to be caught out on the trail after dark.

HORSEBACK RIDING

The following offer horse back riding:

Aruba

Rancho Daimari ☎ 860239; Rancho Del Campo, Sombre ☎ 850290, and Rancho El Paso, Washington 44 ☎ 873310.

Bonaire

Kunuku Warahama ☎ 5558;

Curaçao

Ashari's Ranch ☎ 8690315 and Ranch Alegre ☎ 8681181.

KAYAKING

Bonaire

Jibe City Kayaking ☎ 5233, Bonaire Boating ☎ 5353, Buddy Dive ☎ 5080, Discover Bonaire ☎ 8738, Plaza Resort ☎2500, and Sand Dollar Dive ☎ 5252.

MOUNTAIN BIKING

Bonaire

Cycle Bonaire ☎ 7558

SAILING

The calm waters are ideal for sailing and if you have never sailed before you can take lessons and then rent your own sunfish or mini-fish. There are also opportunities to sail on trimarans, catamarans and ketches.

There is a land sailing center on Aruba near Eagle Beach.

SAILCARTING

This fast paced sport combines sailing and carting. Aruba Sailcart, Bushiri 23, ☎835133.

SCUBA

There are scores of excellent dive sites to explore and enjoy with Bonaire the least discovered, yet offering the most spectacular. The clear, warm waters certainly offer world-class diving with underwater visibility often more than 100ft (30m), and average water temperature is around 75°F (24°C). There is a wide selection of dive sites from easy ones suitable for novices to hard ones for the most experienced. If you have never dived before you can take a resort certification course, and then head out for the fabulous reefs. There are reef dives, wall dives, ship wrecks, including the largest wreck in the Caribbean off Aruba, and teeming marine life to enjoy.

Dive Operators

Aruba

Scuba
Aruba Pro Dive ☎ 825520; Aruba Scuba Center ☎ 825216; Dax Divers ☎ 836000; Dive Aruba ☎ 827337; Native Divers ☎ 864763 ;Pelican Watersports ☎ 831228; Rainbow Runner ☎ 831689; Red Sail Sports ☎ 861603; Sea Fly & Drive ☎ 838759; Scuba Aruba ☎ 834142; Sea Star ☎ 845058

Snorkelling operators
Aruba Marine Services ☎ 839091; De Palm Tours ☎ 824545; Mi Dushi ☎ 823513; Pelican Watersports ☎ 831228; Red Sail Sports ☎ 861603; Red Sail Sports ☎ 861603; Wave Dancer ☎ 825520

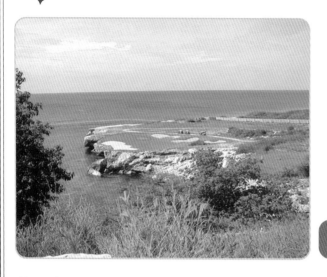

Blue Bay Golf club, Curaçao

Bonaire

Black Durgon Dive Center ☎ 8978; Blue Divers ☎ 6860; Bon Bini Divers ☎ 5425; Bruce Bowker's Carib Inn ☎ 8819; Buddy Beach and Dive Resort ☎ 5080; Cpt. Don's Habitat ☎ 8290; Dive Bonaire, Divi Flamingo ☎ 8285; Dive Inn ☎ 8761; Great Adventures Bonaire, Harbour Village Beach Resort ☎ 7500; Green Submarine ☎ 2929; Photo Tours ☎ 5353; Sand Dollar Dive and Photo, Sand Dollar Beach Club ☎ 5433; Scuba Vision ☎2844; Sea and Discover ☎5322; Sunset Beach Dive Center ☎ 8330; Toucan Diving ☎ 2500; Touch The Sea ☎ 8529; Wanna Dive ☎ 8880

Curaçao

All West Diving ☎ 8640102; Animal Encounters ☎ 4616666; Aqua Diving ☎ 8649288; Atlantis Diving ☎ 8648288; Caribbean Sea Sports ☎ 4626933; Curaçao Seascope ☎ 4625905; Daniel Divers ☎ 8647414; Diving School Wedersfoort ☎ 8884414; Dolphin Divers ☎ 4628304; Easy Divers ☎ 8642822; Eden Roc Diving Center

☎ 4628878; Habitat Curaçao Dive Resort ☎ 8648464; Masterdive ☎ 4658154; Ocean Encounters ☎ 4655756/4618200; Princess Divers ☎ 4658991; Safe Diving ☎ 8641652; Scuba Do Dive Center ☎ 7679300; Silent Immersions ☎ 4658288; Toucan Diving ☎ 4616543

SQUASH

Bonaire

La Cabana All Suites Resort and Plaza Resort Bonaire

Curaçao

Curaçao Golf and Squash Club, Emmastad ☎ 7373590

TENNIS

Almost all the resorts and many of the hotels have their own tennis courts, often floodlit. If newly arrived on the island, book a court early in the morning or late in the afternoon when it is cooler until you acclimatize to the heat.

Aruba

The Aruba Racquet Center, Rooi Santo 21, Palm Beach, is a world-class facility. It is open from 8am to 9pm ☎ 80215.

Curaçao

Santa Cathrina Sports and Country Club has the world famous Bollittieri Salas Tennis Academy ☎ 7677028

WATER SPORTS

Surfing, windsurfing, water skiing and jet skiing are the main watersports activities. Jet skis are restricted on Aruba to designated areas. On Aruba there are beaches to suit all levels of windsurfing expertise. Beginners can start out in the shallow waters of Fisherman's Hut, while Manchebo Beach offers a slalom board area with small but choppy waves, and crack windsurfers can ride the high waves at Boca Grandi. The island now hosts the annual Aruba Hi-Winds Pro-Am World Cup in June, which attracts top competitors from around the world. Boards and rigs can be rented and expert tuition is available. The calm waters of Aruba's south-west coast are a great place for beginners to learn to water ski. Specialist operators include:

Aruba

Windsurf shops - Divi Winds ☎ 84150, Happy Surfpool ☎ 86288, Pelican Watersports Velasurf ☎ 83600, Red Sail Sports ☎ 81603, Roger's Windsurf Place ☎ 81918, Sailboard Vacations ☎ 82527 and Unique Sports of Aruba ☎ 83900. Watersports operators - De Palm Tours ☎ 84545, Pelican Watersports ☎ 81228, Red Sail Sports ☎ 81603, and Unique Sports of Aruba ☎ 83900.

Bonaire

Windsurfing Place offers rentals and tuition ☎ 2288, Jibe City ☎ 5233.

Curaçao

Red Sail Sports, Marriott Resort ☎ 7368800, and Top Watersports Curaçao, ☎ 46173453

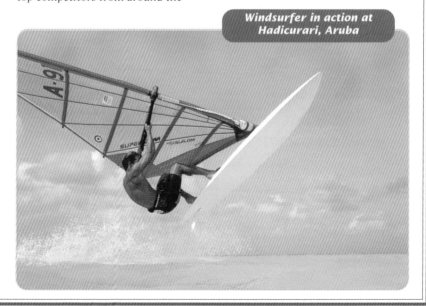

Windsurfer in action at Hadicurari, Aruba

Getting there:

BY AIR

Flying to Aruba, Bonaire and Curaçao poses no problems. Aruba and Curaçao are serviced by a number of major international airlines flying from Europe, North and South America and other parts of the Caribbean while the number of international flights to Bonaire continues to increase. Aruba's international airport is the modern Queen Beatrix International Airport, which is just outside the capital Oranjestad, and can accommodate the largest commercial aircraft including 747s. Bonaire is serviced by the Flamingo International Airport south east of the capital Kralendijk.

Aruba

From Europe – from Amsterdam, Holland, with KLM and Cologne, Germany with Air Aruba, with connecting flights to other major European gateways.

From North and South America – Aruba is serviced by Avianca (Bogota, Colombia); American Airlines (Miami, New York and San Juan, Puerto Rico); Continental (Houston), Delta (Atlanta and Toronto), KLM (San Jose, Costa Rica, Quito, Ecuador and Lima, Peru); ALM (Atlanta, Miami and Curaçao); VASP (Brazil), Avensa-Servivensa (Venezuela), SAM (Colombia), VIASA (Panama and Venezuela), and Aerorepublica (Bogota, Colombia).

Connections from Canada are with Air Canada, Royal Air, Canada 3000 and Skyservice.

There are also many charter flights from Atlanta, Boston, Chicago, Cleveland, Detroit, Hartford, Niagara-Syracuse, Philadelphia, Pittsburgh and from Canada.

Bonaire

KLM and Martinair have direct international flights to the island flying from Amsterdam with Sabelair providing services to Brussels. There are many flights from the US and Canada on American Airlines and Canada 3000 to Aruba and Curaçao with regular connections to Bonaire. ALM flies from Miami with a stop over in Curaçao, and there are several flights daily to Bonaire from both Aruba and Curaçao. It is 30 minutes flying time from Aruba and 15 minutes from Curaçao.

Curaçao

American Airlines provide daily service from Miami, connecting with incoming flights from other major US cities. Its affiliate American Eagle has services with San Juan. ALM Airlines flies from Atlanta and Miami, with connecting flights available from most major US cities on United Airlines that also flies direct from Chicago and New York. Air Aruba flies from Newark, Miami, Tampa and Baltimore/Washington, and Guyana Airways flies non-stop from New York several times a week. BWIA also flies regularly from Miami. There are also a number of charter flights.

There are regular flights from Europe with KLM flying from Schipol with connecting flights to and from most UK airports. Martin Air also

flies from Schipol, Sabelair from Brussels and TAP from Lisbon.
There are also regular scheduled services from Buenos Aires, Rio de Janeiro and Bogota.
Note: Hot weather in the Caribbean can often lead to turbulence, and if you are island hopping in small aircraft, you may experience a bumpier ride than you are used to in larger planes. Don't worry, the turbulence rarely lasts long, and the views from the air more than make up for it.

BY SEA

Several major cruise lines visit Aruba, Bonaire and Curaçao regularly, including Carnival, Clipper Line, Deutsche Sectouristik, Dolphin, Fred Olsen, Hapag Lloyd, Holland-America, Norwegian, Olympic, P&O, Princess, Regency, Royal Caribbean, Royal Cruise, Seawind and Sun Cruise.
If you want to travel the islands, the best thing to do is to visit a marina and see if any of the boats want crew or are willing to take a passenger.

ARRIVAL, ENTRY REQUIREMENTS AND CUSTOMS

For US and Canadian citizens and permanent residents proof of identity is required in the form of a passport, official birth certificate or certificate of naturalization with photo ID, or Green Card. A return or continuing ticket is also required.
For other nationals, a valid passport is required, and citizens from some countries also require a visa so check with your travel company. An immigration form has to be filled in and presented on arrival. The form requires you to say where you will be staying on the island, and if you plan to move around, put down the first hotel where you will be staying. The immigration form is in two parts, one of which is stamped and returned to you in your passport. You **must** retain this until departure when the slip is retrieved as you check in at the airport.
Having cleared immigration, you will have to go through customs, and it is quite usual to have to open your luggage for inspection. If you have expensive cameras, jewelry, etc. it is a good idea to travel with a photocopy of the receipt. If traveling on business, a covering letter may prove helpful in speeding your way through customs, especially if traveling with samples.
Visitors over the age of 18 entering the islands are allowed to bring in duty free one quart of liquor, 200 cigarettes, 50 cigars or 250 grams of tobacco.
US adult visitors returning home are allowed to take with them duty free 1 liter alcoholic beverages, 100 cigars and 200 cigarettes and $600 worth of goods and gifts. The next $1,000 worth of goods is subject to a flat rate 10% duty.
Canadain visitors are allowed to return home with 40oz of wine or liquor, 200 cigarettes and 50 cigars and up to $300 worth of goods (provided you have not claimed this benefit in the previous 12 months).

AIRLINES

Aruba

Aero Postal ☎ 839040; Airport Information ☎ 824800; ALM ☎ 838080; American Airlines ☎ 822700; Avensa ☎ 827779; Avianca ☎ 823388; KLM ☎ 823547; Viasa ☎ 836256;

Bonaire

ALM/KLM ☎ 8300/8500 (weekends);

Curaçao

ALM ☎ 4613033/612255; American Airlines ☎ 4695707; Avianca ☎ 4680122; BWIA ☎ 4687835; KLM ☎ 4613033; Lufthansa ☎ 4656799/ 4656850; Servivensa ☎ 4680500; Surinam Airways ☎ 4689600; TAP (Air Portugal) ☎ 4686241; United ☎ 4613033

BANKS

Bank hours vary on the islands. On Aruba most are open Monday to Friday from 8am or 9am to noon and from 1.30pm or 2pm to 4pm. Some main branches stay open during lunch. On Bonaire they are open from 8am to 4pm Monday to Friday, and on Curaçao, banks are open from 8am to 3pm Monday to Friday. The airport bank is open from 8am to 8pm Monday to Saturday and from 9am to 4pm on Sunday. ATM machines are also available and dispense cash in Florins.

Aruba

Some bank branches on the L G Smith Boulevard remain open during lunch. The Aruba Bank branch at the airport is open daily from 8am to 4pm except holidays. There are ATM machines at:
ABN/AMRO Bank – Cayo G F Betico Croes 89 (Main Street), Sun Plaza Building, L G Boulevard 160, Dr Horacio Oduber Hospital, and Port of Call Mall, at L G Smith Boulevard 17.
Caribbean Mercantile Bank – Caya G F Betico Croes 51 (Main Street-downtown), Oranjestad; Palm Beach 48, Noord; Zeppenfeldstraat 35, San Nicolas; Santa Cruz 41, Santa Cruz; L G Smith Boulevard 17 and in the Seaport Village Mall.

Bonaire

ABN-Amro Bank, Kaya Grandi ☎ 8429; Antilles Banking, Kaya Almirante P.L. Brion, 4500; Banco di Caribe, Kaya Grandi ☎ 7595; Maduro and Curiel's Bank, Kaya L.D. Gerhart ☎ 5520

Curaçao

Banco di Caribe, Schottegatweg Oost 205 ☎ 4323000; Orco Bank, Dr H. Fergusonweg 10 ☎ 437200; Rabobank, Scharlooweg 55,☎ 4652011

BEACHES

There are fabulous beaches on all three islands with the water on the southern and western coasts tending to be calmer than on the beaches on the northern and eastern shores. Best beaches include:

Aruba
Palm Beach, Eagle Beach, Druif Beach, Baby Beach and Rodgers Beach.

Bonaire
Pink Beach, Cair Beach and Sorobon Beach on Lac Bay, Playa Funchi and Boca Slaagbaai.

Curaçao
The best beaches are along the south coast and include Knip, Klein Knip, Daaibooi, Port Marie, Santa Cruz, Westpoint, Santa Barbara, Jan Thiel and Sequarium Beach.

BEAUTY SALONS AND HAIRDRESSERS

Many of the resorts have their own facilities and there are other facilities on all the islands.

CAMPING

It is not allowed on any of the islands and there are no facilities.

CAR RENTAL

Cars and 4-wheel drive vehicles can be hired and provide the best way of exploring the islands. If you plan to go at peak periods, it is best to hire your vehicle in advance through your travel agent. Cars can be hired, however, at airports, hotels or car hire offices on the island.
To hire a vehicle you must have held a valid international or national driving permit for at two years and be at least 21 years old, although some companies have a minimum age of 25. Some companies also have a maximum age and will not hire vehicles to people over the age of 65 or 70.
Hire car rates range from US$35 to $40 a day for a small vehicle but there is competition and it pays to shop around. Insurance is not usually included in the basic hire price. Motorcycles and scooters are also available from US$15 to $20 a day.
Before accepting the vehicle, check it for scratches, dents and other problems, such as missing wing mirrors, and make sure these are clearly listed. Also check there is a spare tire in good condition and a working jack.

Rules of the road

Drive on the right, and unless signed otherwise, give priority to traffic from the right. The speed limit in towns is 40kph (25mph) and 60kph (37mph) in the country.

Drinking and driving is against the law, and there are heavy penalties if convicted, especially if it resulted in an accident.

Avoid clearly marked 'no parking' zones or you might pick up a ticket, but parking generally does not pose a problem.

If you have an accident or breakdown during the day, call your car hire company, so make sure you have the telephone number with you. They will usually send out a mechanic or a replacement vehicle. If you are stuck at night make sure the car is off the road, lock the vehicle and call a taxi to take you back to your hotel. Report the problem to the car hire company or the police as soon as possible.

Hire companies are:

Aruba

Ace Jeep and Car Rental ☎ 876373; Airways Aruba Rent A Car ☎ 821845; Avis ☎ 825496; Budget ☎ 828600; Caribbean Car Rental ☎ 829118; Courtesy ☎ 824129; Dollar ☎ 22783; Economy Car Rental ☎ 825176; Hertz ☎ 824400; J/M Car Rentals ☎ 823230; Marco's ☎ 825295; National ☎ 821967; Optima ☎ 835622; Super ☎ 878765; Thrifty ☎ 835300; Toyota Rent A Car ☎ 834832

Bonaire – car, scooter and bicycle rental

AB Car Rental ☎ 8980; Avis ☎ 5797; Bonaire Motorcycle Rentals ☎ 8420; ; Budget ☎ 4700; Coral ☎ 7800; Cycle Bonaire ☎ 8420; De Freeweiler ☎ 8545; Hertz ☎ 7221; Hotshot Scooter and Cycle ☎ 7166; Island ☎ 2100; Macho Scooter ☎ 2500; NAF ☎ 6670; National ☎ 7940; Total ☎ 8313

Curaçao

Antillean Car Rental (Dollar) ☎ 4613144/4690262; Avis ☎ 4611255/4681163; Best Car ☎ 7361433; Budget ☎ 8680644; Caribe Rentals ☎ 4613089 and 4615666; Hertz ☎ 8880088; National ☎ 8694433; Star Rent A Car ☎ 4627444; Vista ☎ 7378871

CHURCH

Most of the population are Roman Catholic but many other denominations are represented by small populations, including Anglican, Bahai' Faith, Church of Christ, Dutch Reformed, Evangelical, Lutheran, Jehovah's Witness, Methodist and Seventh-day Adventist. There has been a Sephardic Jewish community on Curaçao for more than 300 years.

Visitors are welcomed to worship at all churches on the islands, and times of services are generally available from hotels.

CLOTHING

Casual is the keyword but you can generally be as smart or as cool as you like. There are a number of upscale restaurants and clubs where there are dress codes, and if you plan to visit these, you should pack accordingly. Beachwear is fine for the beach and pool areas, but cover up a little for the street. Informal is the order of the day and night, and this is not the place for suits and ties or evening gowns, unless you really like dressing up for dinner or the casino. During the day, light cotton, casual clothes are ideal for exploring. During the evening, a light jumper or wrap may sometimes be needed. It is fun to change for dinner, but for men this normally means smart slacks or trousers, and for women a summer dress or similar. There are establishments, however, where sports coats or jackets are not out of place, and women can be as elegant as they wish.

If you plan to explore on foot, stout footwear and a good waterproof jacket are essential. Also, wear sunglasses and a hat to protect you from the sun during the hottest part of the day, and you will need sandals on the beach as the sand can get too hot to walk in bare feet.

CONFERENCE VENUES

Aruba

Many of the major resort hotels on the island offer meeting and banqueting facilities with full back up services. In addition, the Aruba Sonesta Conference Center is a 40,000 sq ft conference center in the Seaport Village with meeting, exhibition and function facilities. The center includes a main ballroom that can accommodate 1200 for banquets and 1900 people in theatre-style seating, additional meeting rooms and state of the art audio-visual equipment.

Bonaire

Harbour Village Beach Resort and Plaza Resort Bonaire have convention facilities.

Curaçao

World Trade Center, plus most of the large hotels have meeting and convention facilities.

CRUISE LINES

Dolphin ☎ 1-800-222-1033, Holland-America ☎ 1-800-426-0327, Norwegian ☎ 1-800-327-7030, Princess ☎ 1-800-421-0522, Regency ☎ 1-800-388-5500, Royal Caribbean ☎ 1-800-327-6700, Royal Cruise ☎ 1-800-227-4534 and Seawind ☎ 1-800-258-8006.

CURRENCY

The official currency on Bonaire and Curaçao is the Antillean Guilder, and on Aruba it is the Aruban Florin (or Guilder) both of which are divided into 100 cents. There are silver 5, 10, 25 and 50 cent coins as

well as 1 and 2.5 florin coins. The Aruba 50c coin, known as the 'yotin', is unmistakable because it is square. The current exchange rate with the US dollar is about US$1=Fl 1.77, but the rate fluctuates with the dollar on the world market. Current exchange rates are listed at banks and hotel exchange desks but US dollars are widely accepted. Major credit cards are also widely accepted in tourist areas and by most car hire companies, hotels, restaurants and large stores. There are also ATM machines available.

The American Express representative on the islands is SEL Madura and Sons. Aruba – Rockefellerstraat 1, Oranjestad ☎ 23888, and Curaçao, Breedesstraat 3B, Willemstad ☎ 4616212.

Note: Always have a few small denomination notes for tips.

DEPARTURE TAX

There is an airport departure tax of US$20 although this is often incorporated into the price of your air ticket.

DRINKING WATER

Drinking water is produced from desalination plants and is safe although bottled mineral and distilled water is widely available.

ELECTRICITY

The electricity supply is 110-120 volts AC 60 cycles on Aruba, and 110-128 volts AC 58 cycles on Bonaire and Curaçao, both of which are suitable for US appliances but not for most European appliances unless they have dual voltage capability. Adaptors are often available at the hotels, or can be purchased if you do not travel with your own.

EMBASSIES AND CONSULATES

Aruba
Denmark, L G Smith Boulevard 82
☎ 824622

Germany, Caya G F Groes 42
☎ 832929

Italy, Stadionweg 17A
☎ 821393

Spain, L.G. Smith Boulevard 112B
☎ 823475

Sweden, J. G. Emanstraat 58
☎ 824417

Curaçao
(all in Willemstad)
Belgium, Caracasbaaiweg 109, Salina
☎ 4615666

Canada, Plaza Jojo Correa 2-4
☎ 4613515

Denmark, Carawaraweg 84
☎ 4614044

France, Ontarioweg 8
☎ 4614300

Italy, Bellisimaweg 10
☎ 7375973

UK, Chuchubiweg 17
☎ 7371698

US Consulate, J. B. Gorsiraweg 1
☎ 4613006

EMERGENCY TELEPHONE NUMBERS

Aruba
Police
☎ 115 or 24555

Hospital
☎ 24300

Bonaire
Police, fire and ambulance
☎ 8000

Hospital
☎ 114/8900

Curaçao
Police and fire
☎ 114 and 44444

Ambulance
☎112 and 4689266

Hospital
☎ 4624900

ESSENTIAL THINGS TO PACK

Sun tan cream, sunglasses, sun hat, camera (and lots of film), insect repellant, binoculars if interested in bird watching and wildlife, and a small torch in case of power failures.

FACILITIES FOR DISABLED PERSONS

There are limited facilities for disabled persons but some hotels have ground floor rooms with doors wide enough for wheelchair access.

FISHING

Fishing is a popular pursuit, and many islanders will fish for hours from harbor walls, from the beach or riverside. Deep sea and game fishing is mostly for blue marlin and tuna which can weight up to 1,000lbs, wahoo and white marlin, which can weigh more than 100lbs, amberjack, kingfish, black and yellow fin tuna, shark, tarpon and the fighting sailfish.
Snapper, grouper, bonito, dorado and barracuda can all be caught close to shore. There are a number of boats available for charter, some offering half or full day deep sea fishing trips. Charter boats include:

Aruba
Amira Darina ☎ 834424, Dorothy ☎ 823375, Driftwood ☎ 832512, G String ☎ 826101, Kenny's Toy ☎ 825088, La Tanga ☎ 846825, Lucky Star ☎ 913920, Macabi ☎ 828834, Mahi-Mahi ☎ 836611, Melina ☎ 850125, Monsoon ☎ 833311, Queeny ☎ 878399, Sea Doll ☎ 824478, and Sweet Mary ☎ 827985.

Bonaire
Piscatur Charters ☎ 8774, Club Nautico ☎ 5800, Capt. Chris Morkos ☎ 8774, Ocean Breeze ☎ 5661, Multi Fish Charters ☎ 7033, Capt. Cornelis ☎ 7444.

Curaçao
Heavy Duty ☎ 7473200, Hemmingway ☎ 5630365.

GAMBLING

There is gambling on all the ABC islands and Aruba's first casino opened in 1959. There are more than a score of casinos on the islands – Aruba (11), Bonaire (2) and Curaçao (10) – all offering a range of games including blackjack, baccarat and roulette and all have slot machines. Casinos generally open from 11am (although some open earlier) for playing the slot machines and from 1pm for table games. Only people aged 18 and over are admitted.

HEALTH

There are no serious health problems although visitors should take precautions against the sun and mosquitoes, both of which can ruin your holiday. Immunization is not required unless traveling from an infected area within six days of arrival. All hotels have doctors either resident or on call and there are modern health facilities on all the islands, as well as excellent dental facilities. Aruba has dialysis facilities at the Posada Clinic, L G Smith Boulevard 14 ☎ 20840, but visitors planning to visit the island and requiring treatment must book at least three months in advance.

Tanning safely
The sun is very strong but sea breezes often disguise just how hot it is. If you are not used to the sun, take it carefully for the first two or three days, use a good sun screen with a factor of 15 or higher, and do not sunbathe during the hottest parts of the day between 11am and 2.30pm. Wear sunglasses and a sun hat. Sunglasses will protect you against the glare, especially strong on the beach, and sun hats will protect your head.
If you spend a lot of time swimming or scuba diving, take extra care, as you will burn even more quickly because of the combination of salt water and sun. Calamine lotion and preparations containing aloe are both useful in combating sunburn.

Irritating insects
Mosquitoes can be a problem almost anywhere. In your room, burn mosquito coils or use one of the many electrical plug in devices which burn an insect repelling tablet. Mosquitoes are not so much of a problem on or near the beaches because of onshore winds, but they may well bite you as you enjoy an open-air evening meal. Use a good insect repellant.
Sand flies can be a problem on the beach. Despite their tiny size they can give you a nasty bite. And, ants abound, so make sure you check the ground carefully before sitting down otherwise you might get bitten, and the bites can itch for days.

HOSPITALS

Aruba
Dr Horacio Oduber Hospital, L.G. Smith Boulevard ☎ 874300

The Medical Center, Bernardstraat 75, San Nicolas, is open Monday to Friday from 8am to noon and 3pm to 5pm, although emergency assistance is available round the clock ☎ 848833.
The Labco Medical and Homecare Service, Cabuyastraat 6a, Ponton ☎ 826651, offers a 24-hour service for rental of wheelchairs, walkers, crutches and similar.

Bonaire
Hospital
☎ 8900

Curaçao
St. Elizabeth Hospital, Otrobanda, Willemstad
☎ 4624900

INOCULATIONS

Inoculations are only required for visitors traveling from infected areas.

LANGUAGE

The official language on the islands is Dutch with English widely spoken, although Papiamento is the one most widely used and a law has been proposed that would put it on an equal footing with Dutch. The lilting Papiamento is a Spanish-based Creole dialect which incorporates words from many of the countries that have been involved in the islands' past such as France, Portugal, South Africa and, of course, Holland. The language is said to have originated in the ports of Curaçao in the 1600s where so many nationalities mingled and so many languages were spoken. Within 200 years, the language was in common use throughout the islands and is now spoken by all. Even the national anthem is written in Papiamento. The first Papiamento school was open in Curaçao in 1987 and the Antillean Linguistic Institute has been founded to standardize the language and ensure it maintains its place in the islands' history. English, Spanish, French and German are taught in schools and most islanders are multi-lingual.

Some useful Papiamento words:
(In some words either the letter c or k can be used i.e. cunuco or kunuko, but the pronunciation is the same)

bonbini	welcome
bon dia	good morning
bon tardi	good afternoon
bon nochi	good night
si	yes
no	no
kumbai	hello, how are you doing
con ta bai?	how do you do?
ami ta bon, danki	I'm fine, thanks
te aworo	see you later
kwant or tin?	what time is it?
dushi	delicious
ban come algo	let's have something to eat
hopi	a lot

tiki	a little
cuanto or kwantu?	how much?
masha danki	thank you very much
ayo	goodbye
playa	beach
solo	sun
landa	to swim
kalor	hot
kas	house

LOST PROPERTY

Report lost property as soon as possible to your hotel or the nearest police station.

MEDIA

Major international newspapers and magazines are available, with most hotels offering some US satellite TV channels.

Aruba

Aruba Today and *The News* are English-language newspapers with local and international news and there are English language radio programs.

Bonaire

Transworld Radio broadcasts in English daily between 7am and 8.30am and 10pm and midnight.

Curaçao

There are several daily newspapers with the *Curaçao Gazette* printed in English. Curaçao was the home of the world's first fully solar operated radio station in 1984 and now has many radio stations and Radio Paradise transmits news in English on the hour from 9am to 1pm and at 5, 6 and 7pm and in German at 10.30am, 12.30, 16.30 and 18.30pm. Tele Curaçao has programs in English, Dutch, Spanish and Papiamento.

NIGHTLIFE

There is a very lively nightlife from hotel entertainments to theatre, and from cabaret to casinos. There are clubs and discos for late night dancing, limbo and steel band shows and romantic piano bars.

PETS

Dogs and cats are permitted to enter the island provided they have a valid rabies and health certificate recently issued by a recognized veterinarian. Pets from Central and South America, however, are not permitted and most hotels do not allow pets.

PERSONAL INSURANCE AND MEDICAL COVER

Make sure you have adequate personal insurance and medical cover. If you need to call out a doctor or have medical treatment, you will probably have to pay for it at the time, so keep all receipts so that you can reclaim on your insurance.

PHARMACIES

There are pharmacies on all the islands, and most hotels have shops selling some over the counter medicines and preparations.

PHOTOGRAPHY

The intensity of the sun can play havoc with your films, especially if photographing near water or white sand. Compensate for the brightness otherwise your photographs will come out over exposed and wishy-washy. The heat can actually damage film so store reels in a box or bag in the hotel fridge if there is one. Also remember to protect your camera if on the beach, as a single grain of sand is all it takes to jam your camera.

It is very easy to get 'click happy' in the Caribbean, but be tactful when taking photographs. Many islanders are shy or simply fed up with being photographed, and others will insist on a small payment. You will have to decide whether the picture is worth it, but if a person declines to have their photograph taken, don't ignore this.

POST OFFICES

Aruba
Paraguaystraat
Oranjestad

Bonaire
J A Abraham Boulevard
opposite Plaza Wilhelmina.

Curaçao
In Willemstad – Waaigat,
Schottwegatweg Noord
and Breedestraat
Otrobanda.

PUBLIC TOILETS

There are not many public toilets on the islands, but bars, restaurants and hotels have private facilities that can usually be used if you ask politely.

RESTAURANTS

There is a remarkably large choice when it comes to eating out on the islands. There are the inevitable fast food burger, pizza and fried chicken outlets, beach cafes offering excellent value for the money and elegant upscale dining rooms, as well as restaurants offering a wide

range of ethnic cuisines, from Creole and Caribbean cooking to Latin American and Chinese.

Most accept credit cards and during peak times of the year, reservations are recommended. If you come across a restaurant not listed in the guide, or have comments about any of those that are, I would very much like to hear from you.

The restaurants listed in the itineraries are classified by price ($ inexpensive, $$ moderate, $$$ expensive), based on quality of food, service and ambience. The lists are in no way definitive.

SECURITY

It makes sense like anywhere else, not to walk around wearing expensive jewelry or flashing large sums of money. Don't carry around your passport, traveler's checks or all your money. Keep them secure in your room or in a hotel safety deposit box. It is also a good idea to have photocopies of the information page of your passport, your air ticket and holiday insurance policy. All will help greatly if the originals are lost.

As with most tourist destinations, you might be pestered by touts trying to sell tours, souvenirs and even drugs, or by young people begging. A firm 'no' or 'not interested', is normally enough to persuade them to try someone else. It is safer to take a taxi late at night and don't stray into lonely, dark or unfamiliar areas.

SERVICE CHARGES AND TAXES

Aruba

There is a 6% government room tax, an 11% service charge on all hotel rooms plus a service charge of 10%-15% on food and beverages, in lieu of gratuities. In shops, the price on the label is what you pay. When buying in markets and from street vendors, try haggling over the price.

Bonaire

There is a government tax of US$4.50 per person per night added to room rates, and most resorts add 10 to 15% as a service charge in lieu of tipping.

Curaçao

There is a 7% room tax, 6% sales tax and 12% service charge. Hotels normally add 19% to bills (room tax and service charge), while restaurants add the 6% sales tax plus a service charge of 10% or 15%. Some hotels also levy an energy tax of US$2 a night.

SHOPPING

There is a wide range of shops, from up market malls and top name boutiques with the latest high fashions, to craft shops and wayside vendors. Of interest to North American and European visitors is the wide range of goods imported from South America. The islands offer

duty free shopping with substantial discounts over prices in North America and Europe, especially for perfumes, jewelry, crystal, china and watches.

There is also a wide range of local art and handicrafts available such as pottery, painting, leather goods, woodcraft and hand painted clothing, as well as local liqueurs and the music of the many rhythms of the islands.

SIGHTSEEING

Sightseeing and island tours by land or sea can be organized through hotels, tour representatives or one of the many specialist tour companies on the islands. All offer a number of trips and excursions, or can tailor itineraries to suit you. Many of the tours sound the same, so check to see that you are getting value for money, or getting something special.

These include:

Aruba

Aruba Friendly Tours, ☎ 825800, Aruba Taxi Transfer and Tours ☎ 822116, De Palm Tours ☎ 824400. Archaeology, geological and nature tours – Marlin Booster Tracking Eco Tours ☎ 41513.

Bonaire

Achie Tours ☎ 8630, Baranka Tours ☎ 2200, Bonaire Boating ☎5353, Bonaire Tours ☎ 8778, and Chogogo ☎ 4435.

Curaçao

ABC Tours ☎ 4675105, Ben Tours ☎ 4882366, Blenchi Tours ☎ 4628377, Caribbean Incentives ☎ 4619310, Casper Tours ☎ 4653010, Curaçao Tropical Tours ☎ 8687194, Curven Tours ☎ 7379806, Daltino Tours ☎ 4614888, Dushi Safari Tours ☎ 4656310, Grayline Sightseeing ☎ 4613622, Old City Tours ☎ 4613554, STAR ☎ 4652255 and Taber Tours ☎ 7376637.

STAMPS

Aruba has its own stamps bearing its name and these are highly collectible. Collectors can subscribe for new issues or purchase recently published sets from the Philatelic Service, Post Office, Oranjestad ☎ 21900. Curaçao has a philately section in the main post office in Willemstad.

TELEPHONES

International calls can be made from all resort hotels via the operator, or telephone booths around the island with a phone card. Phone cards are widely available. The international dialing code for Aruba is 297-8, for Bonaire it is 599-7, and for Curaçao it is 599-9. For the UK dial 0044 + area code+ number, for the US and Canada dial 001+atrea code + local number.

To reach an AT&T operator for collect or credit card calls to the US dial 001-800-872-2881.

On Aruba calls can also be made at Setar Teleshop offices in Palm Beach in front of the Hyatt Regency Aruba Resort, and in the Strada Complex 11 in Oranjestad, and from the post offices in Oranjestad and San Nicolas. Cellular phones can be rented on Aruba from Setar at Seroe Blanco ☎ 820005. USA Direct calls can only be made from the airport or the cruise terminal.

To make a local call on Aruba you must now dial 8 before the 5-digit local number. All Curaçao telephone numbers now have 7 digits.

TIME

The islands are four hours behind Greenwich Mean Time and one hour ahead of Eastern Time in the United States. If it is noon in London it is 8am in Aruba, and when it is noon in New York, it is 1pm on the islands.

While it is important to know the time so that you don't miss your flight, time becomes less important the longer you stay on the island. If you order a taxi it will generally be early or arrive on time, and if you have a business meeting it will start on schedule, for almost everything else be prepared to adopt 'Caribbean time', especially in bars, restaurants and shops. Don't confuse this relaxed attitude with laziness or rudeness, it is just the way things are done in the islands, and the quicker you accept this, the sooner you will start to relax and enjoy yourselves.

TIPPING

Service charges of 10 to 12% are generally added to restaurant bills so a tip is not necessary unless you want to acknowledge an outstanding meal, but it is customary to tip bell hops in hotels, taxi drivers, guides and other people providing a service. Tip taxi drivers around 10-15% and bell hops US$1 or equivalent for each piece of luggage.

TOURIST INFORMATION

Aruba
Aruba Tourism Authority, L G Smith Boulevard 172, Aruba
☎ 23777

US
1000 Harbor Boulevard, Weehawken, New Jersey 07087 ☎ (201) 330-0800 and 1-800-TO-ARUBA

2344 Salzedo Street, Miami, Florida 33134-5033
☎ (305) 567-2720

1101 Jupiter Street NE # 1101, Atlanta, Georgia 30309-3688
☎ (404) 89-ARUBA

12707 North Freeway, Suite 138, Houston Texas 77060-1234
☎ (713) 87-ARUBA

CANADA
5875 Highway 7, Suite 204, Woodbridge, Ontario L4L 1T9
☎ (905) 264-3434

NETHERLANDS
Schimmelpennincklaan 1, 2517 JN Den Haag, The Netherlands
☎ (70) 356-6220

Bonaire

Bonaire Tourist Bureau, 12 Kaya Lib. Simon Bolivar, Kralendijk ☎ 8322.

US
Tourism Corporation Bonaire, 10 Rockefeller Plaza, Suite 900, New York 10020
☎ (212) 956-5912 or 1-800-BONAIRE

EUROPE
Bonaire Tourist Office, Visseringlaan 24, Rijswijk, 2288ER, The Netherlands
☎ 31-70-395-4444.

Curaçao

Tourist Information Office, 19 Pietermaai, Willemstad
☎ 4616000

US
Curaçao Tourist Board, 475 Park Avenue South, Suite 2000 New York NY 10016
☎ 1-800-3 CURAÇAO or (212) 683-7660

Curaçao Tourist Board, 330 Biscayne Boulevard, Miami Fl 33132
☎ (305) 374-5811

GERMANY
Curaçao Verkehrsamt, Arnulfstraat 44, D-8000 Munich 2 ☎ (49-89) 598-490

NETHERLANDS
Curaçao Tourist Bureau, Vasteland 82-84, 3011 BP Rotterdam
☎ (41) 42639

WEDDINGS

The romantic atmosphere and tropical surroundings make the ABC islands a popular setting for weddings and honeymoons. Most hotels offers special packages for couples wishing to marry on the islands, and many have qualified staff able to handle most of the details and paperwork. And, there is no shortage of special places to get married, from the beach to special wedding gazebos set in tropical gardens, and from churches and chapels to historic buildings.

Aruba

Civil weddings are only possible on Aruba if one of the partners is an Aruba resident, but Catholic, Protestant and Jewish weddings can be arranged on the island.

Jewish couples must submit a certificate of verification of Judaism from both partners from their rabbi and submit a petition to the Aruba Jewish community: Isrealitische Gemeente – Bet Israel, A Lacle Boulevard 2, Box 2, Aruba ☎ 23272.

Roman Catholic couples must bring a permit to get married from their home priest, attend pre-wedding preparation in their parish, have an official form stating that neither party was ever married in a church, and present a baptism certificate for each person.

Protestant couples wishing to have a religious wedding on the island must marry before civil authorities in their native country, submit a wedding certificate and contact Pastor Anthony van der Doel, Bilderdijkstraat 7, Oranjestad ☎ 21961 or 21435.

Civil weddings are possible aboard the seagoing yacht *S Y Wyvern 11* as the ceremony is conducted by the Captain, in international waters. While a wedding certificate and a copy of the ship's registration are provided, couples must register their wedding certificate with the civil

authorities in their hometown for it to be recognized. The procedure for this varies from State to State within the US and from country to country, so check in advance what is required for the ceremony to be legally recognized back home. Capt van Erp can be contacted through Aruba Marine Services NV, Seaport Marketplace 204, PO Box 4104, Aruba ☎ 839190.

Bonaire

In order to wed, one of the parties must request temporary residence in writing and both parties need to present passports, birth certificates, proof of single status or papers to prove divorced or widowed status. Documents sent by post or fax must arrive at least two weeks before the wedding and at the same time the Registrar must be notified of the planned date and time of the wedding. The Registrar office is open Monday to Friday between 8.30am and 8pm. Weddings on Monday are performed free, those conducted between Tuesday and Friday within working hours cost Guilders 150, and if a later evening wedding is planned Guilders 200. Weekend weddings cost Guilders 300.
On Bonaire the following can take care of all the paper work and make all arrangements for the wedding, reception and honeymoon if required: Multro Travel and Tours ☎ 8334 and Bonaire Sightseeing Tours ☎8300.

Curaçao

In order to marry at least one of the parties must be resident (temporary or otherwise) on Curaçao when registering at the Aliens Registration Office, Concordiastraat 24, Willemstad, and at least two days must elapse between this and giving notice of marriage. Both parties must submit copies of birth certificates, passport, proof of single status, and if previously married a copy of divorce papers or death certificate. Notice of marriage must be made in person at the Registry and at least two weeks must elapse between this and the wedding date. Witnesses at the wedding must be residents of The Netherlands Antilles. The cost of the ceremony is Guilders 50 on Monday and Tuesday, and Guilders 75 on Wednesday to Friday. The marriage certificate costs Guilders 32.50.

YACHTS, CHARTER AND PRIVATE MOORINGS

There is a wide range of options if you want to sail. You can charter yachts either crewed or unmanned, you can be pampered on day cruises combined with snorkelling, take sunset, dinner and dancing cruises and romantic moonlight cruises.
The following yachts are available for trips:

Aruba

Cruising – Andante ☎ 847718, Aruba Marine Services ☎ 839190, Aruba Pirates Cruises ☎ 824554, De Palm Tours ☎ 824545, Mi Dushi ☎ 823513, Pelican Watersports ☎ 831228, Red Sail Sports ☎ 864500, Tattoo ☎ 823513, Tranquilo ☎ 831228, Wave Dancer ☎ 825520 and Windfeathers ☎ 823513.
Sailing trips – Aruba Marine Services ☎ 839190, Aruba Pirates Cruises ☎ 824554, Discovery Tours ☎ 875875, Octopus Sailing Cruises ☎ 833081, Van E&B Yacht Charters ☎ 837723 and Windfeather Charters ☎ 865842.

Bonaire

Blue Band ☎09-5607897 (marine phone), Bonaire Boating ☎ 5353, Bonaire Dream glass bottom boat ☎ 8499, Insulinde ☎ 09-5601340, Oscarina ☎ 7674, Paranda ☎2450, Pirate Cruise ☎ 8330, Sails of Bonaire ☎ 7797, Samur ☎ 5592, Sea Witch Charters ☎ 09-5607449, and Woodwind ☎ 09-5607055.

Curaçao

Insulinde ☎ 4601340; Mermaid ☎ 7375198; Miss Ann ☎ 4671579; Miss Hilda Veronica ☎ 4611257; Sail Curaçao ☎4 676003; Vira Cocha ☎ 4676003.

INDEX

Published in the UK by:
Landmark Publishing Ltd,
Ashbourne Hall, Cokayne Avenue, Ashbourne, Derbyshire DE6 1EJ England
E-mail landmark@clara.net Web-site www.landmarkpublishing.co.uk

Published in the US by
Hunter Publishing Inc,
130 Campus Drive, Edison NJ 08818
Tel: (732) 225 1900, (800) 255 0343 Fax: (732) 417 0482
website: www.hunterpublishing.com

ISBN 1 901522 04 0

Landmark Visitors Guide - Aruba, Bonaire and Curaçao

© **Don Philpott 2002**

British Library Cataloguing in Publication Data:
A catalogue record for this book is available from the British Library

Print: Centro Grafico, Ambrosiano
Cartography: Mark Titterton
Design: Mark Titterton

Front cover: Palm Beach, Aruba
Back Cover: Government House, Kralendijk – Bonaire

Picture Credits
Aruba Tourism Authority – Fernando Arroniz – Front Cover, p.3, p.6, p.10, p.14, p.15 top;
middle & bottom, p. 22 top left and middle, p.30, p.31, p.38 bottom, p.39, p.42 top , p.123
Stuart Cummings – p.38 top, p43, p47 left; middle and right
Tourism corporation Bonaire – p.22 top right & bottom p.58, p.66 top & bottom,
p.75 top & bottom
Curaçao Tourism Development – p.78 top and bottom, p.82, p.83, p.87 top left & right,
p.90, p.95 top & bottom, p.99 top & bottom, p.106 top; bottom left & right
for further information on Curaçao visit www.curaçao-tourism.com
remaining photographs by the author Don Philpott